D1216509

REQUIEM FOR COMMUNISM

REQUIEM FOR COMMUNISM

tom + laura —
natalie sends this
book your way. I
hope to meet you
properly some day.
— charity

CHARITY SCRIBNER

The MIT Press Cambridge, Massachusetts London, England

© 2003 Massachusetts Institute of Technology
All rights reserved. No part of this book may be reproduced in any form by any electronic or mechanical means (including photocopying, recording, or information storage and retrieval) without permission in writing from the publisher.

This book was set in Hoefler, Knockout, Uni, and Volta by Graphic Composition, Inc., Athens, Georgia, and was printed and bound in the United States of America.

Library of Congress Cataloging-in-Publication Data

Scribner, Charity.
 Requiem for communism / Charity Scribner.
 p. cm.
 Includes bibliographical references and index.
ISBN 0-262-19488-0 (hc. : alk. paper)
 1. Communism and art—Europe. 2. Socialism and art—Europe. 3. Post-communism—Europe.
 4. Europe—Intellectual life. 5. Arts, European—20th century. 6. Arts—Political aspects—Europe.
 7. Nostalgia in art. I. Title.

HX521.S38 2004
700'.458—dc21

 2003051200

to Raphaël Thomas Delaney Smith (1967-1993)

CONTENTS

ACKNOWLEDGMENTS

This book came together in three apartments in Berlin's Prenzlauer Berg between 1993 and 2002, but its impulses extend to other cities and earlier dates. In 1983, somewhere in the 7th arrondissement in Paris, I saw a monument to the Polish Solidarity trade union. Studying in Cracow in 1986, I once struck upon a combat zone of tear gas and thrown stones that had opened up between pro-democracy protesters and the police. On 10 November 1989 I shared a sleeping compartment of a railway car with a wasted cultural attaché from East Germany. He kept me awake the whole night with his stories of doubt and regret. Later, over the course of my graduate work, certain occasions prompted memories of these encounters. I fell into conversations about socialism and its aftermath in a number of places — the Red Fish studio collective in Brighton, a bar near the Sorbonne, and a curatorial office in the former Stalinstadt. These flashpoints continue to illuminate my reading of European literature and art.

This study is the product of multiple collaborations with scholars and editors. The staff and faculties of Foreign Languages and Literatures at the Massachusetts Institute of Technology and the faculties of both Comparative

Literature and Art History at Columbia University established the intellectual context that fostered this project. I am grateful to Isabelle de Courtivron, Elizabeth Garrels, Edward Baron Turk, William Uricchio, and Dean Philip Khoury at MIT, as well as Benjamin H. D. Buchloh, Anna Frajlich-Zając, Ursula Heise, Rosalind Krauss, and Jeff Olick at Columbia. Special acknowledgment goes to Andreas Huyssen, the professor who directed this project's development into a doctoral thesis at Columbia and has continued to advise me in my first years in the academy. The Kulturwissenschaftliches Institut im Wissenschaftszentrum Nordrhein-Westfalen enabled refinement of this manuscript with a postdoctoral fellowship from 2000 to 2002. I'm obliged to Slavoj Žižek and other members of our Studiengruppe "Antinomien der postmodernen Vernunft" for their cooperation. I'd also like to thank Jörn Rüsen and Doris Almenara for promoting our research.

A number of individuals and institutions helped to build the framework for this study. I'm pleased to mention the British Film Institute, the Documenta Archiv, the Independent Study Program of the Whitney Museum, the Dokumentationszentrum Alltagskultur der DDR in Eisenhüttenstadt, the Sammlung Industrielle Gestaltung in Berlin, Lynne Cooke, curator at the Dia Center for the Arts, Hortensia Voelckers, director of the Kulturstiftung des Bundes, and the Center for European Studies at Harvard University. This project was funded with grants from institutions in both Germany and the United States. They include the Fulbright Foundation, the Deutscher Akademischer Austauschdienst, MIT, Columbia University, and the Kościuszko Foundation.

Over the past six years I have presented the ideas contained here as works-in-progress before audiences at the Whitney Museum of American Art in New York, the Carnegie Museum of Art in Pittsburgh, the Stockholm International Forum on the Holocaust, the Zentrum für Kunst und Medientechnologie in Karlsruhe, and the Department of Comparative Literature at UCLA. A number of colloquia round out this list, including "Nach Lenin: Gibt es eine Politik der Wahrheit?" at the Haus der Technik in Essen, "Paradigma Zentraleuropa" at the Université Catholique de l'Ouest in Angers, and the conferences of the Modern Language Association and the American Comparative Literature Association.

Earlier versions of the material in this book have appeared in the following publications: "Object, Fetish, Relic, Thing: Joseph Beuys and the Museum," *Critical Inquiry* 29, no. 4 (Summer 2003); "Second World, Second Sex, and Literature on the European Left," *Comparative Literature: Journal of*

the *American Comparative Literature Association* 55, no. 3 (Summer 2002); "August 1961: Christa Wolf and the Politics of Disavowal," *German Life and Letters* 55, no. 1 (January 2002); "John Berger, Leslie Kaplan, et 'l'autre Europe,'" in *Paradigma Zentraleuropa: Nonverbale Artikulation und kulturellen Codes* (Innsbruck: Studien Verlag, 2002); "Left Melancholy" in David L. Eng and David Kazanjian, eds., *Loss: The Politics of Mourning* (Berkeley: University of California Press, 2002); "Sophie Calle and the Specters of Collective Memory," *Found Object* 11 (Autumn 2001); "Rhetorik der Trauerarbeit," *Kulturwissenschaftliches Institut-NRW: Jahrbuch 2000/2001;* "Tender Rejection," *EJES: The European Journal of English Studies* 4, no. 2 (August 2000); "From the Collective to the Collection: Curating Post-Communist Germany," *New Left Review,* no. 237 (September/October 1999); "Parting with a View: Wisława Szymborska and the Work of Mourning," *The Polish Review* 44, no. 3 (1999); and "Eastern Time: The Race to Curate the Communist Past in Germany," *Documents,* no. 13 (Autumn 1998). I'm grateful to all the editors who saw fit to publish these early essays.

This book would not have been possible without the cooperation of several artists and writers. I thank Chantal Akerman, Sophie Calle, Alan Chin, Nina Lorenz-Herting, Judith Kuckart, Thomas Struth, Nick Wall, Rachel Whiteread, and Florian Zeyfang for allowing me to reproduce their work here. Through their scholarship, Charles S. Maier and Christopher Pavsek gave me crucial insights on German history and philosophy. Pam Lee gave sound advice from afar. This book has been read, in whole and in part, by Greg Bordowitz, Peter Dimock, Bettina Funcke, Terri Gordon, Juliet Koss, John Maciuika, Helen Molesworth, Michael Rothberg, Anne Routon, Linda Schulte-Sasse, and Slavoj Žižek. These colleagues — together with the generous readers at the MIT Press who wrote the first reports on the manuscript — gave a critical slant to the theses elaborated in this book.

My work with Markus Müller and the team of Documenta 11 provided a fresh counterpoint to my research from 2000 to 2002. Friends and family have encouraged me over the longer period that this project has taken, providing intellectual, editorial, and material aid across the Atlantic. I'd like to thank Marc Bennett, Hunter Bivens, Katy Chevigny, Winson Chu, Natalie Jeremijenko, Oliver Juds, Myron Liptzin, Kirsten Painter, Andrew Piper, Anna Snider, Lisa Soltani, Christopher Stevens, Dorothy Teer, Alice Ting, John Urang, and Matthias Weichelt. Of this inner circle I am deeply indebted to Dalton Conley and John Zilcosky, my most constant allies. Their own research remains a great inspiration to me.

In the final stages of revision, this book benefited from the insights and labor of three research assistants — Udhay Krishnan, Tara McGann, and Yang Song. At the MIT Press, the key figures in the conception and publishing of this book have been Matthew Abbate, Tímea Adrián, Susan Clark, Lisa Reeve, and Paula Woolley. Finally, I am beholden to the counsel of my editor, Roger Conover; this book seasoned under his fine direction.

Closing credit goes to my students: the sophomores in Contemporary Civilization at Columbia, the reserve officers who took my first German course at the Bronx's 353rd Civil Affairs Command, and — especially — the members of my seminar Avant-Garde and Culture Industry at MIT. Working with them, I have seen how much reading and writing matter.

Cambridge, March 2003

REQUIEM FOR COMMUNISM

INTRODUCTION

The Second World

Others have labored,
and you have entered into their labor.

John 4.38

In 1996 an obituary for the ideals of socialism appeared on the streets of Berlin. Framed in a black border, the notice invited the public to join a funeral procession that led from the Memorial Church in the western half of the city to the "Cemetery of the Welfare State" that had been temporarily marked out in the East. The artists who orchestrated this performance struck a peculiar chord — one that resonated not only in Germany, but in the rest of Europe as well. For although many Europeans considered the project to build a workers' state to be a failure, they have proceeded to mourn its collapse, nonetheless.

This collective sorrow has motivated a proliferation of literary texts and artworks, as well as a boom of museum exhibitions that survey the wreckage of socialism and its industrial remains. The literature and art that recalls the socialist collective does not simply indulge in melancholia for an idealized communist or welfare state of the past. Rather, it heightens the awareness that something is missing from the present. State socialism's ruin signaled that industrial modernity had exhausted its utopian potential.

Writers and artists in both Eastern and Western Europe look back from our digital age to the moment when the promise of solidarity manifested itself

among the men and women who labored together on the factory floor. This collective hope was shared by miners in England, laundresses in France, and machinists in the Germanies and Poland. Yet it registered most deeply in the former people's republics that the new world order has pronounced obsolete.[1] In Eastern Germany and Poland factories fall into decay, but they have not yet been fully supplanted by the informational economies of late capitalism. As a result, cities like Chemnitz (formerly Karl-Marx-Stadt) and Nowa Huta (in English, New Foundry) lie at the threshold between Europe's industrial and postindustrial moments. Wasting pockets of this so-called "second world" also persist in the outskirts of London, Paris, and other Western metropolises, but it is the East that stalls most momentously in the shadow of heavy industry's eclipse.[2] This lull discloses something that the new Europe, as a whole, cannot afford to leave behind: a means of collective experience that provides a singular perspective on its counterparts, the "first world" and the "third." As the traffic condenses between the first and third worlds, a new "empire" emerges in which old boundaries dissolve — including the second world that once mediated between them.[3] Yet today, when the forces of globalization are smoothing over Europe's industrial wastelands, we can still keep hold of the second world's cultural memory and claim its remainders as sites of reflection and resistance.

An understanding of the contemporary cultural and political condition — even in its global dimensions — is only possible with sustained attention to the recent transitions in Eastern Europe. The cultural memory of this moment cannot be accounted for, however, if we limit ourselves to Eastern sources and texts. For the socialist project also belonged to Western Europeans. Most Western intellectuals never lived in or visited the Eastern Bloc, but many of them, especially those of a leftist orientation, declared an investment in socialism with a fervor matched only, perhaps, by Soviet ideologues. When state socialism entered its final agonies, many artists and writers were reminded of the wearing out of Western welfare states such as Britain and France. A number of recent texts and artworks betoken these corollary forfeitures, often narrating the demise of worker solidarity in a single space of industrial obsolescence that welds together aspects of Eastern and Western European culture.

By the 1980s and 1990s, democratic impulses were gaining momentum in Poland and East Germany, and totalitarian repression was becoming a thing of the past. Many writers and artists from these countries thus felt a greater affinity with their Western neighbors than they did with Russia.[4] As the Cold

War began to thaw, the exhaustion of the welfare state and the collapse of communism brought the European labor movement to the brink of ruin and called for a fundamental rethinking of socialist strategy across the continent. The aesthetic response to this socialist crisis disclosed cross-cultural bridges that linked the otherwise disparate societies of Eastern and Western Europe. The object here is to illuminate these transcontinental formations in literary and visual culture.[5] Most of the work examined in this study was produced in the past three decades, when the socialist emergency linked leftists and dissidents from Britain, France, Germany, and Poland.[6]

Many Europeans have perceived the crisis in socialism as part of a larger process, one that involves the breakdown of the trade union, the disempowerment of women, and even, at its extremes, the disappearance of the working class. Whether this is the case, or whether capital has rather destabilized the forces of collective labor, dispersing and relocating industrial manufacture to the economies of the South, it appears that the figure of the worker— particularly the woman worker— has been pushed to the margins of contemporary European culture. Although some of the positions once occupied by factory hands are being filled by the employees of the emergent information and service industries, it is unclear whether such immaterial labor can either activate collective and historical consciousness or secure the right to work for all Europeans, men and women alike.[7] Michael Hardt and Antonio Negri have recently considered the immateriality of advanced forms of production, and have suggested its potential to enable "the multitude" of subjects to form high-speed networks to operate both through and against global capital. They caution that the new theory of immaterial labor cannot adequately account for residual practices of industrial manufacture, but still their arguments largely endorse the technologies and strategies facilitated and accelerated by the first world's media society.

Requiem for Communism also aims to negotiate the realities of the post-industrial moment, but it focuses on the field of contemporary literary and visual culture. At odds with postmodern flux, this book fixes its attention upon the local, the concrete. Whereas Hardt and Negri identify a subversive "deterritorializing power" flowing within the multitude, one might ask whether the masses of under- and unemployed in Manchester and Magdeburg can actually exercise this agency or whether, in fact, this power has been wielded against them by the corporations that have downsized, reconglomerated, and hauled out of Europe.[8] This apprehension informs the literature and art considered here. Reading these works, one confronts the corporeal and

material vestiges of socialist history that have escaped the attention of many cultural critics. These remnants might be consigned to oblivion, but, for the time being, they persist as an important component of European collective memory. Until this cultural formation is given its due, a brisk ovation like the one that concludes Hardt and Negri's *Empire* — their last words salute "the irrepressible lightness and joy of being communist" — cannot ring true. Before we can move forward, we must take stock of what remains.

The sharpest accounts of Europe's second world remind us at once of the actual catastrophes of industrial labor and the particular values and social relationships that were the by-product of the factory. Oskar Negt and Alexander Kluge bring this insistence to bear upon their collaborative works of *Kulturphilosophie, Öffentlichkeit und Erfahrung (Public Sphere and Experience;* 1972) and *Geschichte und Eigensinn (History and Obstinacy;* 1981).[9] Their projects offer a cinematic presentation of historical antagonisms that mixes together historical and sociological abstracts, fairy tales, documentary photographs, hypertext, diagrams, and doodles. Negt and Kluge anticipate the array of narratives and artworks that would commemorate socialism's many failures. Through their interdisciplinary scope, they also chart the territory of the book at hand. While conceding the left's defeat in industrial modernity, Negt and Kluge seek to redeem some lesson from the countless hours of dead labor stored in the manufacture and mining of Europe's past. What both capital and communism first sought to exploit as a productive capacity, cultural practice might reclaim as collective memory.

The authors and artists who survey the second world aim to salvage from the factory hour not the mechanical function of managed labor, but rather the collective sites of resistance that also occupied that historical moment. The downtime, for example, when a steel press would unexpectedly call for repair. The exchange of glances across a combine. The sigh at the siren, and the group exit out of the factory gates. As Negt and Kluge maintain, the actual postwar factory has been streamlined into a stronghold of surveillance, industrial-relations boards, and legal institutions that more resemble Europe's absolutist states of the eighteenth century than they do any sort of democratic public sphere or *Öffentlichkeit*.[10] The critical minds of the postindustrial era concede this truth. Thus, their literature and art does not so much take us back to the factory as it looks for something to take out from it: the intractable moments of both solidarity and intrafactory arbitration that did not square with the market or the plan. These "factory seconds" were more temporal than material. Although they were sedimented

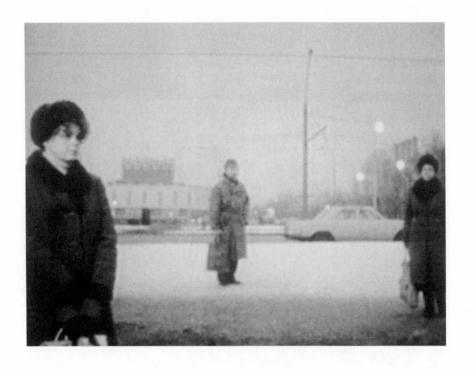

0.1 *D'Est (From the East),* dir. Chantal Akerman, 1993.

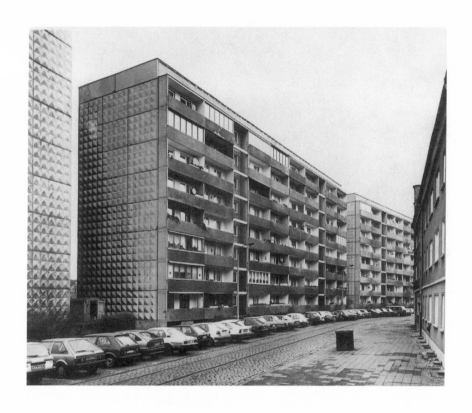

0.2 Thomas Struth, *Ferdinand-von-Schill-Straße, Dessau,* 1991.

into the products *seconded* for their imperfections, they were counted as *seconds lost* to the production process. In the reigning logic of capital such interruptions are dumb and dysfunctional, but in the utopian imagination they renew the conviction that no subject can be instrumentalized and reduced to a determination at the economic level. The most compelling stories of the second world considered in this project transpose both the antagonisms and associations *(Zusammenhänge)* of the workplace into the text, where author and reader might reenter protracted negotiations over the work's meaning.

Often the second world and its aftermath are best captured in pauses and absences. Chantal Akerman's film *D'Est (From the East;* 1993) measures the stillness that set in when industries halted. Her camera pans along queues of Eastern Europeans, still waiting on line, long after 1989. Thomas Struth's photography of East German industrial cityscapes, empty in the early morning hours, notes a rest between the past and the future. These oblique works recount Europe's factory seconds more resonantly than any document. In postindustrial, unifying Europe, it is not the factory as such but the cultural residues of collective labor that promise a new forum, a *glasnost,* or literally an openness on the order of Negt and Kluge's public sphere.[11]

Historians and social scientists in Europe and abroad have begun to record and assess the disintegration of real socialism and the welfare state. Although their analyses have enriched our understanding of the second world, little critical attention has been directed toward the aesthetic response to the socialist crisis.[12] *Requiem for Communism* enters into this gap, and examines a set of key texts, artworks, and films which convey the currents of mourning and melancholia that are stirring both sides of Europe today. Factors of aesthetic objectivity and disciplinary constraints do not govern the selection. I have chosen the projects that, to my mind, most forcefully register the politics of memory.

Until recently, utopian thought offered an alternate route away from implacable historical reality. Now, at the purported "end of history" when time seems to pause in the eternal present, utopia veers into the longing for History itself — for the touch of the real that postindustrial virtualization threatens to subsume. Nineteenth-century modes of production that were long considered violent and destructive return to us as the object of nostalgic interest. At the same time, much recent art and literature manifests the desire not only to recollect ways of living and working that were imagined to be possible under the rubric of the socialist alternative, but also to resuscitate the

principle of hope that inspired much of the last century's social and cultural production. The aesthetic response to the socialist crisis ranges from sober, historical description to melancholic fixation; from brutal erasure to the painful work of mourning; and from dismissal to nostalgic longing. Walter Benjamin suggests that real historical memory sustains emancipatory potentials that were once crushed. If this is true, when does authentic attachment to the past wend into nostalgia? The first part of this book lays the foundation for this analysis.

Against the triumphalism of the digital economy, many of the works under examination measure the status of collective experience today, asking whether virtual communities can foster a historical consciousness which matches that of the industrial collective. Chapter 1 compares two projects that enter into this inquiry: the German museum collection the Offenes Depot (Open Depot; 1997–present), and *Die Entfernung* (*The Detachment;* 1996), an installation by the French conceptual artist Sophie Calle. These two projects track the passage from the working collective to the museum collection and monitor its impact on the faculties of collective memory. They gather their energy from the dismantling of ex-communist objects and spaces, and participate in one of the most striking trends currently burgeoning in Europe, namely the exhibition of socialist material culture in museums and galleries. A number of East German curators have recently organized exhibitions of everyday objects produced by the decommissioned state industries, or *Volkseigene Betriebe.* In this process, objects once conceived for their use or exchange value are being elevated to the realm of exhibition value. Located in the Center for Documentation of Everyday Culture in the Eastern German town of Eisenhüttenstadt (formerly Stalinstadt), the Open Depot is housed in the abandoned nursery building of a socialist realist-style urban complex. This museum has become a metaphor for Eisenhüttenstadt. The transformation of this space from a site of biological and industrial re/production to one of museal re/collection and conservation signals the redirection of the aesthetic imagination from the future (as was the case in both the historical avant-garde and socialist realism) to the past (as is the case in much contemporary art and literature).

If the Open Depot suggests the sexual charge of the cultural response to the socialist crisis, the works examined in chapter 2 make manifest the gender politics that have recently determined the dynamics of memory and history in Eastern Europe. Here I consider Andrzej Wajda's *Człowiek z marmuru* (*Man of Marble;* 1977) and *Człowiek ze żelaza* (*Man of Iron;* 1981), two films that

mix fact and fiction in an attempt to recount the legacies of the Stakhanovite and Solidarity labor movements in Poland. Although Wajda made this epic well before communism's collapse, it prefigured the more recent requiems for communism with its attention to the problem of mourning. Caught up by the current of Polish messianism, Wajda displaces the films' fierce heroine from the vanguard of labor organization in Gdansk, and then recasts her as the serene Mother of Future Poland. In the first film, she investigates the deposition of a model worker; in the second, she marries the worker's son and tries to put the past behind her through various acts of mourning. Although Wajda cuts documentary footage of Lech Wałęsa and other union leaders into his narratives, in the end Solidarity is only a dramatic backdrop to the epic. The driving force behind these films is not Poland's actual history of discord and dissent in late socialism, but rather the desire to resolve an Oedipal dilemma. Wajda set out to mourn the failures of the labor movement, but then derailed his films into more melancholy grounds.

Since the fall of communism, many have been quick to brand Eastern Europeans as pining for a social safety net that never really existed. Germans have even coined a term for this condition: *Ostalgie*, or "nostalgia for the East." But this malaise is hardly limited to the East, nor is it always indulged in unknowingly. Recently Richard Foreman's Ontological-Hysterical Theater in New York put on *Now That Communism Is Dead, My Life Feels Empty* (2001), and many Western Europeans have proved themselves just as prone to postcommunist reverie. Chapter 3 examines four works that touch on the matter of nostalgia for the days of socialism and the welfare state in Britain and France: John Berger's literary trilogy *Into Their Labors* (1979–90), Leslie Kaplan's novel *L'Excès-l'usine* (*Factory Excess;* 1982), Mark Herman's film *Brassed Off* (1996), and Tony Harrison's film *Prometheus* (1998). Berger, the renowned Marxist author of *Ways of Seeing* (1972), waxes nostalgic about industrial labor in the French provinces. Kaplan, the ex-Maoist who wrote collaboratively with Marguerite Duras, depicts the assembly line as a place of women's abject alienation, where the sentimental song "Those Were the Days" drones on, bringing time to a standstill. The postscript to *Factory Excess* makes explicit the relevance of the Polish Solidarity movement to the fate of industrial workers in France. In *Prometheus,* Harrison engages cinematic means to link the demise of UK collieries with the fate of miners across Europe — from Germany, through the Balkans, to Greece. Of these four works, only *Brassed Off* envisions a future path for worker solidarity, even though Herman concedes both heavy industry's breakdown and the British welfare state's exhaustion.

The second part of this book focuses on the three signal modes of collective memory in Europe today: mourning, melancholia, and disavowal. Each of these modes finds its distinct formal expression in the works examined here. In his classic study "Mourning and Melancholia" (1917), Freud defines the labor of mourning not only as the transfer of libidinal energies from the lost object (a person, a country, an ideal) onto another object, but also as the sublation of the lost object's material presence. Melancholia, then, is the condition in which the subject insists upon his narcissistic identification with the lost object. If, as psychoanalyst Daniel Lagache has maintained, mourning is a kind of "killing of death," whereby the love object must be tenderly rejected, then melancholia is the frustrated attempt to incorporate and sustain the dead object inside the body of the bereft one.[13] Against Freud's doxa, some critics have recently asserted the conceptual and ethical primacy of melancholia. After a loss, there always persists a remainder that mourning work cannot integrate. Yet there is a way both to investigate any simple privileging of melancholia and to resist the standard interpretation that merely opposes the labor of mourning to the shiftlessness of melancholia. For a third mode of memory — disavowal — complicates this opposition. Disavowal permits the subject to split his or her stance toward the lost object, so that the object's loss is at the same time accepted *and* denied. An elaboration of disavowal as a mode of memory resonates not only at the level of literary analysis, but also in the register of the political, particularly in postcommunist culture.

Despite the dominance of "Mourning and Melancholia" in psychoanalysis and literary criticism within and beyond German culture, it appears that Freud himself harbored doubts about his 1917 thesis on mourning. After his daughter's death, Freud reexamined his earlier conviction that the healthy mourner can bring his grief to term. He began to consider the possibility for a new mode of mourning work— one that sustains its fidelity toward a lost loved one, even when this commitment keeps certain wounds open. Freud's late revision finds its complement in two works that describe the collective charge of mourning: Jacques Lacan's sixth seminar, *Le Désir et son interprétation* (*Desire and Its Interpretation;* 1959), and the second volume of Negt and Kluge's *History and Obstinacy.* Deriving theoretical impetus from these texts, chapter 4 engages the sculpture of Rachel Whiteread to plot out mourning as a site of destruction and reconstruction, where the individual mourner is bound into the collective — and into history. Whiteread's *House* (1993), a sculpture cast from a condemned building in a semi-industrial London district, touched a nerve in British public culture. Widely perceived as an elegy for Britain's flag-

ging council housing program, the project invited a mournful response from viewers. Local authorities ordered the untimely demolition of *House,* but even in its absence Whiteread's sculpture works a lingering effect. As Negt and Kluge suggest in a reading of *Antigone,* such public acts of memory constitute collective identity. Although *House* lends itself to productive comparison with Freud's foundational texts on mourning, Whiteread's project nonetheless tests the German grip on memory work, and suggests that other discourses, other topographies, and other genealogies require a rethinking of loss and its representation.

The question of nostalgia for communism nonetheless begs a return to another moment in German critical theory, Walter Benjamin's essay "Linke Melancholie" ("Leftist Melancholia"; 1931). The harsh judgment that Benjamin passed on left-leaning authors of the interwar years still holds for the contemporary writers and artists who produce works that waver in the doldrums of melancholy. Joseph Beuys's installation *Wirtschaftswerte (Economic Values;* 1980), an assemblage of household goods from the Soviet Bloc, falls into this camp. Chapter 5 undertakes an examination of the international art exhibition Documenta IX (1992). It focuses on the organizing role of *Economic Values* in Documenta and the distinctive catalogue essays about it written by playwright Heiner Müller. Both Beuys and Müller consider the material remains of Eastern Europe to possess subversive energies. Following their logic, the very existence of a Trabant automobile or some other such leftover, in and of itself, counters capitalist commodification. The matter of how an artist would mobilize such a "readymade" does not concern them. Beuys's and Müller's nostalgic accord contrasts with the drama *Melancholie I, oder Die zwei Schwestern (Melancholia I, or the Two Sisters;* 1996). Written by West Berliner Judith Kuckart and performed at the Berliner Ensemble theater, this work makes palpable the ambiguity of such melancholic fixations.

Chapter 6 develops the notion of disavowal as a mode of cultural and historical memory. Although Eastern European nations have sought to gain distance from their totalitarian legacies, efforts toward transitional justice in the legal sphere there are only just starting to be formalized.[14] Beginning in the 1990s, public opinion on how to account for crimes committed in the names of Marx, Lenin, and Stalin has switched back and forth between two courses. Whereas some Europeans have demanded systematic lustration, many more have resigned themselves to the platitudes, on the one hand, that state socialism victimized everyone within its reach or, on the other, that perpetrators had no choice but to follow orders. Early campaigns for truth and reconcilia-

tion have ceded to a longing for the social securities that many wistfully project onto their past, even if they never fully enjoyed them in the first place. Christa Wolf's writing offers a critical perspective on this condition, as it insistently returns to the question of what good has survived the socialist crisis intact. Should Europeans leave the labor movement behind, or might its ideals still afford them a critical perspective on contemporary realities? Wolf's correspondence with Jürgen Habermas is brought to bear on this aesthetic and political analysis, one that interrogates both the notion of Eastern Europe's "belated revolution" of 1989 and its attendant expressions of "belated modernism." Perhaps the most striking disavowal of Wolf's career is the near-total circumvention of the Berlin Wall in her writing. Chapter 6 examines the literary negotiation with the GDR's troubled past in Wolf's postcommunist publications, particularly her stories in *Auf dem Weg nach Tabou* (*Parting from Phantoms*; 1994) and her last two novels, *Medea: Stimmen* (*Medea: A Modern Retelling*; 1996) and *Leibhaftig* (*Incarnate*; 2002). Although it is only in this most recent work that the Wall figures plainly, a survey that reaches back into her earliest novels illuminates Wolf's alertness to the dialectics of disavowal that has informed her work since the 1960s. This, coupled with her determined (and even obstinate) concern with the woman's body — at work, at rest — makes her writing emblematic of the second world. Finally, the Afterword reconsiders the memory fever that has beset Europe after the socialist crisis. Here Krzysztof Kieślowski's film *Bleu* (*Blue*; 1993) emerges as a signal work. Realized during the caesura between socialism's passing and the reintegration of Eastern and Western Europe, this narrative recounts a French woman's struggle to complete her husband's "Concerto for the Unification of Europe" after his death. The composition enters her into the collective work of mourning. In the end, *Blue* parts with the past, and returns the future-oriented perspective of the historical avant-garde to the new Europe.

14

Working memory

Certain disciplinary tendencies have impeded critical inquiry into second world culture. Whereas the study of fascist and postfascist history and culture (particularly within the field of Holocaust research) has been advanced by an interdisciplinary impulse, work on socialist and postsocialist formations has lost this dynamic. Scholarship on the historical institutions of socialism and postsocialism has outweighed studies in literature, art, architecture, and music.[15] The question of how to read the second world puts more at stake

than simply widening the girth of World Literature. Posing it reinforces the juncture between history and culture, that same link that makes research on the Holocaust so compelling but that, in the case of socialism, seems to be losing its grip. Historian Charles S. Maier has asked why Europeans' horrified interest in National Socialism grows more inflamed while their concern with state socialism has diminished, despite the fact that both regimes perpetrated unbearable violence and repression. Whereas the memory of Hitler still burns with rage, that of Stalin has tempered to a cooler degree. Fascist terror has a longer half-life, Maier argues, not only because National Socialists targeted their victims — as Jews, as homosexuals, as Slavs, for example — but because the question of complicity, so central to Germany's genocide, remains "infinitely renewable."[16] This "hot memory" will smolder forever in the European soul, but we should not let it obscure other historical formations.[17] Articulating the unique contours of second world literature and art might revitalize the dialectic between historical and cultural study, and thus prompt scholars to uncover hidden flash points in the frozen expanses of socialist history. We might discern flickers of complicity and compromise within the bleak horizons of postcommunist and postindustrial Europe and so come to realize that this memory is not so cold after all. This book affirms Marx's investment in the working collective. But its objective is to reveal the second world's failures and thus to reawaken the critique of socialism, as it variously unfolded across Europe.

Another disciplinary tendency that has hampered analysis of the second world is the Area Studies complex that has cordoned off socialist culture to the confines of the former Soviet Bloc.[18] A conceptual iron curtain still divides the continent more than a decade after the dismantling of the Berlin Wall. But the socialist project, particularly its investment in heavy industry, was not restricted to the "other" Europe, nor did its lifeline terminate abruptly in 1989. It continues to charge across the continent, constellating together eastern and western urban centers. From the 1960s to the 1990s, the regrets that overcame oppositional writers, artists, and public intellectuals in Western and Central Europe aligned them into a cultural formation that distinguished them from their counterparts in Russia and the United States. Although these links were most evident between the two Germanies, they extend toward the flanking cultures of Britain, France, and Poland. Taking these four, adjacent traditions as a set, we can gain a fresh outlook on Europe's postwar literature and art. Still, Germany is the dark heart of this project — not only because the two Europes found their fold at the barrier that divided East and

West Berlin, but also because the conceptual contours of "memory" and "work" have largely been defined by Freud and Marx. Although Freud's study of grief leads us to the field of French poststructuralism to examine Lacan's work on collective mourning, Marx's theory of labor continually returns us to the German terrain that spans from the Second International, through Theodor W. Adorno, and up to Negt and Kluge. Marx's critique of political economy is our point of departure. The destination is an assessment of the mnemonic modes that have governed recent European literature and art.

The sense of loss prompted by socialism's collapse is actually double: the wasting of collective labor elicits the impression that collective memory itself is dissipating. Many Europeans perceive postindustrial society as posthistorical, and so look back to their labor history as the only site of authentic memory work.[19] The response to the Solidarity movement is a case in point. The struggle for an autonomous trade union at the Lenin Shipyards in Gdansk resuscitated Poland's collective memory, often linking historical fact to romantic fiction. Some of the movement's most prominent leaders were historians and writers, but the ultimate irony of their intervention lay in the union's success. Solidarity's victory ushered Poland into the postindustrial era, where the chances for both the autonomous organization of workers and the deepening

of historical consciousness seem to diminish. The greatest event in Europe's postwar labor history contributed to the erasure of the movement's conditions of possibility. One of the sad truths of Gdansk is that although a memorial to fallen strikers (which Solidarity demanded in 1980) now looms over the harbor, the Lenin Shipyards have gone bankrupt. Yet despite the movement's many failures, it awakened the interest of writers and artists across the continent.

While Solidarity was stirring the hearts and minds of European socialists, a new current emerged in the global economy. As corporations entered the race for dominance in cybertechnologies, the Soviet Bloc suffered immense losses. Although Margaret Thatcher, Helmut Kohl, and Ronald Reagan might like to take credit for vanquishing the "evil empire," the truth of state socialism's dissolution lies in the West's lucrative digital leap in the postwar years. With the mandate of the US military, corporations such as IBM implemented innovation upon innovation, and profited richly. Meanwhile, planners in Eastern Europe saw their economies' imminent failure, and staked everything on the outside chance that they might compete favorably in the production of microchips and memory boards. In the late 1980s, East German authorities, in particular, found themselves caught in a contest "between computers and collapse."[20] Although engineers in the Dresden-based concern Robotron

made valiant efforts to stay in the technological lead, they were ultimately done in by the upstarts in Silicon Valley.

The transition from industrial manufacture to digital technologies has left its mark on European culture. One example of this is the shifting meaning of the expression "working memory," an expression that inflects this project. Metaphorically, working memory is that which remains "in living memory." In the lexicon of digital technology, however, it designates "random-access memory," or RAM: the space of temporary storage where programs are created, loaded, and run. Once a programmer has manipulated this data on the screen or desktop, he or she has the choice of writing it into the computer's hard drive. Our recollection of life under socialism now hovers at the same level as digital working memory. It remains to be determined how the second world's history might be recollected. Will it be permanently inscribed into Europe's collective memory or merely deleted from the disk? The mission is thus twofold: to examine literature and artworks that recall waning modes of labor and, at the same time, to inquire into the process of recollection itself. Here the memory of work miters together with the work of memory.

Continental philosophy and social thought offer a number of perspectives on the contiguity of labor and remembrance. In the section on religion in the *Phenomenology of Spirit,* Hegel considers the structuring of memory.[21] He imagines a series of forms — the stem of a plant, a honeycomb, obelisks and pyramids — and considers how each element is made. The forms we find in nature are conditioned by heredity, by instinct. The stem's telos is to grow and reproduce. The first structure to depart from this natural, productive drive, Hegel speculates, must have been a monument, a memorial to the dead, planned and built by a collective of workers. The individual enjoined into this labor is an artificer, a *Kunstmeister.* He comes to know himself in his work. His mnemonic labor surpasses the base action of making a shelter, a reflex that is as primary as eating or mating. Thus, the first monument was not built toward the goal of utilitarian reproduction. Its purpose was to mourn. Collective awareness of our potential for work, Hegel insists, was generated by our need to commemorate the past. Even in its most alienated form, collective labor is a work of memory. Now, after the socialist crisis, it is not enough to say, as Freud did, that mourning is a labor *(Trauerarbeit)* by which loss is symbolized. A return to Hegel enables a stronger argument: labor and memory sustain and inform one another. Just as memory is work, work itself instills the past into collective memory.

In the twentieth century the Soviet gulag and the German death camp cast a pall over labor and its related conceptions. Hannah Arendt is one of the most

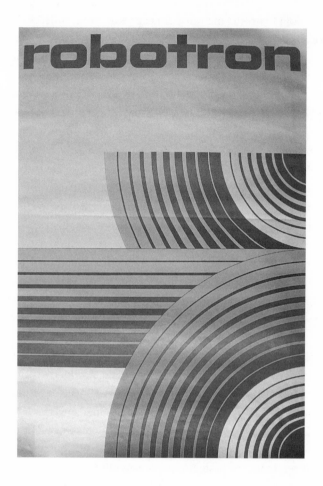

0.3 Robotron poster, 1983. Sammlung industrielle Gestaltung, Berlin.

articulate critics of this violent subjugation. In *The Human Condition,* she maintains that forced labor has liquidated the formative potential of both "work" and "labor." Arendt investigates the disparate etymologies of the two words: in Greek and Latin, as in German and French, "work" and "labor" differ from one another. Whereas the equivalents for "work" once connoted expertise and mastery, those for "labor" have always presented associations of pain and trouble. "The German *Arbeit,*" Arendt notes, "applied originally only to farm labor executed by serfs and not to the work of craftsmen, which was called *Werk.* The French *travailler* replaced the older *labourer* and is derived from *tripalium,* a kind of torture."[22] Stalin's and Hitler's abuses of the working body have collapsed "work" and "labor" into the lowest common denominator—painful drudgery. Surveying the Western cultural canon, Arendt finds no convincing affirmation of labor. Repairing "the waste of yesterday" does not require courage, she maintains, but rather submission to "relentless repetition." Hercules' labor of mucking out the mythological Augean stables was heroic, then, because he had to do it only once.[23] Against Arendt, many of the texts examined in *Requiem for Communism* seek to redeem both work and labor.

In *The Human Condition,* Arendt names her primary opponent: Marx. His take on these terms does not fully align with Arendt's. In *Capital,* it is true, Marx charges the revolution not with the duty of emancipating the laboring classes, but rather with that of liberating humankind from labor itself. Only when labor would be abolished could the "realm of freedom" supplant the "realm of necessity."[24] But the revolution that Marx imagines is the one with the big R, the Communist Revolution that requires the realization of industrial socialism to precipitate it. In the socialist society envisaged by both Eastern and Western Europeans, Arendt's differential between labor and work would be inconsequential, as both would maintain their dignity. The communist future is a future anterior; the literature and art examined in this study illustrate this contingency. Instead of aiming to document the actual histories of European socialism, the works under analysis attest to the collective memory that survived its crisis. Whether melancholic or mournful, these memories disclose the traces of Europe's utopian imagination—the remainder of the last century's failed welfare states and workers' republics that endures into the new millennium.

The socialist imagination that inspires today's writers and artists would be embodied by working collectives inclined into many modes of labor, including the kind of dumb, physically taxing chores that Arendt degrades—rote factory assembly, collective potato harvests, street-sweepings commanded to meet the plan. The bodily labors, in other words, that have

conventionally been the lot of women and slaves. Indeed, in her reflections on the laboring body, the body troubles Arendt just as much as labor does. Because she perceives the human form as a cipher of individuality that is driven to restrain intelligent life from intellectual and political action, she diagnoses the human condition as one of nearly incessant pain.[25] But this laboring body stands at the crux of socialist solidarity. Without the collective experience of the body in real time, in real space, without the punch-clock and the shop floor (which, in a word, Negt and Kluge call the *Zeithof,* or, literally, "time-yard"), class consciousness could never have arisen as it did in Europe.[26] Neither could feminist politics have taken the same course that it has. A considerable amount of literature and art produced in the postindustrial years seeks to recollect precisely this figure of the woman at labor, the woman as part of the working collective.

The performance artists who staged the requiem for communism in Berlin, mentioned at the beginning of this introduction, picked up on the sexual politics of post-1989 Europe.[27] The funeral they organized was meant to lay to rest the three feminine graces of socialism: Labor, Guaranteed Education, and Hope for the Future. One of the first concrete changes to attend the collapse of state socialism has been the disproportionate unemployment of women and their withdrawal from the public sphere. A number of the authors and artists discussed in the following chapters inscribe the second sex into Europe's second world, as if to reanimate the working woman for a hitherto unknown political reality. Their works calculate the physical price exacted by collective labor, but also locate a matrix of agency within those efforts. If the best of these projects challenge Arendt's dismissal of the body in pain, they also, at the same stroke, illuminate the visions of two thinkers who have written powerfully about modern Europe's history. At the Vienna Institute for Human Sciences in 2001, Paul Ricoeur reminded historians that memory cannot be separated from the work of mourning.[28] And Friedrich Nietzsche's maxim from the *Genealogy of Morals* still resonates as deeply as it did at the turn of the twentieth century — only that which does not cease to hurt remains in memory.

Like most of the works it examines, *Requiem for Communism* itself marks a singular historical moment: that moment when the site of collective labor was perceived as the locus of solidarity — among men and women. Socialists aspired not only to lift the Genesis curse of labor, but rather to find collective and creative fulfillment *in work.* If the spark that ignited this hope seems to dim in the workplace, its glow can be rekindled in the literature and artworks that remain.

1. The Collective

Berlin. Surrounded by a halo of light, a brown pantsuit, circa 1973, hangs stiffly within the museum vitrine. This is a relic of East German popular history, put on view for a demanding public. The garment is fashioned out of an easy-care fabric called "Present 20," a one-hundred-percent synthetic textile developed by industrial engineers as part of an initiative to better provide for the consumers of the former German Democratic Republic, an initiative issued from the highest echelons of the Socialist Unity Party. First introduced in 1969, the fabric was so named to commemorate the twentieth anniversary of the establishment of the GDR. At that point, few would have imagined that the Party and the constellation of other Eastern European socialist governments would survive only another twenty years of planned production, limited expression, and compromised desires. Fewer still would have anticipated that the polyester fabric of this pantsuit would outlive the industrial collectives that, in part, brought it into existence.

This artifact of the failed utopian project of Marxism-Leninism is one of thousands that are currently being displayed in museums throughout the eastern half of Germany, now called the new federal states. Museum directors there have entered a race to curate the communist past. In recent years at

least six separate exhibitions of GDR everyday life and popular culture have opened. The show that featured the "Present 20" suit was installed in the galleries of the Offenes Depot (Open Depot) at the newly established Center for Documentation of Everyday Culture in the GDR. Together with other museums; which have held exhibitions such as *Eastern Mix* and *Commodities for Daily Use: Four Decades of Products Made in the GDR,* the Open Depot participates in an emerging trend of recalling life as it was lived under socialism. Artists, too, have entered into this new scene of visual culture. They have taken up the shards of communism and incorporated them into their works as found objects. For example, Rafael Rheinsberg, a West Berliner, has used the rusted parts of GDR hoardings as "readymades" in his work. Like the assemblages of the historical avant-garde, Rheinsberg's works are shot through with a subversive charge. This time it is not a sexual convulsion that goes through them (as was the case in the work of Marcel Duchamp and Max Ernst), but rather the distant frisson of revolutionary hope. As the "people's own industries" of Eastern Europe cease to function, and as Easterners replace their old belongings with new, Western-made goods, the material culture of the GDR is vanishing. For those who have experienced the new Germany less as a unification and more as an annexation, this disappearance is a cause of anxiety. Without the material effects of the GDR, they ask, how can we remember the gains and losses of the socialist collective?

Sophie Calle, a French photographer and conceptual artist, has tried to record the dematerialized traces of this culture. In 1995 she began a work which seeks out vestiges of the second world in the sites of East Berlin where postcommunist urban transformation was first implemented. She went looking for a socialist alternative that seemed to have passed, as political theorist François Furet put it, like an illusion.[1] What she found were the empty pedestals and stricken street signs that remained after the removal of socialist realist objects and architecture. With little to photograph, Calle turned to passersby and asked them to recall the way it used to be in the "Eastern times." Their responses, more than the photo documents, tell the story. Out of these conversations came *Die Entfernung* (*The Detachment;* 1996), a would-be travel guide of the former East Berlin, which aims to reconstitute a sense of the collective in the aftermath of real existing socialism. Both the Open Depot and *The Detachment* trace the ongoing shift from a society that was once emphatically collective to one that centers itself around the act of collecting.

Whereas Calle mediates the voids of Berlin, the Open Depot tracks the displacement of objects from the working collective to the museum collec-

tion. The artist and the curator work with different materials; their practices are informed by different concerns. But *The Detachment* and the Open Depot intersect over the grounds of collective memory, and so merit consideration under this single scope. Each project registers a central component of collective memory: the text-based artwork reveals the social construction of memory; the museum exhibition exposes the gap between collective memory and the archive. In turn, each project discloses the critical position of Germany's second world within twentieth-century Europe. The matter of the collective reaches back through the caustic compromises of the State Security, or Stasi, to the dark decades of Nazi and Stalinist violence. The memory of the collective, meanwhile, remains in question. As unified Europe enters the new millennium, curators and artists both contend with this past imperfect and seek to salvage something of value from the socialist crisis. The residues of the second world as well as the empty spaces they once occupied have become the departure point of their enterprise. As *The Detachment* and the Open Depot suggest, collective memory does not dwell in objects and architecture alone — it consists in the transfer from person to person.

The GDR maintained its fair share of museums and monuments before the Wall came down. Policy makers recognized the imperative to discern a heritage separate from that of West Germany, and so generously directed funds toward memorials that would legitimate the new socialist nation. Exhibitions that highlighted the antifascist resistance movement, the Soviet liberation, and the life of the proletariat filled both museums of fine art and the galleries of historical societies. But since unification, much of this has changed, as many institutions of visual culture have been put under Western direction. Years before the Open Depot was established, Westerners had anticipated the impact that an exhibition of second world material culture would have. Already in August of 1989, West German curators had organized the first such exhibition at the Habernoll Gallery near Frankfurt am Main. But this show, *SED: Stunning Eastern Design,* merely lampooned the "pallid universe" of démodé East German consumer goods.[2] The selection of GDR products depicted in the exhibition catalogue — from faded packets of vulcanized rubber condoms to cartons of "Speechless" cigars — appears aimed to prove by object lesson the superior tastes of sophisticated Westerners. Later, in the early nineties, the Museum of German History on East Berlin's Unter den Linden underwent a massive overhaul that entailed the closeting of displays such as one that juxtaposed Hegel's spectacles with the first television set manufactured in the GDR. In 1996 the Museum of Working-Class Life

packed up and relocated from the center of East Berlin to the peripheral district of Marzahn. To this day, most of its collection languishes in deep storage.

Many Germans remain skeptical about the continuing desire to organize exhibitions about GDR life. Some critics dismiss this focus on the Eastern times as overly sentimental, attributing it to a dysfunctional vanguard that has languished too long in its leftist delusion. Others seek to rescue from opprobrium the right to wax nostalgic. They argue for the importance of cultural memory at this time of transition. Institutions of visual culture are now among the main sites upon which the battle over German-German identity is being waged. Museums and galleries have become places of reckoning in which viewers might work through the complexities and contradictions of Germany's divided history and collective memories.

When Maurice Halbwachs first used the expression "collective memory" in his studies *The Collective Memory* (1922) and *The Social Frameworks of Memory* (1925), he understood memory to be dependent upon the spatial environment of a given group.[3] Any material loss sustained by the group would translate into a mnemonic aporia. In contradistinction to the fleetingness and immateriality of our remembered impressions, "space," Halbwachs argues, is "a reality that endures." Indeed we can only recapture the past by understanding how it is "preserved in our physical surroundings" (Halbwachs 140). Place and group mutually constitute one another: the collective's understanding of both its present and its past materializes in the spaces it inhabits. The spatial dimension of collective memory does not limit itself to the larger structures of the urban environment such as streets, squares, and bridges; it also continues along to the other end of the spectrum. It includes what Oskar Negt and Alexander Kluge call the smaller *Zeithof* of the collective workspace as well as small-scale objects, such as the kind of wares collected by the Open Depot.[4] Small things circulate within the collective and bind it together just as effectively as a stone wall that encloses a village or a factory gate.

In many ways the Open Depot cooperates in this trafficking of communal property, even if it establishes itself at the terminus of the line. A collective defines its reactions to the outside world in relation to "a specific configuration of the physical environment," Halbwachs argues. It can sustain only light injuries to the material skeleton that defines and delimits it. If a community were to lose its location "in the pocket of a certain street, or in the shadow of some wall or church," he insists, they would then lose the tradition that grounds their existence (Halbwachs 135, 137). According to Halbwachs's early propositions, the no-places of Calle's *Detachment* could hardly nourish

mnemonic faculties. Rather, these empty sites would only set off collective amnesia. Halbwachs's initial conjecture offers a useful perspective from which to compare and critique the Open Depot and *The Detachment* as works of collective memory. The question, then, is this: what memory without material?

The Open Depot

The Open Depot is located in the former model city of Eisenhüttenstadt, close to the Polish border. After the founding of the GDR, Eisenhüttenstadt was established as Stalinstadt, the "first German socialist city." It only reassumed the name Eisenhüttenstadt, or literally "Ironworks City," in the mid-fifties, after Stalin's death. Despite this name change, the city, with its grid of wide boulevards and great chunks of socialist realist multistory buildings, betrays its socialist past. Unlike many other Eastern European cities, Eisenhüttenstadt has renamed few of its streets; many of its citizens reside at addresses named after communist revolutionaries, like Karl-Liebknecht-Straße or Clara-Zetkin-Ring. In postwar reconstruction efforts, state socialist urban planners commissioned imposing architecture like East Berlin's futuristic Television Tower and Warsaw's bombastic wedding cake of a high-rise, the Palace of Culture. Visible from the furthest reaches of town, such structures aimed to unify urban life and consolidate the central power of the state administration.[5] Provincial Eisenhüttenstadt never had any towering buildings of this sort. The city's centrifugal force found its epicenter in the Living Complex *(Wohnkomplex),* which comprised trundling, uniform blocks of flats, shops, and schools. Originally erected to gird the workaday with freedom, equality, and unity, the Living Complex has been abandoned to those who cannot (or do not want to) meet the exigencies of market competition.

The emptying of Eisenhüttenstadt's arcades prompts a series of questions about the city's socialist legacy and the uncertain future that awaits citizens of postcommunist Germany. With the reorientation of financial resources toward new concerns such as service, tourist, and informational industries, operations such as Eisenhüttenstadt's ironworks, which once formed part of the industrial base of the GDR's economy, have been shut down. The dismantling of heavy industry in the new states brought on the attendant trend of massive unemployment. In an attempt to alleviate the present economic depression, the European Union plans to direct large sums toward the renovation of the Eisenhüttenstadt factories. But some structures

and programs, both commercial and social, are considered too outmoded, too inefficient to be revitalized and fast-forwarded into the late capitalist cultural moment. Curator and cultural historian Andreas Ludwig, a citizen of Eisenhüttenstadt, is one of many Eastern Germans trying to come to terms with the ongoing transitions.[6] In the early 1990s he secured funds from the German Ministry of Culture to found the Open Depot. The museum takes up residence in the defunct nursery unit of Eisenhüttenstadt's Living Complex. Although most of the building's original interior fixtures have been removed, one can detect traces of the building's childhood: safety guards on the windows, toddler-sized toilets in the restrooms. Until its reincarnation as a museum, the nursery had fallen into disuse and had become a ghost of its former self. The Open Depot's objects range from paper products to heavy machinery. The lightest collectibles — books, food wrappers, and the like — are of materials so fragile, so acidic, that they appear much older than their true fifteen or twenty years. In contrast, the clumsy, leaden, but still functional office equipment and household appliances — adding machines which weigh in at fifteen pounds, blenders at twenty — seem built to last an eternity, whether carefully curated in museums or wantonly abandoned to the rubbish bins of history.

With the influx of Western consumer goods after the postcommunist turn, or *Wende,* many Eisenhüttenstadters have chosen to upgrade their homes and workplaces. Now, on rubbish collection days, possessions that were cast off to make room for new furnishings and appliances litter the local sidewalks. For some Eisenhüttenstadters, this gesture of jettisoning the outmoded seems arduous. Supplanting the trusty family radio with a Chinese-made stereo system is a freighted act for them. So, instead of leaving the radio, the face of which bears the names of satellite stations in distant Bucharest and Minsk, to wait for the sanitation workers, some opt to bequeath these artifacts to the Open Depot. In the acquisition process, a group of museum staff, trained by Ludwig in the methods of oral history, interviews the donors. They pose questions not only about the provenance of the objects but also about the owners' memories of the way they once lived with them or among them. Although the interview records have not yet been made public, much of the collection is open to view, as are the densely inscribed guest books where visitors can record their responses and reflect upon the thoughts of those who have come before them.[7] The Open Depot sets memory work into play on a human scale by concentrating on household objects. Amassing and displaying these mundane artifacts, Ludwig creates a space where viewers not only can

1.1 Offenes Depot (Open Depot), Eisenhüttenstadt, exterior
(photo Alan Chin).

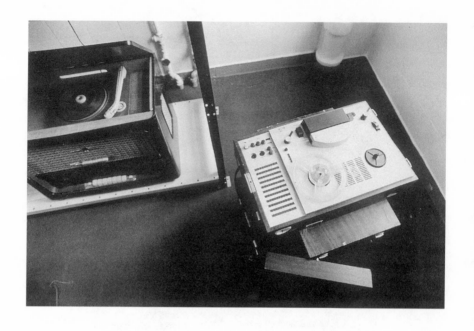

1.2 Offenes Depot (Open Depot), Eisenhüttenstadt, record player (photo Alan Chin).

come together to debate their past and future, but where they can also identify and insert their private lives, their own memories of countless tiny details, into the larger body of German history. Yet the Open Depot leaves unresolved many of the difficulties of historicizing the GDR, particularly with regard to its troubled national heritage, or *Erbe*. What were the continuities and breaks between the first unification of German states in the nineteenth century, the Nazi legacy, and real existing socialism? The Open Depot does not directly address this question, but just outside Berlin in Oranienburg, at the recently established *Kita-Museum der DDR* (Kindergarten Museum of the GDR), these historical tensions erupt more forcefully into the curatorial agenda. Indeed they impinge upon the very future of the museum.

Like the Open Depot, the Kindergarten Museum rechristens a municipal space that city planners had originally conceived as a nursery. Due to demographic changes in the postcommunist period, many such daycare facilities have closed down: since 1991 dozens of centers in Berlin and Brandenburg have ceased operation. Faced with an uncertain future in the unified Germany, many women of the new states have opted to forestall or forgo pregnancy. Eastern birthrates dropped by nearly half in the first six years of unification.[8] With the concomitant tendency for many women to be downshifted to part-time jobs or even to complete unemployment, many nurseries and kindergartens have been rendered superfluous. Effectively, the programming of the GDR museums fills the vacuum of the vacant classrooms.

The Kindergarten Museum was planned and is now directed by Heidemarie Waninger, an educator who lost her job in the Brandenburg school system. It draws more visitors with each month, many of whom worked as teachers in the former GDR. Like the Open Depot, the Kindergarten Museum is staffed by docents who once would have left off their children at the school in the early morning hours before punching the clock at the ironworks. Instead of striving to meet the state goals of industrial production, today these women and men attend to the task of collecting the relics of the GDR past. Where the communal energies of East Germans were once directed toward the twin plans of heavy industry and the steady growth of the labor force, now, in the wake of state socialism's collapse, the emphasis has changed. Where once the goal was reproduction, both industrial and biological, today the raison d'être for many in Eisenhüttenstadt and Oranienburg is one of remembering and recollecting. With the faltering of the Marxist grand narrative, citizens of the new states no longer heed the modernist battle cry to "make it new." Instead they find themselves stirred to action by a different

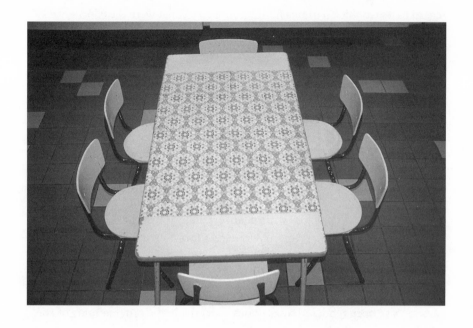

1.3 Kita-Museum (Kindergarten Museum), Oranienburg, table and chairs.

aesthetic and political imperative: to research and conserve the past, recoding it in the interests of the new Germany.

Although few non-Germans have had the opportunity to visit the little Kindergarten Museum, or for that matter even know that it exists, many are at least somewhat familiar with the history of the city which surrounds it, namely Oranienburg. For there loom the gates of Sachsenhausen, the concentration camp that was turned into a memorial site in 1961, the same year the Berlin Wall was erected. After the *Wende,* efforts have been made to renovate the memorial; architect Daniel Libeskind's plans are currently being realized there. Yet these steps have not been taken easily.[9] Some Oranienburgers would prefer that the government apportion more of its limited funds to develop and maintain memorials to the history of the GDR. They fear that the Sachsenhausen museum will overshadow smaller projects such as the Kindergarten Museum, distilling the city's complex history down to a single, overdetermining historical moment: the Holocaust. Discord about the funding of the Sachsenhausen memorial is growing in Oranienburg, but to date no one has lodged a complaint about the establishment of the Kindergarten Museum.

The dynamic of protest about the different Oranienburg museums discloses an economy of memory and history — a circuit generated by the competing but not fully discrete histories of national and state socialism. In the essay *Versuch, mir und anderen die ostdeutsche Moral zu erklären* (*An Attempt to Explain the East German Morality to Myself and to Others*), social critic Annette Simon analyzes this dynamic within the unification process.[10] Many Germans accepted the country's division according to the London and Paris treaties of 1954 and 1955 as due punishment for the crimes committed under Hitler. They saw the Berlin Wall and the barriers that cleaved the country in two as concrete signs of collective guilt and atonement. Unification forces Germans to reconfront the legacy of fascism in a new geopolitical landscape. The current press to musealize German history, not only in the form of Holocaust monuments (and the heated, even theatrical debates which surround them) but also via the recent explosion of GDR exhibitions, can be seen as an attempt to ground German-German identities in the material objects and structures that remain behind. In the absence of the Cold War symbols of the nation's punishment-by-division, Germans see these museums as the enduring stigmata of their violent history.

Germans are not the only Europeans consumed with a kind of museum fever. Ministries of culture in other countries have also devoted ever greater

resources to the project of historical commemoration. But the rapid proliferation of GDR exhibitions sets itself apart from this museal tendency in several ways. While most memorial projects tend toward the monumental, the Open Depot and the Kindergarten Museum focus on the miniature, the minor detail, the ephemeral. In the same vein as certain provincial museums of popular culture (such as a small host of French sites maintained by curators schooled in the *Annales* tradition), the shows in Eisenhüttenstadt and Oranienburg make memory work life-sized. The Open Depot and the Kindergarten Museum concentrate on the private and the domestic, the realm of what East Germans called "niche culture." Ludwig, in particular, asserts that private lives were led under communism, despite the state's attempts to deny individualistic indulgences. But, significantly, the emphasis on niche culture comes over and against the documentation of larger, state-sanctioned practices. Neither Ludwig nor Waninger discerns the patterns of identification that connected the private to the monumental, the personal to the political in the GDR past. Indeed, these collections of GDR material culture seem to offer refuge from some of the most difficult issues informing the Germans' collective heritage. The Open Depot, for example, does not collect materials used in state-organized events, or represent many of the customs that once engaged citizens as a mass. Ludwig also employs different installation strategies for artifacts associated with private life and those associated with large institutions. Whereas some rooms of the Open Depot contain case after case of barely distinguishable appliances, stacked catacombs of the GDR's industrial and bureaucratic history, elsewhere Ludwig has staged the artifacts in panoramas of life as it was lived in the recent, but rapidly receding past. While objects used in the home tend to be propped up in lifelike settings, those from public offices — typewriters, telephones, binders for filing documents in triplicate — are simply laid out on shelves, warehouse-style. This display technique suggests that Ludwig prefers to reanimate the moments that were lived behind closed doors, while allowing the remainders of public life to hibernate, albeit within view. East Germans were just as likely and just as entitled to be house-proud as people from any culture, but it should not be forgotten that the space of the domestic was the only place where any discontented resident of the GDR could imagine an internal emigration for himself or herself. The fact that the collected instruments of bureaucracy lie dormant within the galleries of the Open Depot suggests that Eastern Germans still want to distance themselves from the former state institutions. By

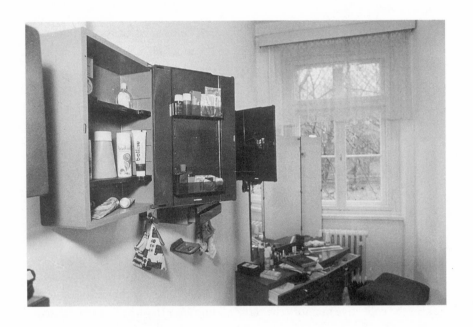

1.4 Offenes Depot (Open Depot), Eisenhüttenstadt, medicine cabinet (photo Alan Chin).

placing these office wares on shelves, Ludwig consigns them to a separate register of historical memory, one not unlike that of the archive.

The archive

In the forty-year history of the GDR, the archive, as an institution of memory, played a role more central than that of the museum. The essential archive was that of the Stasi, but no vestiges of this surveillance system figure in the Open Depot. After the armed forces, the Stasi was East Germany's largest employer; its archives documented information on more than a quarter of its citizens. The key to the archives, a master repertoire containing a single index card for each Stasi staff member, informer, and object of surveillance, extends for more than a mile. Following government directives, Stasi informants compiled classified reports, which recorded in minute detail the lives of millions of individuals whose daily actions were considered to bear upon matters of national security interest. 22.31 Telephone rings. No answer. The object continues to read. 22.40 The object converses briefly with spouse. 23.02 Object's spouse draws curtains in north-facing windows. 23.10 Lamps extinguished.

Given that the Stasi was foundational to every aspect of GDR life — not only the public sphere, but also the domestic one — their archives continue to inform the collective memory that is unfolding after the *Wende*. A crucial distinction separates the archives from the official histories disseminated in the GDR. While academics, curators, and administrators of other state institutions presented affirmative accounts of the building of socialism, secret police files stored the largest records of actual politics and society. Despite the ideological censorship of Stasi data, it was (and remains) an accurate source of information about the times when things went out of order, or *außer Betrieb*. Such failures and "factory seconds"—strikes, missed production goals, and moments of general discontent—were kept secret from the public. The Stasi held tight rein over its information, allowing access only to the highest ranks of the nomenklatura. The Stasi's existence was common knowledge, but its archives seemed to withhold mysteries. To read the contents of one's file, in those times, was to know one's status vis-à-vis the big Other. The archives belonged neither to the patently public domain of official history nor to the private sphere. Rather, they functioned as a covert supplement to state-mandated discourse. These chronicles were recorded in an alienated, impersonal mode, yet they penetrated into the intimate recesses of private life. Since 1989, much of the archive has been opened to the public. As more

details surface, Eastern Germans work to figure these reports into their own memories of life in the industrial collective. The interest in the Open Depot and the Kindergarten Museum is a product of this struggle.

At its founding, the Stasi archival system faced the future: the genesis of its protocols set the stage for the way life would be lived in the GDR. This repository of information would become an archive in the most literal sense: the roots of term "archive" reach back to the Greek verb *arkhein,* which carries two meanings at once: not only "to begin" but also "to rule" or "to command."[11] In contradistinction, the word "museum," a cousin to "mausoleum," looks back to the past. Gathering from the arguments Halbwachs makes in *The Collective Memory,* it seems that he would have been sensitive to the difference between these two terms. For Halbwachs draws a dividing line between collective memory and history. He imagines these two mnemonic modes as split by an axis that opposes internal to external knowledge and experience. This same axis distinguishes the museum from the archive. Whereas memory, on the side of the internal, takes shape along the lines of a rich and continuous "autobiographical" portrait, history discloses only the "condensed and schematic" external hypercodes of a telegram (Halbwachs 77–80). For Halbwachs, memory multiplies and disperses as it flows; it is part of a group's active life. Ephemeral, contingent, specular, memory could never be recollected and sedimented into a single unified story. Like a ghost, memory is summoned forth in collective conjuration. History, on the other hand, pretends that memory does lend itself to unification, that it could be delivered intact from period to period and from place to place. If history is a monument that calcifies lived experience, memory is a condition. If history records, memory responds. Halbwachs imagines the museum as a place for cultures to die, more a cancer ward than an obstetrics unit.

In *The Collective Memory,* Halbwachs refers to and then refutes the insights that Henri Bergson, his early mentor, presents in *Matter and Memory.* To read the two texts together is to gain a stronger grasp of Halbwachs's distinction between history and memory. Bergson envisions memory as something with all the concreteness and repletion of a book, a bound volume in the library of the unconscious, in which vivid images of past events would lie like so many pages sewn into signatures. These leaves of memory would be kept neatly folded shut, waiting for an inquiring reader to open them. Bergson was convinced that human mnemonic faculties harbored the potential for total recall. Once an individual lived through a particular experience, an imprint would be indelibly inscribed into his or her internal template, where it would

silently await retrieval. For Halbwachs, however, anamnesis only exists as a counterpart to amnesia. In order to be able to remember, one must also be able to forget. What remains in memory are not "ready-made images in some subterranean gallery of thought"; instead memory survives in the form of an uneven smattering of "piecemeal impressions," whose meaning can be divined only through the lens of the social (Halbwachs 75). Whereas for Bergson, memory is a thing of specific character and dimension, an object which can be possessed and conserved by a single individual, for Halbwachs, memory is more a question of communication — it can only exist as a work-in-progress, which is kept in motion or held aloft within a plural collective.

Historical memory starts only when a particular tradition ends or when collective memory withers away (Halbwachs 77–80). As historian Pierre Nora, one of the main inheritors of Halbwachs's thought, has put it more recently, collective memory and history, "far from being synonymous," actually oppose each other. If "memory is life," then history reconstructs "what is no longer."[12] Within Halbwachs's paradigm, the Open Depot and the Kindergarten Museum align with the communicative attributes of collective memory's "depository of traditions," while the Stasi archives fall under the rubric of the "record of events" that are inscribed into history (Halbwachs 77–80). Ludwig's and Waninger's curatorial practices depart from the systematization of the archive at both temporal and spatial junctures. When, for example, an Oranienburger donates an object to the Kindergarten Museum, he or she chooses to mark time, to bring a figment of the past into the present. Overall, the cultural moment of the contemporary GDR exhibition is a belated one. And it is precisely in this belatedness — not only in the individual bequest, but also in the curatorial gesture on the part of the museum administration — that the Open Depot and the Kindergarten Museum differ from the archive. Whereas the order and structure of an archive determines and secures its future content, the GDR museums answer back to the past; they respond to a desire that certain aspects of GDR history not be forgotten.

Displacement and postcommunist space

Although Halbwachs acknowledges the temporal difference that distinguishes the museum from the archive, his main theoretical intervention lies in his elaboration of the spatial dimension of collective memory. In his initial propositions, he conjectured that no memory could thrive without some anchoring material referent. Yet, as Halbwachs developed his thought, he

began to complicate his thesis. Later he contradicted his claim that an absolute limit governs a collective's resilience to the destruction of its material world. By 1925 Halbwachs came to see that, although collective memory is first programmed according to spatial constraints, once spatial memory instills itself into the individual mind, it need not remain tethered to concrete objects. Collective memory can sustain itself through communication. Indeed the links that attach the community to its physical locale, Halbwachs maintains, gain even "greater clarity in the very moment of their destruction" (Halbwachs 131). Spatial change, whether it be the dismantling of a wall or the disappearance of some valued object, prompts discussion and heightens the collective's awareness of its past.

Halbwachs's notion of the spatial dimension of collective memory offers a critical perspective on the recent debates about museums and urban planning in the new states. Consider the Berlin Wall. First some of its gates were opened in 1989 to accommodate the influx of Eastern Europeans holding newly acquired visitors' permits for the West. Soon afterward, Berliners chiseled out spaces enabling passage from side to side. Eventually most of the Wall would be leveled, only to be reassembled at various points in the city (or even in museums far beyond the German border) in order to commemorate Germany's divided history. But of course the displacement of the Wall is only the most obvious sign of transition in the postcommunist years. Berliners have also witnessed the reintegration of the Eastern and Western public transportation systems, the demolition of certain municipal buildings, and other substantial transformations. These incisive changes to Berlin's post-*Wende* urban fabric inspired Sophie Calle to realize *The Detachment*. Like the Open Depot, Calle's project gathers its energy from the shifting and dismantling of ex-communist spaces and objects. Further, *The Detachment* is intricately informed by many of the same concerns about the spatial dimension of remembrance that spurred Halbwachs on to write *The Collective Memory*.

The Detachment, simultaneously issued as a book and mounted as a gallery exhibition, functions as a travel guide of disappeared socialist realist objects and architecture in the Berlin area. Multiple elements constituted Calle's work process: visiting the places from which symbols of GDR history had been effaced, asking Berliners to describe the objects which had once filled these empty spaces, and photographing the sites of disappearance. In the guidebook Calle compiles the photographs with maps and an assortment of statements from those who were able to remember something of the city's socialist history, a legacy that is rapidly being effaced in the effort to

1.5 Sophie Calle, *Die Entfernung (The Detachment)*, 1996. © 2002
Artists Rights Society (ARS), New York/VG Bild-Kunst, Bonn. Courtesy
Arndt and Partner, Berlin (photo Daniel Rückert).

"modernize" and reinvent Berlin as the new capital. The memory samples which Calle selects for the guidebook—for instance, recollections of a towering Lenin statue that once stood in the center of a block of flats—join together to tell a story about both the socialist collective and collective memory. Even though most of the Lenin figures and other signs of socialist state power had been detached and removed by the time Calle arrived, the after-image of the second world lingered in the collective memory of East Berliners. *The Detachment* contrasts material absence with mnemonic presence. The text, which weaves together collected remembrances, contends with the missing symbols and monuments.

When exhibited at the Galerie Arndt & Partner in 1996, multiple copies of *The Detachment* were opened and mounted onto the walls, where they hung below enlarged versions of the photographs featured in the guide. The book's main body divides into "chapters" that treat a number of former sights in Berlin: monuments, plaques, and street signs, among others. In the center of the book are detachable postcards of the disappeared sights, flanked on either side by full-spread photographs of the Berlin Wall. The chapter on the Lenin bust at the Russian Embassy on Unter den Linden reveals the tenacious stains of the second world in Berliners' field of vision. At the time when Calle was making *The Detachment,* and indeed for much of the early nineties, a protective wooden case, the sort that is customarily installed in the winter months, bedecked the Lenin bust. Some wondered whether embassy representatives had surreptitiously confiscated the original statue. Whether or not this is true, the wooden case obscured the view and came to serve as a screen upon which viewers could project their memories of what was there before.[13] One person tells Calle, "I see the box, but I know he's under it, and I can imagine how he looks." Two more people make similar claims about the other effaced figures and symbols; one remarks, "I don't remember what he looked like, but that fellow still lives here," and another, "There's a resistance in that hole. In my mind it's still there. Like a ghost, I see it there."

In *The Detachment,* individuals are bound into a collective not only by particular visual memories, but also by the act of conjuration. Calle participates in this cross-cultural séance, even assuming the role of spiritual medium. But the message is unclear. *The Detachment* could either reanimate the ailing patient of revolution or function as a requiem for communism, a death certificate of sorts. At its weakest points, Calle's project disengages with the traditions of conceptual art and veers off into the venues of journalism. *The Detachment* neither matches the intensity of the bygone material world it

traces, nor contributes anything new to the already massive proliferation of critical writing on the socialist crisis. What the work does offer, nonetheless, is a composite portrait of collective memory. As Halbwachs argues, it is the conversations and the exchange of personal narratives that keep memory present to the collective — the work of memory consists in the reception of *The Detachment*. Calle reveals three identifying characteristics of collective memory: its compositeness, its spatial attenuation, and its mutability.

The Open Depot and the Kindergarten Museum also activate collective remembrance, for they challenge the imperatives of archival history. If Ludwig and Waninger were to limit their responsibilities to the conservation and cataloguing of objects manufactured by the socialist industries, their museums would serve as tombs — fixtures on the order of Lenin's and Stalin's refrigerated mausolea. Even if Ludwig and Waninger do not directly confront the Stasi legacy, their exhibitions nonetheless initiate a more critical curatorial practice in Eastern Germany. (To wit, the Stasi Headquarters were converted into a museum, the Forschungs- und Gedenkstätte Normannenstraße.) Ludwig's strategies of coupling objects with memory samples and using guest books both break from the forward drive of the Stasi files and make the museal space more public. Since the Open Depot and the Kindergarten Museum assist in the displacement of GDR objects, and since the curators emphasize the present and continuous labor of collective memory, the exhibits resist the archival imperatives that controlled the space of the GDR. Where the Stasi sought to secure the East German state, these museums expose the alterity of history.

One could see the Open Depot and the Kindergarten Museum as an anaesthetic to the most painful symptoms of the GDR's absorption into a market economy, where rage and despair are conveniently encrypted, segregated from the rest of life, submerged into the unspeakable. But, on closer examination, these sites of reckoning appear to offer something more. For not only do Ludwig and Waninger commemorate Germany's divided history, but their exhibits also serve as touchstones in the transition to a single Europe and a single market. Instead of hoarding GDR wares or sentencing them to oblivion, Germans are setting them apart, laying them to rest by installing them in the museum environment. A kind of "tender rejection," the desire to donate these relics and visit the Open Depot and Kindergarten Museum can be understood in contradistinction to a more saturnine kind of memory, the melancholy fixation on the past.[14] In these two museums, as in Calle's book, collective memory emerges not as a thing, but as an act: the viewer of the

Open Depot deposes; the viewer of *The Detachment* detaches. As works of memory, they serve a role that Negt and Kluge have identified as central to the democratic public sphere. As a supplement to the institutions of historical preservation, these projects protect "that which is other than history." Whereas monuments and archives register specific historical situations and their attendant distortions, the open spaces of visual culture allow the public to "deform, change, and improve" collective memory.[15] Germany needs both.

Today cultural custodians direct the GDR's transit from the working collective to the museum collection, but they cannot foster memory without the collaboration and interest of the public. As the factories of the second world are shut down, it becomes even clearer that the shop floor cannot provide a truly public sphere. But the culture industry can play a central role in sustaining collective memory. Against the digital network, the museum and gallery have emerged as mass media that offer dynamic historical perspectives. Curators and artists draw viewers into common spaces, in real space and real time. But the objects they display there — the GDR's physical remains or the belated representations of them — are only part of the work of memory. For it is not the securing of the material world that activates remembrance, but rather our collective displacement and reassessment of these things. It is the public's task to enact this — to shift from material to memory, from collective to collection, from site to sight.

2. Solidarity

In one scene of Krzysztof Kieślowski's *Trois couleurs: Blanc* (*Three Colors: White*; 1993), a priest delivers a eulogy for the protagonist, Karol Karol. His wife solemnly bows her head at his grave; snow blankets the cemetery. But Karol Karol is alive and well and living in Warsaw. A Mitteleuropean mafioso who made it rich in the first years of postcommunism, he staged his own funeral in order to mastermind the new life he wanted to lead. In the early 1990s most Poles were still overwhelmed by life outside the socialist safety net. Some were swindled by agents of bogus life insurance policies. Others found themselves divested of their homes by Germans and Americans who flocked eastward to reclaim property that the communists had annexed at the previous political turn.[1] Karol Karol, however, not only made a profit from the transition to liberal democracy, he also managed to save his marriage through the conceits of mourning that he set up. His marital masquerade makes a peculiar intervention into both the contemporary culture of memory and the historical narrative of the second world's postcommunist reality.

Kieślowski's irony sets his cinema apart from that of other great Polish directors. Today, the work of Andrzej Wajda, Kieślowski's renowned colleague, seems to fade into the distance of Poland's satellite past. His most

recent feature is the costume drama *Pan Tadeusz, czyli Ostatni Zajazd na Litwie* (*Pan Tadeusz, or, The Last Foray in Lithuania;* 1999), an adaptation of Adam Mickiewicz's romantic epic (1834) that reflects upon divided Poland's struggle for liberation.[2] But Wajda's earlier films speak volumes about the Polish workers' movement and the years when state socialism came to crisis. *Człowiek z marmuru* (*Man of Marble;* 1977) and *Człowiek ze żelaza* (*Man of Iron;* 1981) dramatize the Solidarity trade union's struggle for fair conditions for working men and women and document the rebirth of democracy in Eastern Europe. The two-part epic begins with a young woman's investigation into Poland's suppressed collective memory. Agnieszka, the heroine, surreptitiously films prostrate statues of Stakhanovite workers that have been consigned to deep storage in the National Museum.[3] Her subsequent journey leads her into direct contact with the actual leaders of Solidarity: Lech Wałęsa, Jacek Kuroń, Adam Michnik, and Anna Walentynowicz. Kieślowski's *White* has been rightly acclaimed for its mordant *précis* of postcommunist gender trouble, but *Man of Marble* and *Man of Iron* still offer unique perspectives on the potentials — and the vicissitudes — of historical antagonism in Europe, both among men and women and between them. These perspectives extend from the parameters of cinema right into the quick of history itself.

Like the parodic funerals that punctuate *White,* Wajda's Solidarity films touch on the problem of putting the past to rest. Well before state socialism was dismantled, Wajda's films prefigured the requiems for communism that Kieślowski and others (Chantal Akerman, Laura Mulvey, and Nikita Mikhalkov, for example) have realized since 1989. Whereas some critics have read Wajda's cinema as a future-oriented rehabilitation of the socialist project, it is worth considering the extent to which *Man of Marble* and *Man of Iron* were already epitaphs for the very struggle in which they were embedded. In their repeated returns to burial sites, the two films focus our attention on socialism's past. But despite five hours of sanctimonious reflection and numerous funeral scenes, Wajda lets something go unrequited. Where Wajda's contestation of censorship and repression once electrified audiences from Warsaw to Cannes and Hollywood, today the films, especially the sequel, seem flawed. A reconsideration of *Man of Marble* and *Man of Iron* reveals the slips that escaped the first warm waves of critical reception. From our contemporary vantage point we can also detect faultlines that shot through the Solidarity movement itself, even in its early years. In voicing its grievances against the Communist Party, the trade union had to tread a difficult path. One of their demands sought to avenge past injustices: they requested permission to erect

a monument of three steel anchors to commemorate the massacre of Gdansk strikers in 1970. No change in the present before reckoning with the past, the activists insisted. Solidarity eventually won the right to build the monument, but then lost their stronghold among the shipyard workers in the early post-communist years. There was yet another point of the Solidarity platform that reflected unfavorably upon the movement, one that many Western leftists active in the eighties reluctantly tolerated. In a pledge of allegiance to the Vatican, Lech Wałęsa and the other trade union leaders argued for the repeal of Poland's 1956 law legalizing abortion in the socialist state. A faction of Solidarity initiated this campaign in the late seventies and ultimately succeeded in winning the Party's consensus.[4] In 1993, when Solidarity had been legitimated as a political party, legislation passed in Poland that criminalized abortion in almost all cases. Despite the continued controversy over abortion law, today the Solidarity party remains staunch in its convictions.[5] Attacking the totalitarian regime, the union revitalized the labor movement. But at a price. The restriction of women's reproductive rights short-circuited Solidarity's revolutionary program. Today, as Solidarity loses more and more votes to other parties with progressive abortion agendas, they confront the consequences of their platform. Wajda's filmic staging of gender has become a critical optic through which to reassess the movement.

Wajda aligned himself closely with Solidarity activists; the tremors that unsettled the movement also register in his films. *Man of Iron* was shot with the union's permission and was quickly released in the heady days of the early eighties. Yet, when compared with *Man of Marble,* the sequel seems to subdue a number of subversive impulses that charged the first film. Even before Wojciech Jaruzelski imposed martial law, it was apparent that Solidarity was not driven purely by the democratic ideals that were put into play by Adam Michnik and Jacek Kuroń and applauded by the Western left. In order to secure the support of the Catholic Church, Solidarity leaders also had to cede to conservative elements within their ranks. The antinomies that troubled the movement were not limited to the battleground of sexual politics, but extended into the order of political economy. Paradoxically, Solidarity's legitimation slated the trade union's destruction, as it ushered in market forces bent on dissolving the political fulcrum of the laboring collective. What started as a workers' movement ended as a compromise of socialist principles. *Man of Marble* and *Man of Iron* offer clues to Solidarity's fate, for although they purport to mark the traumas of labor strife in Poland, in the end they leave these wounds untended. Instead of fully exploring the workers' discontent and the

events of totalitarian repression, instead of working through the past, Wajda diverts the viewer's attention to a more traditional family affair. Melancholic idealization fills the space that might have been dedicated to the work of mourning. The sequel, in particular, does not give form to Poland's historical memory, but rather reinscribes Solidarity's genealogy into the grounds of patriarchal narrative. *Man of Iron* tells a story of a father and a son, a man and a woman. The actual antagonisms that fueled Solidarity are reduced to little more than dramatic scenery. Yet Wajda's metastasis of historical memory into false mourning merits our attention, for his aesthetic failure also registers the historical limitations inherent to Solidarity itself.

As Adam Michnik has recently argued, *Man of Marble* and *Man of Iron* couple together to create a national narrative of epic proportions.[6] They chart the political and popular shifts in Polish postwar history from the Stalinist years of reconstruction, through the decades of smoldering discontent in the sixties and seventies, up to the initial legalization of Solidarity's independent trade union in August 1980. Each film is shaped by the political climate of its specific historical moment. Whereas the censorship of 1977 exacted the taut, aesthetic vision of *Man of Marble,* the comparatively liberal cultural politics of 1980–81 allowed Wajda to relax his cinematic discipline in *Man of Iron.*[7] Paradoxically, without the constraints of the censor, Wajda lost his grasp of the real history that was being made right in front of the camera. Whereas the first film dramatizes the political tensions that led to the formation of Solidarity in the 1970s, the second incorporates documentary footage of the 1980 strikes at the Lenin Shipyards in Gdansk into a feature film that restages Solidarity's glory days. But in *Man of Iron* a standard romance upstages the drama of the strikes, and derails the historical trajectory that Wajda initiated in the first film. In retrospect, it appears that a great divide separates the two films. This rupture renders them less two installments of a single epic than the torn halves of a narrative that do not add up. Further, Wajda's breach signaled that, even in its formative years, Solidarity harbored regressive potentials that few leftists wanted to acknowledge.

Man of Marble follows Agnieszka's efforts to shoot a student documentary about the Stakhanovite builder Mateusz Birkut. Once heralded for exceeding production plans, Birkut was later made a nonperson in the eyes of the state. Agnieszka's research becomes an attempt to requite his disgrace. This guides the line of the entire film: she uncovers confidential film footage that tracks both his rise to fame and the violent encounter that brings about his demise. At a state-sponsored building show, a disgruntled worker passes a burning

brick to Birkut's bare hand, maiming him for life. As Agnieszka screens the holdings of the archive and conducts her background inquiries, the complex reality of Birkut's life unfolds. One censored film shows Birkut harassing a party official who refused to acknowledge the workers' harsh living conditions. An interview reveals to Agnieszka that, after years as a recluse, Birkut was killed by police fire in the 1970 workers' uprising. Wajda allows these insights to operate in tension with other, less flattering documentation of Birkut's choices. For example, he also includes lengthy segments depicting Birkut's capitulation to the pressures of the nomenklatura.

Yet while Wajda prepares the viewer to scrutinize Birkut's character, the problems of Birkut's troubled commitment, guilt, and suicidal martyrdom remain unexplored at the end of *Man of Marble*. Wajda takes the viewer to a critical moment in socialist history, but then he stops in his tracks without exploring the implications of his own political imagination. Wajda could have investigated both the position of the workers who conspired to decommission Birkut and Birkut's reflections on his own compromises. Instead, he chose to pursue a different narrative. Birkut's story is gradually demoted to the familiar terrain of the *Bildungsroman* and family drama. In *Man of Iron* Wajda trains his focus upon the psychodynamics between Birkut, his son Maciek, and Agnieszka, and, in so doing, allows the bright edge of Polish labor antagonism to fade into obscurity. Although Wajda made both films with the support of colleagues active in the Solidarity union, the real conditions of the working collective, it seems, did not have the highest priority on his agenda.

The most incisive intervention of Wajda's Solidarity epic — indeed what distinguishes it from other important Polish films about labor such as Kieślowski's *Fabryka* (*Factory;* 1970), *Robotnicy '71* (*Workers '71;* 1972, codirected with Tomasz Zygadło), and *Murarz* (*Bricklayer;* 1973), as well as Andrzej Zajączkowski and Andrzej Chodakowski's *Robotnicy* (*The Workers;* 1980) — is that Wajda cast real historical figures as themselves. In *Man of Iron,* for example, Lech Wałęsa plays "Lech Wałęsa." He does not simply recite famous speeches or reenact critical moments in Solidarity's occupation of the Lenin Shipyards. Rather, he enters into the realm of pure fiction. Wajda's direction in these two films departs from the standard path of historical cinema, and detours into an improbable cinematic space where real figures interact with fictional characters. Although Wajda's "Wałęsa" delivers only a few lines in *Man of Iron,* the Nobel Laureate nonetheless belongs to the corps of mostly fictional minor characters, who testify to the historical "truth" and lend a touch of the real to the narrative. One such fictive supporting role is that of

Anna Hulewicz, the landlady who recounts the critical moments of missed mourning in *Man of Iron*. Hulewicz's humble manner grounds the complex la ering of historical and fictional discourse: for nearly half of the film, the viewer sees Maciek through her eyes, that is, at one remove. To the extent that Wajda confers the responsibility of relating the protagonist's story to this minor character, it not only sustains Maciek's charisma, but also confers credibility to the film's unorthodox marriage of fact and fiction.[8] In this second installment of Wajda's Solidarity epic, authenticity has a female voice.[9] Female characters like Hulewicz and, later, Agnieszka herself function as bearers of memory, who help the viewer to mediate between the film's various temporal moments. Hulewicz, a perfect example of Polish *babuszka* sensibility, masters this role, as she guides the narrative from the present to the past through a series of flashbacks.

One of Hulewicz's most vivid memory sequences recounts her visit to Birkut's burial site on All Saints' Day. November First counts among the most sacred holidays in Polish culture. Although many still participate in the annual commemoration of the dead, these rituals were never more piously upheld than under communism. In the 1980s Poles would convene en masse in cemeteries, bearing symbols which both honored the memory of the dead and expressed their commitment to the Solidarity movement. Some entered with armloads of red carnations, others carried evergreen funeral wreaths and shocks of straw braided into the emblematic shapes of Polish nationalism: the letters P and S, ornamented with hooks and anchors, to represent the persistence of both Poland and Solidarity itself. Visitors would bedeck the graves with small votive candles. Above the mourners' murmurs, one could also hear the random crackling of untempered glass. The cemetery that Hulewicz visits together with Maciek in *Man of Iron* is a public one, but it is decorated as brightly as any churchyard. Searching among clouds of smoke and fog, the two discover that Birkut's grave has disappeared. More than a desecration, the official erasure of the life and death of the former model worker signals the Party's effort to kill the dead themselves.

In subsequent flashbacks, Hulewicz sees Maciek as he welds an iron cross at the shipyard and drives it into the floor of the bridge where the military police shot his father down. Maciek's gesture both retaliates against the Party's violence and presages the transformation of his historical consciousness that will make him a Solidarity leader. He recalls the acrimonious conflicts he had with his father—aware of the widening gap between workers and intellectuals, Birkut blocked Maciek's attempts to join the student demon-

strations in 1968 — and reconsiders his father's mission. Maciek leaves university and redirects his energies toward finding some common ground between intellectuals and workers, that is, toward building solidarity between them.

Or so Wajda would have the viewer believe. On the most immediate level, *Man of Iron* carries through the narrative of Polish labor politics, which Wajda initiated in *Man of Marble*. The first film posits continuities between the Stakhanovite workers' movement, the genesis of independent trade unions in Poland, and Solidarity's eventual legitimation. Yet the sequel has less to do with understanding the differences between Polish intellectuals and workers than it does with exposing the adverse relationship between a father and a son. The driving force behind *Man of Iron* is not Poland's actual history of discord and dissent in late socialism, but rather an attempt to resolve Oedipal tensions through the performance of feigned mourning.

Wajda's woman of memory

An analysis of Agnieszka's character unveils the critical difference between Wajda's two Solidarity films: whereas Agnieszka's anxious insolence embodies the critical economy of *Man of Marble,* her subdued disposition in *Man of Iron* signals the compromise of the sequel. As the protagonist of *Man of Marble,* Agnieszka makes a permanent mark in the annals of postwar cinema.[10] Played by Krystyna Janda, Agnieszka becomes a symbol of second-wave sisterhood, a feminist kino-ikon that few actors have managed to portray, least of all those from Poland, a country where antiquated gender traditions were and still are proudly defended. (Even today, most Polish men do not shake the hands of women, but rather bend down to kiss them.) *Man of Marble* concludes with an extended take of Agnieszka striding down the corridors of the national television headquarters. Countless shots show her pointing her finger imperiously at Warsaw bureaucrats and inhaling the smoke of filterless cigarettes, as if her future depended on it. In every frame she wears the same flared jeans; her hair stays knotted up in a dirty chignon. A rebel with a cause for the seventies generation, Wajda's Agnieszka had to be a woman.

Agnieszka's fury burns through *Man of Marble.* It propels the narrative and illuminates parts of Birkut's shadowy past, yet never meets its target. The story breaks off suddenly when a television producer withdraws Agnieszka's press pass and blocks her access to film stock and support crew. The producer fires Agnieszka not simply because she tried to shed light onto the repressed past of a persona non grata, but just as much because she is unruly

2.1 Agnieszka gestures, *Człowiek z marmuru (Man of Marble),* dir. Andrzej Wajda, 1977.

and unpredictable. She should learn something from her mistakes in television, he warns, and go find some "nice work" elsewhere. Wajda, too, presents her as a live wire that needs to be fixed. His recharacterization of Agnieszka in *Man of Iron* answers back to the interrupted inquiry that she began in *Man of Marble* and compensates for the risks she took there. Downgrading Agnieszka to a lesser role in the sequel, Wajda, in a sense, carries through the firing orders of the producer from the first film. Whatever openness or undecidability Wajda created in *Man of Marble* is closed off in the sequel. Agnieszka does not burst into a supernova of documentary critique, but rather assumes the position of a spectator whose face glows in the reflected light of the screen. No longer the protagonist, in *Man of Iron* Agnieszka only gets the reaction shot.

When Wajda engineers Agnieszka's character shift in *Man of Iron,* the possibility arises to read the film as a portrait of Solidarity's dejection after martial law. But if Agnieszka conveys an unusual sensitivity to the Polish chagrin of the early eighties, this has more to do with Janda's interpretation of the role than it does with Wajda's screenwriting and direction. Although the epic initiates a study of femininity within state socialism, Wajda's leitmotif of filial reconciliation overdetermines the work's meaning.[11] In *Man of Iron* Agnieszka recedes into the background for the film's first half, only to reappear at the end as the sort of bystander to history that Hulewicz plays. The viewer finds her in a Gdansk-area prison, where she is under arrest and interrogation for Maciek's counterrevolutionary activities. A series of flashbacks makes apparent the change in Agnieszka's character: she displays little of her original fervor, but, rather, is graceful, contemplative, even modest. Her new sense of self-effacement approaches self-irony — something that would add an element of psychological texture to the film — but ultimately falls short of this. In recounting her memories, she acknowledges her transformation and explains that her altered comportment is not a concession to state incarceration, but rather the desired result of a spiritual reform that she herself put into effect earlier on. Through Agnieszka's monologue, the viewer learns that she had given up on her film and tried to forget the traumas of the past well before her arrest, as her passion found a new object: not the historical figure of Birkut, but the living, breathing son, Maciek (Wajda casts one actor, Jerzy Radziwiłłowicz, to play the role of both Birkut and Maciek). Although she first traveled to Gdansk to complete her project, Agnieszka stayed there to be with Maciek, who fathered her child and, she explains, gave her a deeper sort of contentment than she ever could have known before marriage. Since their union,

Maciek and Agnieszka have traded roles. He has joined the vanguard, she has withdrawn from the real action.

To the extent that Agnieszka's story in the two films becomes a taming of the shrew, it reinforces the same patriarchal logic that both determines Maciek's resolution with his dead father and defines Wajda's Solidarity epic. The way in which Wajda fixes Agnieszka's femininity does more than add narrative detail, however. Through her recollections she assumes the role of a messenger of authentic memory, and builds the essential temporal frame upon which *Man of Iron* reaches its climax. In *Man of Marble,* Agnieszka did, in a limited way, mediate cultural memory through her research of archival film footage, but her directorial endeavors never composed a complete picture of Birkut's life. Her failure to master the past works to heighten the viewer's interest and expectant investment in the politics of Polish memory. As a prisoner in *Man of Iron,* however, she produces a coherent account of Solidarity's ascendance. Agnieszka speaks about the uprisings at Radom and Ursus, which the Polish state media sought to keep secret. She laments the harsh conditions of Maciek's work at the shipyard. Now that she has stepped out from behind the camera and become a native informant, her flashbacks serve to structure with unimpeachable authority a series of cuts between different, yet related temporal moments. Agnieszka's recollections in these final sequences of *Man of Iron* provide another clear example of the false mourning that informs Wajda's Solidarity films. Since the main characters appear unwilling and unable to mark the losses of the labor movement, they compensate by consoling themselves with future expectation. This tendency finds its fullest expression in Agnieszka's case. When she forfeits filmmaking for motherhood, expectation becomes expectancy. Instead of marking the difference of that which has died off, Agnieszka aims to fill its place with a melancholic substitute for that loss. The viewer who still identifies with Agnieszka at this point no longer regards Birkut as a historical figure who deserves critique, but rather as someone to love.

Agnieszka's flashback series cuts between two main lines in *Man of Iron* — documentary footage of the Gdansk events of 1980 and fictional sequences of her years with Maciek. Through the accretion of her recollections, these two lines weave into each other and establish a mnemonic matrix that structures the film. But each of these memories is also, significantly, the account of a failure: the misunderstanding of Birkut's denunciation, the thwarted attempt to find his body, the inability to mourn his death. Agnieszka goes to his cemetery, but cannot enter the locked gates. When the chiefs of the television sta-

tion pull the plug on her film, she tries to curate a photography exhibition documenting Birkut's life. This, too, is blocked by the authorities. Unseen and unnamed apparatchiks dictated the termination of Agnieszka's visual projects and the desecration of Birkut's grave, leaving her without material to "give body" to her loss or even a corpse to grieve. Yet the real deficiency of her memory work lies not in its interruption by external forces, but rather in Agnieszka's own choice to divert these tasks into a more sentimental occupation.

Interspersed among Agnieszka's attempts to mourn Birkut are a number of vivid memories about her courtship and marriage with Maciek and the conception of their child. Reconsidering her former feminist stance, she gives in to Maciek and begins to see the value, not only of marriage, but of marriage within the church. One scene from their wedding frames the cultural moment of Agnieszka's belated turn toward Catholicism. She kneels beatifically before the priest, but her hands clasp into prayer with conspicuous rigidity, and she almost forgets to cross herself at the end of the ritual. The most remarkable detail of their wedding, however, is that the real Solidarity activists Lech Wałęsa and Anna Walentynowicz stand as witnesses to the ceremony. Wajda directs his cinematographer to keep the camera at a safe distance from the two lookers-on, but the alert viewer can still catch a glimpse of Wałęsa's amateur bearing. Stagestruck, Wałęsa glances furtively at the camera, apparently on the verge of laughter for the length of the take. He confers his own benediction upon the marriage and the couple's future children, and hands red flowers to the bride and groom, to ensure a "democratic" union. Wałęsa's blessing appears mixed a few moments later in the film. Maciek has been arrested, and Agnieszka is shown hugely pregnant, but toiling away in a supermarket. When their friends learn of Agnieszka's predicament, they collect whatever money they can spare, and offer it to her. At first she declines the gift, but when one visitor explains that they come to her "not out of charity, but out of solidarity," she gratefully accepts it. This is the only instance in *Man of Marble* and *Man of Iron* where solidarity with a small *s* is invoked.

When Agnieszka's visitors arrive, she stands before a window, one hand protecting her womb, surrounded by a diffused aura. Wajda's portrait of her recalls the Black Madonna of Częstochowa, an image that (together with the red-lettered *Solidarność* insignia) held iconic importance in Poland throughout the eighties.[12] At the annunciation of the child's conception, *Man of Iron* offers no further elaboration of Agnieszka's future designs as a documentary director. Her days of investigation are over; now she is Mother Poland.[13] On a

2.2 Agnieszka as the Madonna, *Człowiek ze żelaza (Man of Iron)*, dir. Andrzej Wajda, 1981.

superficial level, Agnieszka's recurrent flashbacks of her new family life seem to offer her some consolation for Birkut's loss. But this is a false compensation, one that deflects any authentic engagement with the past. Wajda's emphasis on Agnieszka and Maciek's fertility interferes with the work of mourning and interrupts his depiction of the actual struggle for labor solidarity. On the formal level, this interference also compromises the editing of the film. By manipulating documentary and fictional footage, Wajda drains the Solidarity strikes of their historical specificity. In one sequence toward the end of the film, Agnieszka and Maciek are reunited in an auditorium where the activists have gathered to celebrate the recognition of the union's twenty-one demands. As the camera focuses on Agnieszka and Maciek's tearful embrace, the Gdansk events blur into a colorful backdrop.

A movement miscarried

In *Man of Iron* Wajda presents Agnieszka as a token of kinship. The film's final sequence symbolizes this Oedipal economy in visual terms. After Solidarity is legitimized and Maciek and Agnieszka are reunited, Maciek revisits the bridge where Birkut was shot down. He addresses his father and asks for his posthumous forgiveness for having doubted his political agenda. He puts a copy of the official assent to Solidarity's demands on the spot where his father fell, and weights it down with a lighted votive. Then the camera draws back, and pans to the right: Agnieszka waits in the foreground, at a respectful remove from Maciek's prayer. Once Maciek has made peace with his father, he looks toward his wife, as if to reclaim her from the past and usher her into the future. The assumption that the past belonged to the father and the future to the son is elementary to Wajda's Solidarity epic. As elementary, that is, as the structures of kinship that are set to unite fathers and sons through the traffic in women.[14] Agnieszka senses Maciek's gaze upon her, turns, and follows him away. As the couple retreats from the camera, they leave behind Maciek's funereal offerings to Birkut. Their exit in *Man of Iron* creates an inverse image of Agnieszka's long forward march through the television headquarters in *Man of Marble*. This staging does not simply resolve the two films in two symmetrical conclusions: more than this, it moves the characters, and the viewer, beyond mourning.

To go beyond mourning, in Wajda's films, is not to confront real grief, but rather to detour into sentimentality. The quick steps of Agnieszka and Maciek as they quit Birkut's little shrine suggest that the couple has overcome some hindrance that blocked their way to a bright future. But while they have

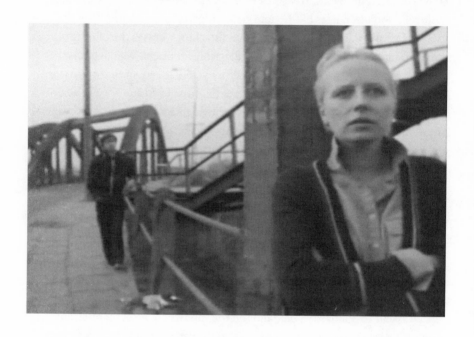

2.3 Maciek and Agnieszka mourn, *Człowiek ze żelaza (Man of Iron)*, dir. Andrzej Wajda, 1981.

acceded to the position held by the older generation, the two have not yet come to terms with Birkut's conflicted past. In view of this deadlock, their steps seem a bit too hasty, as if made in escape. All three of Wajda's protagonists come to melancholy resting points. Birkut falls into a depression that knows no relief except through death. He gives himself up to the police fire in a vain attempt to atone for his past duplicity. Agnieszka and Maciek try to "move on," but only manage to do so by disavowing their unsettling family legacy and fleeing from it. Their baby becomes the object of fixation, a pleasant distraction from difficult questions about the legacy of Solidarity and the role that Birkut played in it. Agnieszka and Maciek do not mourn the past. They feign to master it, and so lapse into melancholia.

When Maciek reconciles with Birkut at the conclusion of *Man of Iron,* it is on false terms. He yields himself entirely to his father's will, and replaces the contradictions of Birkut's legacy with an idealized image that is even more colossal than the marble statues sculpted of him when he was a Stakhanovite hero. Unable to confront Birkut's betrayal of the working collective, Maciek represses his doubts and "writes over" his father's past with idealized memories. The closing scene of *Man of Iron* suggests Maciek and Agnieszka's marital triumph over the past. But the actual members of Solidarity would come to find themselves in a compromised position. In elections in the 1990s, members of the movement lost out against the coalition led by reconstructed communists. But more importantly, as privatization and market dynamics have taken hold in Eastern Europe, Solidarity members have witnessed the erosion of certain guarantees for which they fought. After all, although Solidarity sought to fundamentally reform the socialist state, their strategy was to insist upon the renewal of socialist principles that the Polish government had already ratified. The first two demands of the Inter-Factory Strike Committee make plain the red thread that bound Solidarity together:

1. Acceptance of free trade unions independent of the Communist Party and of its enterprises, in accordance with convention No. 87 of the International Labor Organization concerning the right to form free trade unions, which was ratified by the Communist Government of Poland.
2. A guarantee of the right to strike, and of the security of strikers and those aiding them.[15]

Indeed, Solidarity had its roots in the same socialist regime against which the movement defined itself.[16] Wałęsa and his associates did not draw their politi-

cal weaponry from the arsenal of liberal democracy. Rather, they fended off the obsolescence of late socialism with a revitalized program of worker solidarity. Wajda fails to elaborate the complexity of this genealogy, even if he implicitly acknowledges the links between the naive enthusiasm of the Stakhanovites and the later convictions of Solidarity. As a result, Wajda cannot account for the paradox of Solidarity's postcommunist fallout: once the Communist Party collapsed, the opposition soon tumbled down after it. In the 2000 elections, Wałęsa's party won less than one percent of the vote. In a sense, Solidarity dug its own grave. It remains to be seen whether the democratic spark that ignited their collective project was extinguished as well.

Solidarity is defined by the fellowship arising from common interests and responsibilities, but *Man of Iron* has little to do with this. As Wajda fails to explore the reality of Polish working memory, the second part of his epic is less a story of collective solidarity than one of patriarchal unity. Where his films could have honored the dead, they devolve into the misconstrued melodrama that characterizes the left melancholia of much postindustrial, postcommunist culture.[17] Wajda was not only ahead of his time with regard to aesthetic trends; in *Man of Iron* he prefigured the social conditions of Poland's transitional economy. The film's celebration of private life anticipates the

60

Poles' enthusiastic embrace of the market mechanisms that currently consolidate wealth and privilege in the hands of the very few. This brings us back to Kieślowski's cinema. Through its parody of death, his film *White* discloses some of the contemporary truths that Wajda could only barely imagine in *Man of Marble* and *Man of Iron*, but lost sight of in his most important postcommunist film, *Pan Tadeusz*. To a great extent, the communists who ruled Poland for decades pulled off the same ruse as Karol Karol. In order to protect their own power, the Party accepted liberal democracy and acted out a false requiem for communism. The nomenklatura were reborn as the nouveaux riches.

If Wajda had extended his Solidarity epic into a postcommunist part three instead of revamping *Pan Tadeusz*, he might well have produced something like *White*. It is easy to imagine a film that would trace the steps of Maciek and Agnieszka's son as he ascends to public office and then abuses his power to profit wildly in Eastern Europe's flourishing black and gray economies. *Man of Money*, we could call it.

3. Nostalgia

In the early 1990s West Germans coined a term for the condition that seemed to beset Easterners who longed for the days before unification: *Ostalgie,* or "nostalgia for the East." Many Germans from the new federal states have indeed acted out a kind of retrograde romance with the GDR's second world. In Berlin, activists organized to save the "Little Trafficlight Guy" who flashed on corners in the former East Zone (and won). A new version of the game "Memory," whose cards pictured products from the "people's own industries," appeared in shops. But it was not only East Germans who regretted the loss of both this material culture and the social guarantees that these things were thought to represent. *Ostalgie* also struck Western Europeans. The German Green Party commended the efforts of "actually existing socialist states" to establish a viable alternative to capitalism. In Britain and France oppositional writers, artists, and filmmakers fantasized about an "other" Europe, where men and women labored together to build a better future. This never-never land of the proletariat was charted on the cognitive map of left intellectuals but existed nowhere in reality.

Such Westerners might never have lived under state socialism, but they maintained an investment in the workers' revolution, even when it was clear

that state socialism was on the road to ruin. The system's collapse prompted comparisons to the exhausted welfare states of the West, particularly in Britain and France. In the past three decades a number of writers and artists have produced works that lament not only the passing of the labor-based utopia but also the multiple defeats that were suffered within it. Exploitation, for example. And environmental destruction. In a few key instances their accounts miter together the double loss of state socialism and the welfare state into a single space, reinforcing the joint between the Eastern and Western cultures of the second world.

Nostalgia is the longing for return to an idealized "home" or *nostos,* from the Greek. As cultural historian Svetlana Boym has demonstrated, outbreaks of nostalgia often follow revolutions, as was the case in France after 1789 and in Eastern Europe two centuries later. The "velvet revolution" that terminated Soviet socialism made the twilight years seem, on one hand, like "a time of stagnation," on the other, like a "golden age of stability, strength, and 'normalcy.'"[1] Tony Harrison, the British poet and filmmaker, imagines postrevolutionary fallout to take on a different contour, one shaped by a much longer time-scale. Instead of envisioning nostalgia for yesterday flooding into the wasted battlefield, he sees the defiance of past millennia rushing to fill in the zero hour. When humankind feels itself in chains, the myth of Prometheus reenters history.

Harrison took up the figure of the chained Titan in his recent account of the second world, *Prometheus* (1998), a feature-length Channel 4 film production. In the preface to his script, Harrison emphasizes the potency of Prometheus in the present age of resignation. The inspiration for many literary masterpieces, Prometheus has motivated "the disappointed Utopian" of the past, and might continue to do so for "the Socialist" of today, Harrison maintains.[2] *Prometheus* surveys the postindustrial, postcommunist landscape that stretches from Britain's seconded coal mines, across the Danube, and down to Greece. It also traces the literary legacy that links Aeschylus and Shelley, Mickiewicz and Marx, through the figure of Prometheus. Harrison opens up a literary channel that connects the current predicament of the second world with both the myths of antiquity and the uncertain future that awaits Europe. As a result, *Prometheus* offers an astringent counterpoint to the nostalgia wave that has swept across Western Europe recently. But is Harrison's tonic the only cure?

Three fellow leftists have recounted the loss of the second world in cinema and literature: John Berger, Mark Herman, and Leslie Kaplan. Berger, the

3.1 Frans Masereel, *Prometheus*, 1954, engraving. © 2002 Artists Rights Society (ARS), New York/VG Bild-Kunst, Bonn.

author of *Art and Revolution* (1969) and the renowned *Ways of Seeing* (1972), waxes the most nostalgic about collective labor in his novel trilogy *Into Their Labors* (1979–90). But his stance can be fully evaluated only when compared with the positions of his Western comrades. More than just presenting different readings of the proletarian past, the best minds of Berger's milieu forge literary and cinematic modalities that contest the primacy of nostalgia. Mark Herman's film *Brassed Off* (1996) makes nostalgia for Britain's labor heritage work against itself. In *L'Excès-l'usine* (*Factory Excess;* 1982), Kaplan, an ex-Maoist, collaborates with Marguerite Duras to portray the factory as a place of women's alienation — a place where pop songs endlessly repeat.[3] The gendered charge of *Factory Excess* can be detected in each of the works examined here; the authors draw on this sexual current in ways that lead them to different conclusions about the second world. In almost every case, the nostalgic attachment to the notion that women embody a "biopower" outlasts the fantasy that heavy industry could engineer a socialist future.[4]

Although Harrison's and Herman's films are inextricably bound with the conditions of industrial and postindustrial culture, they also engage narratives of colossal proportion — the myths of Aeschylus and, as we shall see, Homer.

They derive critical traction against both classical form and the European heritage — particularly its musical tradition. All four of these authors touch upon the questions of the culture industry that Max Horkheimer and Theodor W. Adorno framed in *Dialectic of Enlightenment* and that Oskar Negt and Alexander Kluge further elaborated in their cultural critiques. What distinguishes kitsch from art, and nostalgia from the work of memory? Who can claim Europe's cultural tradition? In reaching back to antiquity, these works pass through two nodes of historical antagonism that have defined modernity. One, general: the repeated acts of expropriation that constitute capital itself. The other, specific: the perverse and ultimately failed attempts of Hitler and Stalin to yoke labor power to the instruments of totalitarianism. In these accounts of the second world, the best writers make a dialectical move that connects real history to literary culture and, in turn, discloses the constitutive link between labor and memory.

Nostalgie absolue

John Berger's trilogy *Into Their Labors* traces the modern odyssey of the European worker. *Pig Earth* (1979) commemorates the peasant struggle for survival

in the French countryside; *Once in Europa* (1987) follows the farmer into the factory; and *Lilac and Flag* (1990) collects images from the industrial and postindustrial landscapes of Troy, where Hungarian mongrel youths make their living trafficking in passports stolen from Trans Europe Night couchette cars. By 1990, when Berger wrote the last volume of the trilogy, the other Europe had become the flash point for labor on the continent.[5] Yet the failing workers' republics of the East only serve as vague backdrops in *Into Their Labors;* ultimately Berger can locate labor's redemptive potential only in the premodern customs of the peasant.[6]

Although Berger sees little hope in the industrial collective of working men, he finds in the woman's body a window onto eternity. Whereas industry takes its toll on Berger's male characters, the women prevail. Berger had already staged an industrial accident in *Once in Europa.* Odile Blanc is the heroine of this industrial love story, which is set around 1956. She manufactures radio parts and shares a room in the barracks called "IN EUROPA" with Stepan Pirogov, a worker from behind the Iron Curtain. When he falls into a manganese oxide furnace, Odile insists that he lives on — inside her. Odile is Berger's kind of woman; she is a bearer of memory. She is a factory hand, but her peasant heart links her back to the village, back to the origins of humanity. Berger finds shards of memory only in the agrarian world imagined by women, where the working day ends with a folksong and not a factory siren. In effect he opposes community against change, an opposition that matches his sexual binary.[7] Although Berger cripples and kills off the male characters who would drive the red wedge into industrial society (the maquisard in "The Three Lives," Michel Labourier in *Once in Europa,* Murat in *Lilac and Flag*), he consistently aligns the figure of woman with peasant remembrance. Berger's women serve as escape hatches out of history; they are heavenly messengers of a heritage that seems to bear little relationship to real time. In *Lilac and Flag* the female body defies language: "It's a kind of power. But not the power men pump themselves up with. Perhaps this is why it has no name. It goes through us and joins us with the beginning of everything. It offers us the earth, more than the earth, the sky, heaven."[8]

Into Their Labors collapses under the weight of such an idealized female body, a weight compounded by the strain of nostalgia. With this trilogy Berger suggests that the only recourse from the disasters of industry and the postindustrial afterworld is via a politics of return. He stressed a related point in his essay "Keeping a Rendezvous," published in the *Nation* in 1990, just after *Lilac and Flag* appeared. Here Berger reflects upon state socialism's failure in East-

ern Europe — a revolution, he reasons, that was "made without utopian illusions." So much is true. Yet Berger shows his color a few lines later when he considers the historical lesson that the agents of this transformation have to teach us. Perestroika was not propelled by "the dreaded, classic exhortation of *forward*," he argues, but rather was inspired by "the hope of a return."[9] To claim that Berger forecloses a revolutionary future by finishing off his communist heroes would require of his readers only an obtuse and cursory gloss of the texts. Getting at Berger's real misrecognition, however, demands closer attention. Berger gives up on the potentials of industrial solidarity and chooses to set his sights on the afterlife. He fails to see that no worker can afford a nostalgia trip back to the industrial utopia. Today labor must look back to the second world, but not return there. What is needed is the solidarity that flourished in the factory, not the planned economies or environmental destruction, not the disregard for individual livelihood. To recall the second world is not to fix it or consign it to the past, but to keep it running in the working memory of our present.

Because the men of *Into Their Labors* seek a return to the woman's body ("Inside: where we were before we had to learn about life and were thrown out . . ." [Berger, *Lilac and Flag* 108]), where they will find passage to some immanent reality of peasant life, they lose track of the present and derail into the excesses of nostalgia. For Berger, the struggle for labor organization became contaminated by mechanization and the complexities of politics and current events. To this extent it no longer bears any resemblance — or relationship — to the peasant's struggle for survival. In *Into Their Labors* Berger envisions working memory as a phenomenon that is dying out with the last of Europe's peasants: the farmers of the Ukraine, the fishermen of Greece. This leaves Berger's industrial workers with no hope apart from the brute genealogy that links them back to their origins, a one-way street through "woman," since she alone can see "everything beginning again" (Berger, *Lilac and Flag* 124). It is Odile who most clearly expresses the disappointment that motivates *Into Their Labors:* "There is nothing in the factory which can have a memory."[10] Where, then, does this leave those whose lives have been determined by heavy industry and its vicissitudes?

"Factory. The factory. Earliest memory." The French writer Leslie Kaplan also takes up the problem of working memory in *Factory Excess,* a prose poem that forms part of Berger's cultural context (Kaplan 70). Kaplan presents the factory as an ontological paradox. Here things live and die at the same instant. Things do not take time, they only take place. In this historical vacuum, the

worker cannot fully access her first memory; she can only indicate that it exists. Her memory is blank.

One is in the workshop where the conveyor belt is.
One sits. The conveyor belt is going to start.
Palpable air, blank memory.
One is there, one sits. Stool. Cartons. (Kaplan 53)[11]

Much of *Factory Excess* reads like this passage. Divided into nine "circles," the text is sparse. Often it stalls and then repeats itself. Kaplan makes the process of writing about the factory appear more difficult than Berger would have the reader believe in *Into Their Labors*.

A labor activist in the 1960s, Kaplan worked in a factory in France before turning to writing. After *Factory Excess* came a series of novels including *Le Livre des ciels* (1983), *Les Mines de sel* (1993), and *Le Psychanalyste* (1999). In a published exchange with Marguerite Duras from the early eighties, in which the two writers discuss the Solidarity strikes in Poland, Kaplan touches upon the arduous process of writing *Factory Excess,* which took ten years to complete. Kaplan did not want to write *about* the factory, she explains — she wanted to actually *write the factory (écrire l'usine)*.[12] *Factory Excess* is not socialist realism. It is not the narrative of working life that *Into Their Labors* is. Written in a highly experimental, poetic mode, *Factory Excess* cannot be reduced to its narrative. Like a factory, Kaplan's text circulates, consumes, produces, and reproduces. Its cadences follow the movements of machines and pull the reader into its moments of repetition, into its pauses. This rhythmic element of *Factory Excess* plays a part in another essential distinction between this work and Berger's novels — that of temporality. Berger's trilogy regresses to the preindustrial past; Kaplan's prose poem is stunned by the perpetual reproduction of the present:

The words open out towards infinity.
God exists, the factory.
There is no history. That is the horror.
One doesn't know how to do anything. (Kaplan 17)

The "one" from whom these lines issue in *Factory Excess* goes unnamed, lacking singular quality. The speaker is more a placeholder for a subject than it is an actual narrator. Kaplan's deployment of this subjective cipher is very different

from the discursive shifts that Berger sets into play. In *Once in Europa,* for instance, Berger introduces passages where the narrative perspective switches among characters. In *Lilac and Flag* this decentering device parallels the juxtaposition of different temporal moments. Whereas the stories from *Pig Earth* center around a single voice, the second and third volumes gradually spin out into an entropy of disjointed subjective and temporal positions. As modernity eradicates peasant traditions, a textured influx of voices complicates the narrative clarity that informs the first volume of *Into Their Labors.* Yet nothing in *Once in Europa* or even the last chapter of *Lilac and Flag* begins to approach the subjective exhaustion of *Factory Excess.*

At the beginning of *Once in Europa,* Odile remarks that the first sounds she remembers are "the factory siren and the noise of the river" (Berger, *Once in Europa* 111). The rest of the story develops out of the dissonance between these two recollections. Kaplan's speaker ("one") fails to summon forth any memory substantial enough in its particularity to produce such discord. She merely tabulates the equivalence between the terms "factory" and "memory," and then returns to her patterns of serial repetition. The blank memories recorded in *Factory Excess* are of an order too general to body forth a subject who could say "I." The factory invades space and dissolves the limit between inside and outside.

In *Factory Excess* every differential dissolves but one: gender. Working and dreaming are cosubstantial, life and death collapse into one another, but the axis of gender remains as constant as it does in *Into Their Labors.* Kaplan's "one" — or, in French, *on* — is feminine, but the reader can divine little else about her: "On est assise"; "On est précipitée" (Kaplan 53, 60). Kaplan never approaches the sort of philosophy of the feminine in which Berger indulges, but her insistence on the sexual charge of the factory worker's subjection leads *Factory Excess* to a conclusion more consonant with that of *Into Their Labors* than the reader might initially suspect. For Kaplan, industrialized labor depletes the worker's agency, leaving both man and woman in the same position as that conventionally occupied by women. The crucial insight of *Factory Excess,* Marguerite Duras maintains, lies in Kaplan's constellation of worker (*l'ouvrière*), writer, and woman. Each of these positions is "open" *(ouvert)* to the world, as blank as Kaplan's factory. Duras understands "open" as being "open *upon*": "Nothing opens onto nothing[. . . . N]othing is open onto itself[. . . . T]his 'openness' creates a religious space within oneself. I am that in which everything takes place, even horror itself, but I do not feel it. This could constitute a definition of the working class."[13] The worker, writer, and

woman embody the "faculty of receptive submission" in Kaplan's work.[14] Indeed, Duras claims, this debility is the state of writing itself (*l'état d'écrire*).

Writing the factory, Kaplan brings literary practice to a limit, and puts the industrial workspace into the order of trauma. To this extent Kaplan differs markedly from Berger. Kaplan insists that, in contemporary culture, literary expression can be effected only by moving through the sites of trauma that define our moment: writing must "go through" the factory. Berger, however, engages an opposing strategy. He stakes *Into Their Labors* on the argument that the community of language and literature depends on the maintenance of the premodern traditions that first produced them. Hence the factory and industrial modernity must be resisted in toto.

Circulating in the eternal present, the women of *Factory Excess* lose any sense of history, including the potential for collective memory. Into the gap enters the moment of "absolute nostalgia," a stand-in for real memory. It is this crisis of memory that is the greatest loss suffered by factory workers: their interminable nostalgia stands at one remove from the sort of sentimentality that infuses *Into Their Labors*. Berger idealizes preindustrial traditions and so presents the standard image of nostalgia. When Kaplan writes of the "absolute nostalgia for a factory corridor," she describes the achronic condition of *Factory Excess,* a cultural moment in which "nostalgia for nostalgia" stands in for real memory. Here Kaplan aligns with Negt and Kluge's arguments about proletarian temporality in *Public Sphere and Experience*. As the worker ("on") possesses only a synthetic individual identity, his or her experience of time cannot be determined with the same objectivity as that of a bourgeois individual.[15] When the jukebox plays in *Factory Excess,* it always plays the same song: "Those were the days, my love, ah yes those were the days" (Kaplan 14, 82, 105).[16] All that remains to Kaplan's industrial laborers is the nostalgia that blocks every aspect of anamnesis, even the capacity to forget:

Endless sky, already fallen apart.
There is no forgetting, ever. (82)

"We fought and lost"

Tony Harrison's poem and film *Prometheus* make little effort to depict the actuality of industrial production. Harrison's goal, rather, is to render the epic dimensions of modern labor history. *Prometheus* forges explicit links between

3.2 Kirkby Main Colliery, *Prometheus,* dir. Tony Harrison, 1981 (photo Nick Wall).

the two sides of Europe. The primary level of action takes place around the decommissioned Kirkby Main Colliery and Oceanus Fish Factory of northern England, but the misery of these sites is amplified by interspersed scenes shot in the industrial wastelands of Central Europe and the Balkans — Ústí nad Labem, Nowa Huta, and Copşa Mică among them. Harrison begins with a prolegomenon on the figure of Prometheus in Europe's utopian, literary imagination. The gods condemned Prometheus to eternal torture for having dared to take firepower from them; out of his suffering the poetic soul was born. From these classical origins Harrison then traces out Prometheus's modern legacy. Since the Industrial Revolution, Prometheus's "cry of agony yet futurity" has made him the "patron saint" of the proletariat.[17] The film dramatizes the enmity between the Titan and Zeus, overlaying Prometheus's struggle onto Europe's twentieth century. Hermes, the narrator, recounts Zeus's designs in an irregular iambic tetrameter. Zeus returns to us in the guise of modern destructive agents — he is personified as both Hitler and Stalin, and materialized as smoldering industrial ruin. Although Prometheus once stole fire to foil the destruction of humankind, now he plays into Zeus's hands by giving men and women the freedom to use this power and, perhaps, to engineer their own defeat. The narrative vehicle that drives *Prometheus* across Europe is of a tragicomic order. Hermes recounts the transport of a Prometheus bronze (as big as a socialist realist hero, but literally cast from the molten bodies of redundant laborers) across the English Channel and toward Elefsina, Greece.

En route, Prometheus passes through Poland. He moves from the defunct Nowa Huta foundries and on to the crematoria of Auschwitz. Here Hermes rails at the memorial votives lit by mourners:

These candles that can help them cope
with history and lack of hope
are anathema to Führer Zeus
who hates fire's sacramental use,
Jews flaunting in Lord Zeus' face
the fire he'd meant to end their race. (Harrison 61)

But Harrison does not invoke the Holocaust just for dramatic effect. When he directs the camera to linger over the words welded into the death camp gates — "Arbeit macht frei" — he approaches what Negt calls "the wound of Auschwitz." Even if this inscription only perverted the socialists' industrial

3.3 Hermes and cooling tower, *Prometheus,* dir. Tony Harrison, 1981 (photo Nick Wall).

utopian agenda, the Final Solution robbed the labor movement of its inno-
cence. Since then, Negt maintains, it is nearly impossible to unlock the con-
cept of labor from the camp's degrading and deadly embrace.[18] The point is
not that Auschwitz contaminated labor, but rather that it endures as an ago-
nizing reminder that the workers' movement could not and did not prevent
the genocide of Jews and other "enemies of the state." For democratic social-
ism, this fact remains a wound that will not heal. As *Prometheus* traverses the
grounds of forced labor, it touches upon the complexity of the socialist move-
ment and reveals the adjacent traumas of the concentration camp and the
gulag. It is not just this introjection of historical trauma that fends off nostal-
gia; Harrison also uses literary means to deflect sentimentality. His attempt to
reclaim rhymed meter rings false, and his choice to include extensive footage
of the Prometheus bronze (lashed onto buses, trains, and boats, in transit
across a good number of Europe's highways and borders) nearly makes a farce
of his film. But his juxtaposition of traditional form with postmodern
predicament nevertheless delivers him of nostalgic excess.

Mark Herman's *Brassed Off* takes nostalgia head on. Like *Prometheus,* the
film also depicts a miners' protest, here against the closure of the fictional Grim-
ley Colliery in Yorkshire. It focuses on the years when Margaret Thatcher's
plans to "roll back the state" took hold in England, and makes clear references
to Arthur Scargill's miners' strike of the mid-1980s.[19] Herman first stages the
miners' failed struggle to save their jobs and then devotes most of the film to
chronicling their victory as an upstart brass band. Both *Prometheus* and *Brassed
Off* stand out as prime examples of the British cultural response to the social-
ist crisis of the eighties and nineties. But whereas Harrison's investigation of
the harsh realities of promethean industry deters criticism of the left, Her-
man risks exposing his film to the nostalgia surge that hit Europe when state
socialism and the welfare state came to crisis. *Brassed Off* intervenes into the
Melodrama Department of the culture industry and steals the master's tools.
Through music it finds the inverse of the "nostalgia for nostalgia" that
informs *Factory Excess.*

When Herman's miners learn of Grimley's closure, a poignant violin
score rises up. But this interlude stands in productive tension against what
Brassed Off, as a whole, seems to concede: that, within the coordinates of a post-
industrial, privatized Britain, the campaign for a strong miners' union was
already a lost cause. If we accept this fact, the question upon which the film in-
sists becomes only more salient: Why would a group of workers like those
featured in *Brassed Off* take on a struggle that was scripted for failure? Although

3.4 Protest, *Brassed Off,* dir. Mark Herman, 1996.

Herman captures a few happy moments of the mining workaday, he never romanticizes life in Grimley, and so avoids the wistful tug that guides *Into Their Labors*. Herman shows Yorkshire's polluted landscape, the miners' cheaply built flats, the children's sodden hoods and galoshes. He shows the fractiousness among union members and the despair that led some miners to suicide. The sober details of this portrait make it difficult to imagine that the workers are fighting only in the name of some quaint country tradition, or that they want to stay on at the colliery because the work is so nice.

These grim tokens have a counterpoint in several nostalgic passages in *Brassed Off*. Take the film's score: militaristic marches and dreamy waltzes do not merely accompany the narrative, they also take center stage. This is the story of a brass band, after all; the repertoire is already defined by bourgeois sensibilities and the traditions of nationalism. However, when the Grimley musicians proudly perform Rossini's *William Tell* overture, one might wonder how many layers of false consciousness obscure their music-making experience. But then consider the particular nature of labor sentiment in Britain. In the eighties, unionized miners saw themselves as people of the Real Britain; on the whole they did not feel alienated from the cultural residues of British heritage. Likewise, Herman's miners claim for themselves the entire catalogue of brass compositions — proud trills and all. Invoking imperial memory as part of their own, the miners present themselves as the authentic embodiment of the English spirit, and nowhere more than in their insistence on labor solidarity. From this perspective it would appear that it was actually Thatcher who compromised tradition as she surrendered to globalization on many counts — through privatization, machinations with the European Community, and the resigned embrace of American culture.

With his subversive reappropriation of nostalgia at the conclusion of *Brassed Off*, Herman delivers an upbeat coda.[20] After the Grimley Colliery is decommissioned, the miners go on to win the national brass band competition. Taking a victory tour on a London bus, they play together one last time before returning up north to a future of unemployment and uncertainty. The music: Elgar. *Pomp and Circumstance,* no less.

Siren

If music provides a clue to *Brassed Off*, it does not do so only at the level of content. Music also has structural significance in Herman's cinematic narrative. The miners' actual repertoire means less than the simple fact that the

men stick together. The band's decision to compete after the colliery's closure restates their position. "We are here," it signals. This assertion of subjectivity persists as a symbolic act. At the awards ceremony their leader concedes that the workers had little real agency in the Grimley affair. If the miners could not change their present social reality, then all that remained to them were formal gestures of defiance that would point toward a different future. The leader's monologue becomes a self-reflexive interlude in *Brassed Off,* as it hints at a circuit of alienation that could run through the script, the score, and even the film as a whole. Might the miners, despite their claims, have been estranged from the elite musical tradition? Might Danny's concession lay bare the compensatory function of the band? Could it suggest that music allowed the miners a sense of solidarity that work itself could only deny them? Such questions were prefigured by Horkheimer and Adorno. In their incisive reading of the *Odyssey* in *Dialectic of Enlightenment,* Horkheimer and Adorno isolate the fundamental terms of a late Marxist philosophy of music. These terms can also be employed in an examination of musical tropes in *Brassed Off* as well as in Berger's, Kaplan's, and Harrison's recent projects about working-class culture and collective memory.

Homer's parable of the oarsmen, one reads in *Dialectic of Enlightenment,*

suggests that, even in prehistory, art appreciation and manual labor were unhinging from one another. Circe tells Odysseus of the Sirens' voices, but warns him that there is "no home-coming for the man who draws near them unawares" (*Odyssey* 12.40–41). Enticed by her account, Odysseus undertakes to hear their tragically beautiful song on his return to Ithaca. By commanding his crew to stop their ears with wax and to truss him down onto the ship's mast, Odysseus survives the grave passage through the Sirens' straits and makes his way homeward. As Horkheimer and Adorno understand the myth, Odysseus could hear the Sirens only by deafening his laborers and subjugating them to his will. But, like the bourgeois aesthete of modernity, Odysseus, too, fails to fully experience the performance. What is heard, Horkheimer and Adorno insist, "is without consequence [*folgenlos*] for him." He cannot recount it. Meanwhile the lumpen oarsmen, although they cannot appreciate the music's terrible beauty, "know only the song's danger."[21] Odysseus has his fleeting aesthetic moment, but the laborers gain a deeper knowledge of the work of art that they themselves cannot hear. In a Hegelian twist, they outclass the master by grasping *das Unwiederbringliche* — that which "cannot be called back from the past."[22]

Deaf, the oarsmen nonetheless perceive the limits of total recall. Through their work they secure a temporal anchor that exceeds their master's reach.

3.5 Protest, *Brassed Off,* dir. Mark Herman, 1996.

Since what Odysseus hears is "without aftermath," he stalls, in this context, outside of time, and cannot differentiate between past and present. Indeed Homer leaves it unclear whether Odysseus actually heard anything, or whether the Sirens gave a performance of silence — an extended play of John Cage's *4′33″* before its time.[23] The Sirens not only stilled sound, as Jean-Pierre Vernant argues, they also embodied death ("no funeral, no tomb, only the corpse's decomposition in the open air").[24] The *Odyssey*, as a text, is conditional upon this absence of intended sounds. By circumscribing the song, Homer opens up a space in which his narrative can issue forth.[25] The Sirens' voices resist symbolization; they are not the Muses of Greek mythology, after all, who revive mourning and memory with dance and music. In the end, Odysseus evades the Sirens' seduction and makes it home, thereby obviating the nostalgia that would leave him in the doldrums. Homer's oarsmen miss out on Odysseus's aesthetic encounter, but they maintain some purchase on the inventions of Mnemosyne's daughters. Their music might tend toward kitsch, but it nonetheless marks time. Herman's miners in *Brassed Off* also share this deeper knowledge: when the final sirens signal the colliery's closure, music is all that remains of the collective.

If Hegel's master and slave have continued to trade places, from Homer's

prehistoric seafaring, to the Frankfurt School's midcentury electrotechnics of radios and phonographs, to today's postindustrial culture, then the question of who can make claims on the musical canon — the elites or the subalterns — might well never be put to rest. Indeed a strong reading of *Brassed Off* would amplify the related question about the band's false consciousness to reveal the dialectics operating in the film. As a work of popular entertainment, *Brassed Off* could hardly resolve the contradictions between aesthetic experience and manual labor. Yet, by engaging such antagonism as both content and material, the film invests itself with the authenticity of Art as such.[26] Although scripted into the coordinates of the class struggle, both Horkheimer and Adorno's excursus and Herman's film convey a deeper message about dialectical materialism. For they accord with Marx's dialectic of labor, the paradigm in which history is a process between humankind and nature, the mind and reality, present and past.[27] These coordinates have changed in the half century since *Dialectic of Enlightenment*, but the labor antagonisms press on just as urgently today.

Like Herman in *Brassed Off*, Berger, Kaplan, and Harrison also engage musical matter to make their own points about the crisis in socialism. A colliery brass band appears on some of the B-roll of *Prometheus*, and two other musical intervals come to the forefront of Harrison's film: the mournful song

of the women workers and the klezmer strings that play in the Auschwitz scenes. In *Into Their Labors* and *Factory Excess,* music propels both the workers' predicament and their potentials to the margins of history. The sentimental compositions that accompany *Into Their Labors* betoken Berger's desire to regress from present contingencies into the imaginary harmony of preindustrial working life. Turning away from any such reverie, Kaplan reduces an entire universe to the droning repetition of one pop song. In *Factory Excess,* the factory exists only in a spatial dimension. It is a mythical place outside of time, much like the moldering islands inhabited by the Sirens: "One is outside time under the factory sky" (Kaplan 106). Similarly, as *Into Their Labors* progresses from peasantry to postmodern Troy, spatial phenomena gradually occlude any temporal experience. For both Berger and Kaplan, history dies in the factory.[28] In her conversation with Duras, Kaplan agrees that the factory resembles the concentration camp. Just as these two institutions forged industrial modernity, they also stand in for it here. Harrison's *Prometheus* and Negt's reflections on Auschwitz are a world apart.

In *Brassed Off,* music symbolizes a power rooted in the past but moving through the present—a power which might outlive the adversity facing Herman's miners. That music "works" memory and reactivates the question of who can claim a musical heritage distinguishes *Brassed Off* from *Into Their Labors* and *Factory Excess.* Kaplan's repetition of "Those Were the Days" seems pitched to infuse every aspect of industrial culture with its insipid rounds. In *Factory Excess* the work of memory implodes; what Duras calls *l'anti-travail* (antilabor) could just as well be antimemory. Perhaps it is this resignation that leads Kaplan to agree with Duras in the book's postscript that the Polish Solidarity movement was organized not to strengthen the trade union, but rather to expose the absurd "noblesse de la banalité" at the core of industrial modernity.

Although *Factory Excess* steers clear of postsocialist nostalgia, Kaplan (like Berger, Harrison, and Herman) stumbles over "the woman question" in her projects. Indeed gender trouble operates in the depths of each of these works. The problem of the factory siren leaves the dimension of sound and enters into the narrative space of the feminine, that is, the space of the siren as woman. While Berger can only idealize woman as a symbol of memory, Kaplan and Duras suggest that women—as a class—are receptively submissive to patriarchal forces, particularly in the factory environment. In *Prometheus,* Harrison renders his women nearly mute, yet magnifies their screen presence. The single line spoken by the mother of the Yorkshire family

3.6 Miner-musicians, *Brassed Off,* dir. Mark Herman, 1996.

consists of eleven words and does not take on the meter that defines most of *Prometheus* ("Jack, come back. He didn't mean it. He's upset, your Dad" [Harrison 11]). Io, who animates the film's continental journey, single-handedly takes on the duty of cleaning and restoring the sullied Prometheus statue, but she remains silent, even during her murder.[29] Only the "mournful little number" and "funeral dirge" sung by women from the Oceanus Fish Factory become audible as they accompany Prometheus's procession (Harrison 34, 36). Harrison finds in memory work a division of labor, by which women assume the responsibility of mourning. But their grief keeps them apart from the male collective. In several key scenes Harrison replaces the Oceanus workers with papier-mâché puppets and thereby hypostatizes their lack of agency. Harrison deserves credit, however, for broaching one of the most polemical topics of sexual politics in the New Europe: as the characters cross the border between Germany and the Czech Republic, they encounter rows of prostitutes from the collapsed second world. Harrison chooses not to elaborate upon this situation, but the few lines he composes to describe the point of transit convey a sense of anxiety about the changed conditions of women's work in Eastern Europe. Harrison's jump cuts from the seedy border crossing to the scene of Io praying in a Czech chapel suggest a return to the battleworn madonna/whore opposition.

If *Prometheus* fails to open any new avenues for gender critique, *Brassed Off,* even with its nostalgic trappings, might offer a few points of entry. Herman's main female character, Gloria Mullins, a laptop-toting budget manager, is branded as an infiltrator and rejected by the all-male Grimley Colliery Band. But she wins back the miners' favor by quitting her job and donating her severance check to the band members. In the end she toasts the band's victory together with the women protesters who had held vigil outside the gates when Grimley was being closed down. In *Prometheus* the closing of the Kirkby Colliery is also attended by busloads of women, but they silently stand by and bear protest banners. Leaving aside Herman's problematic decision to have Gloria Mullins sacrifice her own job, we can at least maintain that *Brassed Off* attempts to vocalize the potentials for solidarity among male and female workers. This articulation of shared loyalty and defiance sets Herman's film apart from the projects of Berger, Kaplan, and Harrison.

A formal analysis of these four works opens up a different reading from the previous feminist critique. Although *Brassed Off* closely tracks Britain's social changes, Herman's film, when scrutinized, seems to slacken. The musicians in his film pull off a symbolic act, but the cinematic work as such lacks

the formal intervention which Kaplan, for example, effects through the fragmented poetics of *Factory Excess*. Even *Into Their Labors* risks more to expose a discursive space beyond that of realist narrative. Nevertheless if *Brassed Off*, as a film, only serves as a nostalgic imitation of a symbolic act, it still resists lapsing into antimemory, for it pays homage to the actual events of British labor history. In contradistinction to Herman's working memory in *Brassed Off*, Berger indulges in nostalgic fantasy, and Kaplan stalls in the mode of compulsive repetition that only postpones memory work.

Marxism and form

Prometheus engages formal means to engineer a detour away from nostalgia. Harrison's adherence to rhyme and meter constantly jars today's readers and viewers into recognizing the critical gap that separates them from the aesthetic material. This irritant negates the possibility of any passive reception of exhausted platitudes. After having survived the long march across Europe, the Prometheus figure could stand valiantly at the film's end, symbolizing the triumph of worker solidarity. Instead, Harrison brings *Prometheus* to a somber conclusion, one that does not rest on the faded laurels of the labor movement but instead reveals the magnitude of what is to be done in the future.

At the end of Harrison's film, the Prometheus statue, cast from the bodies of Europe's unemployed, is reduced to ashes. Only Hermes rises up from them. (Harrison calls this scene a "Götterdämmerung" [xxviii].) Hermes has already mediated Zeus's message about capital's encompassing reach as he made his way across Europe's industrial zones.

Zeus entrusts these jobs to me,
free-trade Hermes/Mercury!
When jobs collapse they know their pal
is D-mark-toting Capital! (Harrison 71)

Invested with this authority, Hermes remains impervious to the workers' maneuvers. Unlike the humans, he feels "no wound, no pain, no ache" (Harrison 85). The messenger's ultimate resurrection affirms the logic of his missive: capital constantly regenerates itself, even in moments of crisis.

Although Harrison deprives the laboring mortals of any lasting victory, he does not resign *Prometheus* to an acceptance of capital's totality. Instead, the film operates as an injunction to acknowledge the possibilities for change that

constantly emerge. Through the means of epic and cinematic form, it taps into a vein that Negt and Kluge traced in the seventies and eighties, one that reveals history as radically open, resisting resolution. In *Public Space and Experience* and *History and Obstinacy* Negt and Kluge rethink Marx's premise that capital's origin — the event of primitive accumulation — was written into the annals of humanity "in letters of blood and fire," where it remains an immutable constant.[30] To fix capital's origin in primordial times, Negt and Kluge suggest, is to obscure the fierce antagonisms that still emerge at every turn. If primitive accumulation is constantly being *rewritten* in letters of blood and fire, as critic Christopher Pavsek argues and Tony Harrison implies, then capitalism faces an endless battle to maintain its conditions of possibility.[31] Harrison's Prometheus statue, an agglomerate of collective labor that loses and regains its solid state, materializes this process.

Capital does not emerge once and for all, Negt and Kluge contend. Rather it rebuilds itself, "remounting its pedestal" and renewing "original accumulation" (Negt and Kluge, *Geschichte und Eigensinn* 31–32). These events of collecting and separation are what make history move. Each juncture affords the occasion for new divisions and new alliances. Prometheus entered into this dialectic when he stole fire from the gods, purloining a productive force that could then be harnessed by humankind. Negt and Kluge's revision of the principle of primitive accumulation discloses the relevance of *Capital* to cultural critique, for the factory is not the only site of contest. More than ever, so are the fields of literature, cinema, and art. When Prometheus stole his spark, he also spirited away a desire to tell stories to listeners gathered around the hearth. At one stroke this act delivered to humankind the crafts of both production and ruin, gifts that reopen the end of history and win it back from nostalgia. One of Harrison's characters says as much in his last words:

Fire and poetry, two great powers
that mek the so-called gods' world OURS! (Harrison 84).

If *Prometheus* prompts the question of what is to be done after the socialist crisis, it does so not only through Harrison's design but also through the film's uneven politics of gender and memory. Like *Into Their Labors*, *Prometheus* takes women out of the working circle and makes them into muses of memory and mourning. Set at odds to industry, Berger's and Herman's women engender the "biopower" that some imagine to be an unadulterated force of revolution.[32] This ignorance vis-à-vis women's role in contemporary labor

3.7 Brass band, *Brassed Off,* dir. Mark Herman, 1996.

politics mars much of the left's recent cultural production. But as both Hork-heimer and Adorno and, later, Negt and Kluge have suggested, some lesson can be derived from every mistake. To Horkheimer and Adorno's assertion that "stupidity is a scar," Negt and Kluge add that "social sensibility needs the resistance *upon which* it works and *from which* it works itself out in order to constitute itself as experience."[33] The texts and films examined here fail to strike a productive balance between gender and labor politics, but they heighten our desire to keep working at it.

If history has not yet come to an end, if these wounds persist, then la-borers in the new Europe — even the tour guides, telemarketers, and cyber-technicians who work "off site" — cannot afford to forget the collective hope that first took form between men and women on the factory floors of En-gland, of France, of every country in the European Union. This legacy still links all the constituents of the working classes, whether they labor at the assembly line or the keyboard of the home-office, or whether they wait at home for a new job, as millions of unemployed Europeans do. The strongest accounts of the second world sound out the potentials sedimented into the most obstinately inaccessible moments of history. These works reanimate socialist memory and let its refrains accompany the workers of today on the first steps of their journey into the new economy, where a series of novel chal-lenges remains to be answered, measure for measure.

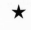

4. Mourning

When "funeral baked meats" turn up at the wedding banquet in *Hamlet*, a specter comes to haunt Denmark. Mourning work has been left unfinished, debts remain unpaid, things are out of order. Now — after the exhaustion of the welfare state, after the collapse of the Soviet empire — some discern a sense of unrest akin to that which set Shakespeare's drama into play. Only this time it troubles all of Europe. The ideals that informed socialist programming on both sides of the Cold War divide have been dispensed with little ceremony. In their stead, competitive market plans and information economies have emerged and prospered. While many rightly have the greatest expectations of this transformation, some have begun to ask whether the death of Europe's second world has been mourned properly. Much as they might like to celebrate, they wonder what has gone amiss.

One of the most visible signals of this transition has registered in the former industrial zones of European cities, particularly in Britain, France, and Germany. As these rust belts are refunctioned, the built environment is undergoing substantial change. Contractors renovate factories into shops, galleries, and office spaces for new start-ups. Cranes careen out from freshly cleared construction sites across streets and squares, prompting some city dwellers to

consider wearing hardhats as they make their daily rounds. Meanwhile some critics warn that this collective anxiety indicates deeper discord: Europeans worry that the sky is falling because the social safety net has been pulled out from beneath their feet. As borders have dissolved and monuments have tumbled down, a sense of security has gone with them.

From the uneven grounds of the new Europe emerges a series of questions. If the passing of the second world has left a debt, how can it be repaid? What sort of mourning work would put into order the fallout of the socialist crisis?[1] In postindustrial culture these concerns have registered in art, in literature, in critical thought. Recently Rachel Whiteread's sculpture has been seen to betoken the need for collective mourning. For many in Britain her somber *House* project recharged the question of socialism and public culture. Whiteread's unframing of the private space was anticipated in the early 1980s when postindustrial and sexual antagonisms were condensing across Europe, in culture and in theory. *Kulturphilosophen* Oskar Negt and Alexander Kluge turned first to *Antigone,* then to the Grimms' fairy tales to reclaim signal images of houses — under duress, at the moment of demolition. Whiteread, Negt, and Kluge variously plot out traces of the second world condition onto Europe's unsettled cultural and political landscape.

Beneath this disquiet lurks a more fundamental problem: the work of mourning itself. Freud already raised questions about this in "Mourning and Melancholia," when World War I marked another chapter in European history. Today this question returns. Although Freud's study endures as one of the seminal statements on grief and its resolution, it actually says much more about melancholia than it does about mourning. Freud left us very little to go on — he wrote that mourning, *Trauerarbeit,* is a kind of labor that unfolds in a process.[2]

Freud briefly describes mourning as the healthy abreaction of grief, and then directs his attention to the condition of melancholia for the remainder of the essay. We can "rely" on the mourner's overcoming of grief "after a certain lapse of time," Freud assures his audience (*SE* 14:245). While grieving, the mourner carries out a series of "reality tests." He or she summons forth "piecemeal" each of the memories and expectations associated with the lost object, and then releases them one by one, such that the libido detaches (*SE* 14:245, 252). From this point, the subject can draw a new object into his or her libidinal economy — one that would replace that which was lost. Whereas any interference with this normal mourning process would only impair it, melancholia presents itself as a sort of "pathological mourning" that requires thera-

peutic intervention (*SE* 14:250). The melancholic lives in a "crushed state." His or her behavior proceeds from a "mental state of revolt" against the imperative that the love object be relinquished (*SE* 14:248). Instead of displacing the libido onto a new object, the melancholic withdraws it into the ego, as if to consume it and possess it fully. Freud finds a striking expression for the ego's identification with the object: "the shadow of the object [falls] upon the ego, and the latter [can] henceforth be judged by a special agency, as though it were an object" (*SE* 14:249). In effect, melancholia consists of the transformation of an object loss into an ego loss. As its dynamic resembles that of narcissism, its etiology captivates the attention of medical researchers, and promises to reveal clues to the fundamental structure of the psyche. But why is the work of mourning given short shrift in the study? Freud himself notes how odd it is that we take this "painful unpleasure" as "a matter of course" (*SE* 14:245). We take the "attitude" of mourning to be self-evident, yet we have only investigated the most shallow contours of this crisis (*SE* 14:244). Aside from these remarks, Freud lets the problem of mourning rest.

Some forty years later, Lacan reexamined Freud's claims about the normalcy of mourning in Seminar VI, *Le Désir et son interprétation* (*Desire and the Interpretation of Desire*). In the *Hamlet* lectures that were a part of this series, Lacan returned to the matter of the "painful unpleasure" that Freud had touched upon. "What exactly constitutes the work of mourning?" he asked his audience. "The question," Lacan noted, "has not yet been properly posed."[3] Although Freud brought forth a fascinating subject, his followers had not adequately elaborated the speculations of "Mourning and Melancholia." In the *Hamlet* lectures Lacan reopened the inquiry and reconceived mourning as a collective process.

When a subject witnesses the death of a loved one, no words can match this experience. In the wake of loss the subject will enact rituals of language and music in an attempt to fill in the gap once held by the missing object. To illustrate this performance Lacan refers to Freud's basic definition of psychosis in the Wolf Man case. What is *foreclosed* from the symbolic order of language and signification comes back to haunt us in the Real — the order of ecstasy and trauma. Mourning, as we see in *Hamlet,* presents an inversion of this psychotic mechanism. What is foreclosed from the Real returns in the Symbolic. In response to this blow, the subject enacts public rites to fill the gap left by the deceased. Crucial for Lacan is the collective charge of this performance. The work of mourning is accomplished at the level of the "logos" — the republic of language that takes "group and community [as] its mainstays."[4]

Each individual mourning act must accord with the reified standards of ritual. Without this symbolic formalization, without collective memory, the subject cannot accept the object's loss. Indeed, the work of mourning constitutes the collective.

The house of mourning

Freud saw mourning as a kind of labor. Lacan saw it as a collective process. The socialist crisis confers new urgency to the problem of mourning, for it prompts a reflexive inquiry into the status of collective experience. The lost object mourned by many Europeans is the collective itself—collective labor, collective memory. In the current search for patterns of mourning, both classical antiquity and contemporary art have been called upon. Touched with a memory fever, visitors file into galleries and museums as if there were no tomorrow. What they find on display, however, seems to matter less than the path they take to find it.

Among contemporary visual artists, Rachel Whiteread has been recruited as the prime messenger of collective memory. In her sculpting process — Whiteread fills forms with fluid compounds, then breaks down the frame — many perceive a parallel for the work of mourning. Her first sculptures from the 1980s — plaster casts molded from secondhand chairs and abandoned mattresses — were seen alternately as metaphors for the human body and as signs of former presence. In the early nineties, Whiteread began to work on a larger scale, creating negative reliefs from the insides of rooms. *Ghost* (1990), her first such work, was cast by hand from a small salon in a Victorian house. Here she inverts the structural logic of interior architecture. As inside becomes outside, the viewer gets a double take of the fossilized details of the surface: soot from the fireplace, nicotine and ventilation stains. All these unleash a series of associations. Where the casts of furniture evoked the individual past, *Ghost* suggested the structures of collective memory. Once Whiteread crossed the line between private and public space, there seemed to be no turning back. Curators, collectors, and critics enlisted her as the default memory artist of the new millennium, and offered her commissions to make several prominent memorials, including the *Holocaust Monument,* which was unveiled in 2000 on the Judenplatz in Vienna.[5] The response to her casts has sharpened the debate about the politics of memory. But this discussion, in turn, has both brought Whiteread the shock of notoriety and obscured the specific conditions of her sculpture.

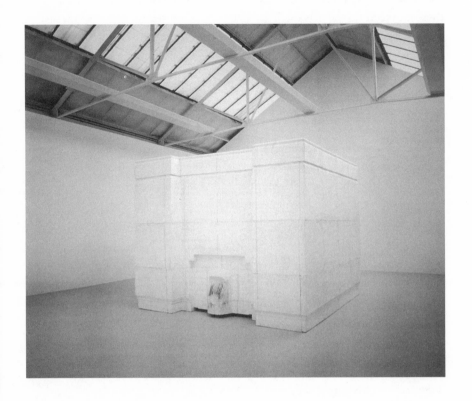

4.1 Rachel Whiteread, *Ghost*, 1990, plaster on steel frame.

In 2001 the Deutsche Guggenheim on Berlin's Unter den Linden commissioned Whiteread to make new casts. For the project Whiteread chose the title *Transient Spaces*. Although it entailed the casting of deserted domestic enclosures — a basement and an apartment — the finely engineered surfaces of these casts left no trace of the lives that once inhabited them.[6] *Transient Spaces* marked a departure from *Ghost*. It was an injunction to observe the fundamental elements of the built environment, to ask how walls and stairs support and transport the human body. Casting *Untitled (Apartment)*, in particular, posed the challenge of indicating the gaps in the structure where the walls once stood. Together with *Untitled (Basement)*, it referenced both modern architecture and modern art.

Process-based, site-specific, postminimal, Whiteread's work locates itself at the intersection of some of the main currents in Western postwar sculpture. To read her casts in the context of this genealogy is to better understand the structural and conceptual statements of her work.[7] Her early sculptures, cast from domestic furnishings, readily lend themselves to comparison with the negative impressions that Bruce Nauman made in the 1960s. Like Nauman's *Cast of the Space under My Chair* (conceived in 1965, realized in 1968), Whiteread's first sculptures induce the viewer both to mentally recast the missing mass into the emptied space and to stage the object as a stand-in for a human being.[8] When Whiteread moved from plaster and cement in her first projects to rubber and resins in the subsequent casts, her work came into line with that of Joseph Beuys and Louise Bourgeois. Like Beuys, she reclaimed the emptied spaces of furnishings; like Bourgeois, she reframed questions of domestic architecture and trauma.[9]

As Whiteread began to cast larger objects in the early nineties, her work approached the sculptural field that takes up architecture itself as a medium. Dan Graham set a precedent for this intervention with *Homes for America* (1966–67), a photo-tractatus on the dual hyperformalisms of both minimalist art and suburbia's housing developments.[10] Whiteread's *Untitled (Room)*, made during the artist's eighteen-month stay in Berlin in 1992 and 1993, also recalls the standards of prefabricated apartment blocks.[11] Unlike *Ghost* and *Apartment, Room* was cast from a plywood mold, not an actual room. The surfaces are devoid of the details and fixtures that would index a life once lived between its walls. But Whiteread's concern with the formal aspects of the domestic interior has largely been lost on many of the critics who have written about this cast (and others). Perhaps this has something to do with the timing of *Room*. For it was also in 1993 that Whiteread created

House, the work that caused a sensation not just in the art world, but also beyond it.

In the foreword and preface to the *Transient Spaces* catalogue, Whiteread's aesthetic interventions register only obliquely. Again and again, mourning and memory trump form. The first to present his reading of *Transient Spaces* is Dr. Rolf-E. Breuer of the Deutsche Bank. "The British sculptor," he begins, "has entitled her exhibition *Transient Spaces.* This may be loosely translated into German as *erinnerte Räume,* or 'remembered spaces.' The past," he adds, "only lives on when we remember it. Records help us not to forget."[12] Breuer's translation is not loose as much as it is wishful. What does the museum want from Whiteread's work? Why has the memory fever spread among Whiteread's audience? If Breuer's (mis)reading prompts these questions, the remarks of Thomas Krens, the director of the Guggenheim Foundation, make them more salient. Krens, too, leaves aside Whiteread's position within modern sculpture practice. He sees *Transient Spaces* as a study of the transformative processes that are taking place in Europe today. To Krens, Berlin serves as "an ideal location" for the project, since it has been "radically transformed several times since the war."[13] He deflects our gaze from Whiteread's work onto the world that surrounds it, leaving untended the formal terms of her installation. In the past half-century, Krens continues, "architectural distinctions between public and private, as well as the spiritual, industrial, and domestic, have become increasingly blurred, as a growing sense of rootlessness has spread throughout Europe."[14] Now that the continent has become a construction site — not just of new buildings, but also of new alliances and new ideologies — many look to art for temporal anchors. As viewers call upon Whiteread to provide this kind of ballast, her work is being delivered over from the precincts of art history into the broader discourse of public culture, sometimes with little regard to her intentions as a sculptor. The second world's eclipse has cast a long shadow over Whiteread's sculpture. It is time to read her work in this half-light. To undertake this task, let's first take Whiteread on her own terms, and then open her sculpture to the expanded field of mourning work.

If *Ghost* suggested a shift in Whiteread's casts from private recollection toward collective memory, the public and critical response to *House* fixed her place as an artist of mourning. Whiteread made this sculpture from a condemned house that once stood in Bow, a depressed, semi-industrial area of East London. *House* did not just invite art historical comparisons with other site-specific and process-based sculpture; it also set off debates on topics ranging from the history of London to class relations and urban planning.[15] To

make the cast, Whiteread had to destroy a two-story home. Within the British context of postsocialist privatization, her act of first filling a house with cement and then tearing down its supporting walls provoked both criticism and interest. The East End's renovation redrafted the cityscape and sent many neighbors off to different districts or out of London altogether. Some mourned this displacement, and so saw *House* as an allegory of the city's loss. For it is not only the death of a loved one that occasions mourning, Freud noted, but also other kinds of endings. As he remarked in "Mourning and Melancholia," we grieve not only for the dead, but also for the loss of other things we have cherished — the "abstractions" that can become just as beloved to us as any person: the ideals of liberty and justice, and even one's home.[16]

Part of the neighborhood in which it was built, *House* raised issues concerning gentrification, the state of housing in London, and the role of public sculpture.[17] More than an exercise in form, *House* became an event that linked art to life in unexpected ways. Bow, where Whiteread chose to build *House,* still bears many traces of Britain's industrial past. It was the site of the Bryant and May Factory, where match girls carried out a fierce (and ultimately victorious) strike in 1888. In the same area, Sylvia Pankhurst founded the East London Federation of Suffragettes just before the outbreak of World War I.

House was located at 193 Grove Road. For most of the twentieth century this street was lined with rows of terraced houses, the homes of industrial laborers and their families. But Grove Road became the site of the first bomb to fall and explode in the city during the air raids of the second world war. In the years of postwar reconstruction, a wave of foreign workers resettled the district. By the early 1990s, when Whiteread began *House,* plans were under way to gentrify the area, which entailed ousting residents, tearing down old houses, and landscaping a common garden. The house at number 193 was the last left standing.

The casting of *House* was a complex process.[18] First Whiteread and her team of assistants used steel bolts to reinforce those junctures of the original house that bore the heaviest loads. The next steps were to smooth down the interior surfaces, fill in the window casements, and then prime the insides of the walls with a specially formulated "delayed release" debonding agent. Having applied the debonder, the team proceeded to install a grid of iron cables that would provide another substrate for the concrete. Then they sprayed a concrete mixture into this mold, starting at the foundations and working their way up three stories until they reached the top. They excised a passage in the roof and then sealed up this hole when the last worker had exited. About a

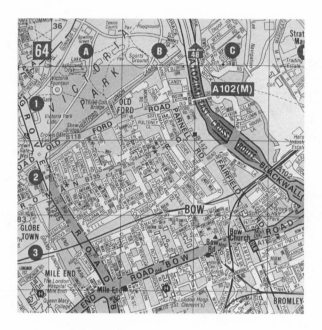

4.2 193 Grove Road, London E3. "Reproduced by permission of Geographers' A-Z Map Co Ltd. This product includes mapping data licensed from Ordnance Survey. © Crown Copyright 2002. License no 100017302."

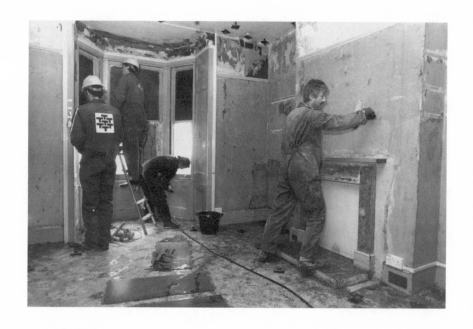

4.3 Building *House,* autumn 1993. Courtesy Artangel, London (photo Edward Woodman).

fortnight later, when the concrete mass had set, Whiteread and team returned to the site to dismantle the exterior walls and roof of the house. The debonder had worked, and they were able to cleanly unseal the cast from the exterior walls to be dismounted. The final result was a highly articulated relief of the interior.

Within a brief period of time, *House* began to attract public attention. In daylight it was surrounded by both journalists and passersby who wanted to take a closer look at the strange, ghostly immigrant that had taken up residence on Grove Road. At night it drew other visitors, some of whom were quick to inscribe right onto the sculpture their own interpretations of Whiteread's project. "Homes for all — black and white," wrote one visitor in large letters. *House* elicited a diverse array of responses from the public. The words of another graffiti artist ("Wot [sic] for? Why not?!") countered the opinion of Sydney Gale, the last tenant of the house, whose indignant remarks were recorded by an East End newspaper. He defiantly announced, "if that is art then I'm Leonardo da Vinci!"[19] Although the public nature of *House* has led many to read the cast as a statement on the history of Bow, Whiteread herself has chosen to focus on the casting process; she has stressed what she calls the "indirect meanings" of her work.[20] *House* makes an inquiry into the operation of seeing. A negative space, at once public and private, inside and outside, *House* is, frankly, difficult, even troubling to look at. Take the "windows," for example. The fact that one could neither see into them nor out of them, the disorientation of interior and exterior structures — these conditions frustrate any optical purchase on the work. Yet it is precisely this complex surface of the sculpture that supports and guides the most productive line of critique. *House* concretizes the impossibility of seeing the past "as it really was."

Whiteread's gesture of at once casting and casting *away* functions as the organizing temporal and spatial agent of the sculpture. *House* accentuates the role of displacement within memory work; the mass that Whiteread casts is part of what remains in the present, but something else is cast off, something else is lost to the past. In realizing the project, Whiteread and her assistants dismantled and discarded most of the actual structure, literally dislocating the habitable dwelling. This rejection takes a parallel trajectory to the one that Lacan plotted out in his *Hamlet* lectures. Returning to Freud's thought on mourning, Lacan references "The Neuro-Psychoses of Defence" (1894). In this early study, Freud characterizes repudiation *(Verwerfung)* as a defense mechanism — a reaction triggered by the subject's encounter with an intolerable force. Although irritated or even imperiled by this agent, the subject cannot

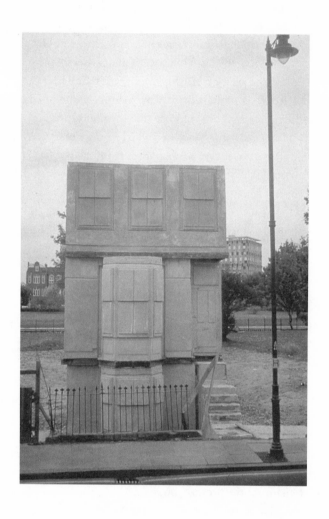

4.4 Rachel Whiteread, *House*, 1993–94. Courtesy Artangel, London.

simply repress it, but must rather exclude it from his or her universe of meaning.[21] When Lacan reconsidered Freud's thesis in Seminar XI, *The Psychoses,* in 1955–56, he wrote over Freud's notion of *Verwerfung* and christened it with a new name: *forclusion* or "foreclosure."[22] Foreclosure, he discerned, differs from repudiation. Here the subject does not repress the intolerable signifier back into the unconscious, but rather casts it out from the Symbolic and into the Real.

To the extent that *House* enacts its own foreclosure, it both aligns with the psychoanalytic work of mourning and renders an expressly public procedure. *House* invokes the more common usage of the term "foreclosure," the one drawn from the lexicon of British housing law. A mortgagor who fails to make payment for three consecutive months risks the foreclosure of his or her home by the lending agency. But the standard English translation of *forclusion* as "foreclosure" is misleading. Lacan makes no association with the term "foreclosure" as it is used in matters of real estate, but these false cognates would undoubtedly please him, whose love for puns was well known.[23] Curiously, the mistranslation of *forclusion* as "foreclosure" generates a truth effect, as Whiteread's project reveals. In the year in which *House* was completed, more than 600,000 British households were at risk of being foreclosed—by far the highest number in the postwar period.[24] Like the rise in homelessness in the 1990s, this spiking in the number of households on the brink of foreclosure was one consequence of the reformative legislation on housing and lending societies passed by conservatives in the 1980s—that is, Margaret Thatcher's campaign to "roll back the state" that also inflected Mark Herman's *Brassed Off,* discussed in chapter 3.[25]

To suggest that Whiteread responded directly to the British mortgage crisis would reduce *House* to agitprop. Yet perhaps the public (critics included) interpreted the project as a statement on the dismantling of socialist policy because they harbored misgivings about the government's new agenda. *House* rests upon the nodal point where the social and the psychological intersect. The externalized interior of the house discloses this intersection as its surface wends its way between the fields of the inside and the outside, the collective and the individual. *House,* an object lesson on the threshold between public and private, was itself a foreclosure.

On the twenty-third of November, 1993, *House* met its destiny when two councils convened to evaluate the sculpture's merits: one at the national level, the other at the local. The Tate Gallery awarded Whiteread the Turner Prize, an annual honor recognizing the British artist considered to have shown the best work within the previous year. On the local level, the Bow council put

House on trial. Many of those who had to live with the sculpture believed that it exerted negative effects on the Grove Road community. Their verdict: Guilty. Shortly thereafter bulldozers entered the scene to demolish the sculpture earlier than Whiteread had planned. In the end, *House* stood for roughly three months, a span of time that matches the maximum period a mortgagor can forestall payment before foreclosure. A match of uncanny exactitude.

The cultural moment of *House* as mass event has overdetermined the sculpture's meaning. Following upon Britain's socialist crisis, Whiteread's work was conscripted into the discourse of collective mourning, where the language of minimalist and site-specific sculpture is seldom spoken. The formal terms of *House* were prefigured by the sculptural interventions of the 1970s, but the timing of Whiteread's cast granted a new translation to the project—one written in the idiom of public culture. The double demolition of *House* (first by Whiteread, then by the local council) not only activated collective mourning, it also staged collective identity.

If the public claims on *House* as a work of mourning accord with Lacan's schema from the *Hamlet* lectures, then they signal a desire to construct and legitimate collective identity. It is this disclosure that sets Whiteread's projects apart from those of Nauman, Graham, Bourgeois, and even Beuys. But perhaps we can draw a more precise comparison between Whiteread and Gordon Matta-Clark, the American artist whose incisions into the built environment set an important precedent for *House*. Whereas Whiteread's work serves to screen disparate projections of collective identity, Matta-Clark's "building cuts" bring to crisis the very notion of community. Two Matta-Clark projects make this difference plain—*Arc de Triomphe for the Workers* (planned in 1975, but never realized) and *Conical Intersect* (1975). Matta-Clark proposed *Arc de Triomphe for the Workers* to pay tribute to a group of communist militants in Milan. Having occupied a decommissioned factory on the city's outskirts, the activists had sketched out an agenda to gradually refunction the property into a community services center. When Matta-Clark entered into the scene, he proposed to cut an arch into the main building. Although local officials had long overlooked the activists' initiatives, the news that an American was going to turn the building into an art space raised their ire and triggered a police shakedown that broke up the squat. Matta-Clark's artistic intervention went from cut to coup de grâce and inadvertantly defused the activists' initiatives.[26]

But, as Pamela M. Lee demonstrates, *Arc de Triomphe* was destined to fail. Not because of the sculpture's subversive intent, but rather because it contradicted the conceptual foundations of Matta-Clark's larger project. Where his

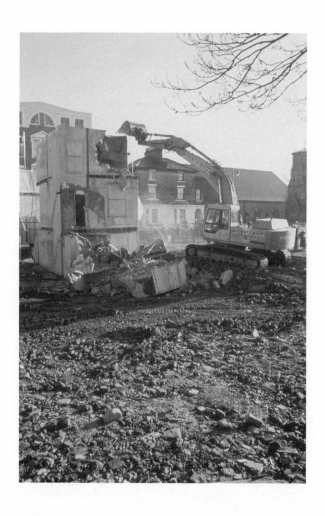

4.5 Demolition of *House,* 11 January 1994. Courtesy Artangel, London
(photo Stephen White).

other building cuts were pitched to reveal the "instability of communal place and the ontological insecurity of its 'audience,'" the project for the Milan collective seemed ill-conceived.[27] *Arc de Triomphe for the Workers* stands at odds to *House*. Whiteread's casts have become makeshift monuments; Matta-Clark's projects resist commemorative projection.[28]

Take, for example, *Conical Intersect*. Countering the monument, this building cut played out Matta-Clark's true sculptural vision. At one stroke, this work sought to disturb the built environment and to expose the illusion of collective identity. Like Whiteread's *House, Conical Intersect* was made out of a condemned building (near the construction site of the Beaubourg in Paris) — but it functioned differently from Whiteread's foreclosure. Both *Conical Intersect* and *House* commented upon the impermanence of the cityscape, but only Whiteread's project spurred on the desire to ground a collective in the built environment. Cutting a large hole into a dilapidated building abutting the condemned markets of Les Halles, Matta-Clark testified to the fragile tenancy of the community tradition. He showed it to be dispossessed, demoded. Lee has accurately designated Matta-Clark's viewership as a "workless community."[29] To address this anomic public is to obviate the cooperative work of mourning that inheres in Whiteread's *House* project and that which unfolded from it. *Conical Intersect* deconstructs the notion of shared identity; the viewership it constitutes is empty and alienated. Against this, the reception of *House* discloses the intractable desire for the collective. It summons forth the same enabling fiction that Matta-Clark puts into question.

Obstinacy

The persistent longing for solidarity that manifested in the *House* project had already been located and assessed by Negt and Kluge in their work on mourning and industrial society. In *History and Obstinacy* (1981), the Marxist critics excavate the borders between the individual and the collective, the political and the psychic, in search of the channels through which social change might be effected. This massive work combines to offer a political economy of labor power that extends out of their earlier collaboration, *Public Sphere and Experience*. But *History and Obstinacy* sustains little of the first project's affirmative charge. Instead it comes across as a residue of the "German Autumn" — the somber season of conservative consolidation that followed the defeat of German radicals in the late seventies.[30] The three volumes of *History and Obstinacy* cover the topics of industrial dispossession and the potentials of collective

labor, but they also make larger claims about the possible links between social revolution and critical inquiry.[31] Composed in Negt and Kluge's signature cinematic style, the project draws all manner of texts into its scope — philosophical discourse, photos of urban waste, and the blueprints of houses; mass media, masterpieces, and myths. In the concluding pages of the second volume, *Deutschland als Produktionsöffentlichkeit* (*Germany as Industrial Public Sphere*), they touch upon two figures cast out of their homes for their insurgence: the "willful child" of the Grimms' fairy tale and Antigone. Negt and Kluge derive critical momentum from the subversive sparks of these two narratives of mourning, dispossession, and destruction.

"The Willful Child" is the shortest and perhaps most horrible of the Grimms' stories. Although it belongs to the *Hausmärchen* (literally, "house-tale") subgenre of fairy tales, it takes on some of the same inverted, *unheimlich* qualities of Whiteread's negative cast in *House*. In its own ghastly way, "The Willful Child" also speaks to the work of mourning.

The Willful Child

Once upon a time there was a child who was willful, and would not do what its mother wished. For this reason, God had no pleasure in the child, and let it become ill, and no doctor could do it any good, and in a short time the child lay on its death-bed. When it had been lowered into its grave, and the earth was spread over it, all at once its arm came out again, and stretched upward, and when they had put it in and spread fresh earth over it, it was all to no purpose, for the arm always came out again. Then the mother herself was obliged to go to the grave and strike the arm with a rod, and when she had done that, it was drawn in, and then at last the child had rest beneath the ground.[32]

The obstinate child of the Grimms' literary imagination is the namesake of *History and Obstinacy*. Just as Negt and Kluge seek to harness some of the child's intractable qualities, they also try to derive a lesson from its dreadful fate, a lesson that persists into the postindustrial age. Even though God strikes down the unruly child, it remains defiant after death, sticking up its arm out of the grave. The child's "bodily member" ("Glied") becomes a metonymy for the members of society ("Glieder der Gesellschaft.")[33] For Negt and Kluge, the headstrong child embodies the transformative potential of the collective workers *(Gesamtarbeiter)*, who have developed critical faculties over the course of history. Like the child, the collective is driven by the same stubborn will to command its fate, to be fully aware of history.

Within Negt and Kluge's work, the word *Eigensinn* conveys a number of different meanings. It lends itself to be translated not only as "obstinacy," but also as "autonomy," "self-will," and "willful meaning." Each of these terms modify Negt and Kluge's concept of "labor capacity" *(Arbeitsvermögen)*, and — to a great extent — are equivalent with one another.[34] Especially in this section of *History and Obstinacy, Eigensinn* stands in contrast to the term *Enteignung* — dispossession or expropriation. Negt and Kluge see the willful child as the incarnation of the historically dispossessed classes. Undead, the child threatens to return again and again, and in the end must be brutally subdued by the mother.

Like the Grimms' willful child, who, one could argue, is gendered as a girl (the neuter pronoun, *es,* stands in for both *das Kind* and *das Mädchen*), the Greeks' Antigone remains stubborn to the end. But the wider frame of the Sophocles drama gives Negt and Kluge the occasion to make more incisive claims — not just about the nature of obstinacy, but about the way it punctuates collective history, as well. Antigone endures as the ethical figure who insisted on properly mourning her brother Polyneices, a traitor to the crown. Recounting her fate, Sophocles dramatizes the conflict between family and state, between public and private — a conflict that continued to resonate in Hegel's ethical treatise "Human and Divine Law: Man and Woman" in the *Phenomenology of Spirit.*[35] Antigone's obstinacy becomes a transgression against the law and leads both to her banishment from the city of Thebes and to her death. What matters with regard to the question of the house of mourning is this: in *Antigone* and "The Willful Child" Sophocles and the Grimms render the trauma of dispossession through the destruction of a home, through the ruin of a way of life. The child's disobedience brings on the curse of a fatal illness that will ultimately expel it from the family domain and into the grave. Antigone's insubordinate act warrants the dual penalties of forced exile and a death which, despite its ethical integrity, is no less grim. But Negt and Kluge want us to consider the deliberateness of Antigone's choice and its implications for historical consciousness. She insists on the absolute value of her brother's life and the basic dignity of mourning his death. Heeding this duty, she chooses her own death; she lets herself be buried alive or, in Negt and Kluge's words, she lets herself be "walled in" ("[sie läßt] sich lebendig einmauern").[36] Thus, Antigone's act is at once both a destruction and a reconstruction. Defying the Theban legal structures that were framed to protect her, she effectively tears down her house. And, at least performatively, she lays the path for her own exodus.

Antigone's grave would be no mausoleum or proper tomb. As an enemy of the state, she, like Polyneices, would be divested of the right to a proper burial. This is not all she forfeits. As a criminal, she is denied both the prospect of marriage and the legal status of a Theban woman, which is conditional upon a matrimonial bond.

No funeral hymn; no marriage music;
No sun from this day forth, no light,
No friend to weep at my departing. (*Antigone* 880–82)[37]

Renouncing both her funeral and her wedding, Antigone unfixes her femininity. Once she is condemned to a profane and solitary death, only the trace of her own mourning work remains legible.

Negt and Kluge and, more recently, Judith Butler emphasize the sexual politics that charge Sophocles' drama of mourning.[38] Contravening the law that would define her as a subaltern, Antigone undertakes a class action for others who have been subjugated. Yet these "feminist" gestures have little meaning outside the collective. More precisely, the feminine charge of this intransigence ("weiblicher Eigensinn") only adds traction to the resistant force of the dispossessed.[39] Antigone forsakes and forecloses "the walls of marriage" ("die Mauern von Ehen"), but only for the higher purpose of publicly commemorating her brother's death. Looking back, for a moment, to "Mourning and Melancholia," Antigone's rites terminate the cycles of melancholia that Freud diagnoses as pathological; they block the return of the dead and bury them for good. It is this blocking that the mother of the willful child fails to achieve in the Grimms' tale. As Negt and Kluge make clear, obstinacy lives on underground as collective memory, where it threatens to seize into melancholia. Death alone will not stay these ghosts. They can only be laid to rest through communal rituals of reconciliation.

The foreclosure of Whiteread's *House* invited a mournful response. Had Whiteread substituted a monument for the Grove Road house, she might have beckoned melancholic investment — the sort of crushed affect against which Negt and Kluge warn us. Instead, she marked out the voids of the present. Viewers projected symbols of their loss onto the space that she cleared. So here we see that the symbolic activity of mourning may be interminable (the subject may not ever really dissolve his or her link to the lost object), but still it remains possible to delimit this impossibility itself. *House* enacts a cut or

separation—not from the object, but rather from the circuit of mourning in which a phantasmatic afterlife of that object could be sustained. *House* opened the ground for an inquiry into the upstairs-downstairs, inside-outside politics of the social being. Who labors to build and maintain the spaces in which we live? Who takes these buildings apart? Who masters and possesses these houses and who is cast out? In the public response to *House,* the work of mourning appeared not as resignation to loss but rather as fidelity to an ideal. The vision of a working collective that loomed up in the wake of the cast's destruction may be illusory. But such illusions should be accounted for—if not by art historians, then by other critical minds.

House resonates deeply at the interface between public and private memory, yet it also moves the viewer from material to memory, from site to sight, and so registers accurately and profoundly as a work of visual art. It is at this juncture that the structural displacement of *House* outdoes Sophie Calle's reflections on postcommunist cultural dispossession in *The Detachment.*[40] Whereas *The Detachment* endeavors to oppose absence to a given material object (say, a Lenin statue), *House* reveals something entirely different. Absence, for Whiteread, does not oppose materiality, but is rather embodied in the presence of a given object. *House* gives body to loss.[41] Like her other sculptures, it testifies to the work of mourning. The negative surfaces of Whiteread's casts enable the viewer to invert his or her perspective, to cut from center to margin, to see from the position of the other. Whiteread's recent insight on *Ghost* expresses this operation. Looking at her sculpture, she stepped out of her own subject place for that first, uncanny moment.

While I was making [*Ghost*], I was just seeing one side at a time. I then took all the panels to my studio and fixed them to a framework. When we finally put the piece up, I realized what I had created. There was the door in front of me, and a light switch, back to front, and I just thought to myself: "I'm the wall. That's what I've done. I've become the wall."[42]

This parallax—essential to Whiteread's casts—aligns with the principles of mourning. To mourn is to see the other as a separate but equal subject. To see the dead as having been already lost to us, even when they lived. To release the other as an object.

Lacan approaches this ethic of mourning in the *Hamlet* lectures: here, the mourning subject must see the other "on the outside," separate from himself.[43] Freud, too, struck upon this principle, twelve years after publishing

"Mourning and Melancholia." In a letter to his grieving colleague Ludwig Binswanger, Freud concedes that, although the most acute state of mourning will eventually subside, a mourner can never be consoled, for he will never find a substitute for his loss:

No matter what may fill the gap, even if it be filled completely, it nevertheless remains something else. And actually this is how it should be. It is the only way of perpetuating that love which we do not want to relinquish.[44]

Whereas the melancholic remains fascinated by a picture of the past, the mourner imagined in "Mourning and Melancholia" reduces the lost object to its signifier. The subject pays respect to this loss through the symbolic rituals of mourning. Yet, as Freud intimates in his letter of condolence, neither of these conditions are truly adequate in the wake of real loss. The fidelity to which Freud alludes in this passage is what Lacan would have called the impossible kernel of the object — that which was in the (lost) object "more than the object itself."[45] Here, however, we approach a blind spot in Lacan's theoretical imagination. Although Lacan does posit that the mourner should merely encircle the resistant core of the lost object, his vision remains a tragic one: the ultimate act entails accepting that nothing can refill the void — no image, no ritual.

Whiteread's casts point beyond the horizons of Lacan's *Hamlet* lectures. By describing the voids of what remains, *House* resisted the drive to document the past. Against the trajectory of historicism, the *House* project disclosed the redemptive potential embedded within the most obstinately inaccessible moments of history. Enlisted as a work of mourning, *House* cannot be accounted for in terms of nostalgia for either the welfare state or working-class consciousness. Rather, it breaks down into a negative map of the prospects that the purportedly posthistorical and outright postideological present threatens to obscure. Today, when the futurological subsumes the future, fidelity to the past at its most intractable is the only way toward a tomorrow that is not simply "more of the same." Our desire gathers force at the limits of mourning. Here we long not for some paradise lost, but for the open struggles and uncertainties of history itself.

5. Melancholia

"What I never had is being torn from me. What I did not live, I will miss forever."[1] With these lines from his poem "Das Eigentum" ("Property"; 1990), Volker Braun touches upon the melancholia that has attended the disintegration of the German Democratic Republic. The GDR once prided itself as the world's tenth strongest economy, but following the *Wende* of 1989, most of its industries were decommissioned, and large masses of workers have found their careers put on hold. The euphoria at the opening of the Berlin Wall dimmed within a few months, and a pall seemed to set in over the new Germany. Although most Europeans acknowledged that the GDR had no real future to promise its citizens, some wondered what had been forfeited with the second world. Braun renders this predicament in the paradox of "Property": what the collapse of communism ruined was a possible past that no one ever really had in the first place.

In 1996 Judith Kuckart wrote and staged *Melancholie I, oder Die zwei Schwestern (Melancholia I, or The Two Sisters)*, a drama that undertakes to diagnose the condition described in "Property." *Melancholia I* premiered at the Berliner Ensemble, the theater founded by Bertolt Brecht and later directed by Heiner Müller. For this production Kuckart fast-forwarded figures central

to the historical avant-garde — Lili Brik, Elsa Triolet, and Vladimir Mayakovsky — into the chaotic cityscape of postunification Berlin. The drama renews the convulsive frisson of surrealism and marries it with the specters of communism. Cutting into the scenes that dramatize the heady days of revolutionary anticipation are interludes of postcommunist disillusionment and, in the end, moments of despair that tilt toward suicide. In one early passage an aging and apparently unemployed couple from the depressed city of Magdeburg sits near a new department store, plastic shopping bags by their feet, and waits for a tram. "So where are the Russians?" the woman asks the man. "Didn't there used to be a red flag hanging there?" No response. She takes up a new tack: "Where did you lose that?" Again no response. What thing is "that"? Soon it appears that the woman herself does not know after what she is asking:

She: I would have seen it there when I was leaving.
He: What?
She: Your thingamajig.
He: So what.
She: But I didn't see it.
He: Where?[2]

The Magdeburgers' confusion about what is missing marks them as melancholics. Freud maintains that the melancholic grasps his condition "only in the sense that he knows *whom* he has lost but not *what* he has lost in him."[3] This is the case both in Braun's poem and Kuckart's drama and perhaps in ex-GDR visual culture as well. The incoherence that manifests at the moment of depressive collapse can be expressed in these terms: "before knowing what is missing, I know that I am missing 'I know not what.'"[4] "Your thingamajig," the woman from *Melancholia I* calls it; *dein Dingsda,* in German. The thing at hand eludes her attempts to designate, to concretize.

The amorphousness of the Magdeburgers' loss lends this scene its complexity and significance. In "The New Opacity: The Crisis of the Welfare State and the Exhaustion of Utopian Energies," Jürgen Habermas identifies this sort of uncertainty as one of the traits that defined European cultures on both sides of the Iron Curtain as early as the 1980s.[5] The disorientation occasioned by the socialist crisis has, in part, induced the memory fever that has spread across Germany. Where many would ask why the past obsesses Germans, *Melancholia I* reframes the inquiry, asking what Germans imagine themselves to have lost, and how they imagine they lost it.[6] The difficulty of

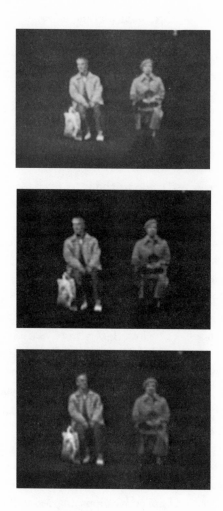

5.1–5.3 The Magdeburgers, *Melancholie I, oder Die zwei Schwestern (Melancholia I, or the Two Sisters)*, Berliner Ensemble, Berlin, dir. Jörg Aufenanger, 1996 (photo Florian Zeyfang).

naming this object— suggested by the Magdeburgers in their obtuse
exchange — is a symptom of postcommunist melancholia.

Kuckart's drama enters into a larger conversation about how to commem-
orate the passing of the second world, a conversation that is composed of not
only melancholic voices, but also mournful and nostalgic ones. After the
Wende this dialogue was stimulated in the fields of both literary and visual
culture. Andreas Ludwig founded the Open Depot, a museum of GDR life.[7]
French artist Christian Boltanski provisionally mobilized the relics of Berlin's
recent past in his 1994 installation *Ost West (East West)*. But the dialogue had
already been initiated before the workers' republics of Eastern Europe broke
down. In 1980 Joseph Beuys, a West German, precipitated the race to curate
the GDR past with *Wirtschaftswerte (Economic Values)*—an assemblage that
combines products from the "people's own industries," or *Volkseigene Betriebe,*
with a small sculpture he had made around 1970. Read together, these works
chart out three modes of memory across the temporal divide of the *Wende:*
mourning, melancholia, and nostalgia.

The lost objects of the GDR afford us a perspective on each of these
mnemonic moments. The melancholic, the mourner, and the nostalgic each
relate to the object in a distinct way. The mourner can name the loss that stuns
the melancholic. The nostalgic, as we shall see, disavows the loss altogether.
Each subject makes a different claim on his loss. Of the three, it is really only
the mourner who can speak of a lost object *as an object.* The melancholic
and the nostalgic remain fixated on *things* that are not entirely separate from
them.[8] Andreas Ludwig, the curator of the Open Depot, maintains that he
knows exactly what is being lost in the process of German unification: the
material residues of "real existing socialism." The puttering, but reliable Tra-
bant automobile. Quick-cooking Tempo Peas, formulated for the working
mother. Grids of prefab apartment blocks that radiated ever further from
industrial centers from the 1950s to the 1980s. His exhibitions catalogue and
display these artifacts, and so document the everyday life of East Germany.
His museum offers a place of collective mourning, a site where visitors can
take leave of the second world.

Christian Boltanski's installation *East West* included many of the same
objects curated by Ludwig— the mementos and dejecta of the once-divided
city's material culture. As part of the exhibition series *en passant,* held at the
former House of Young Talent in Berlin's Mitte district, the French artist
invited Berliners to lend him relics of seventies' youth culture. Before this
project Boltanski had long been concerned with mourning; in his earlier

5.4 Christian Boltanski, *Ost West (East West),* 1994, detail from *West.*

works the "death" of childhood functions as a universal trope for other kinds of loss. (Consider *Tout ce qui reste de mon enfance* [1969], *Autel de Lycée Chases* [1988], and *Les Suisses morts* [1990]). In *East West* Boltanski used this material language to mark the passing of postwar Berlin's twin adolescences. Separate vitrines housed the juvenilia and related ephemera for a few weeks; then the objects were returned to their owners. Although similar finds turned up on both sides of the installation — snapshots, drawings, barrettes, and pencil cases — other contents reinscribed Berlin's polar differences. "East" contained Young Pioneer and Free German Youth badges, a menstrual chart, and a hand-drawn portrait of Engels. "West" held vinyl records from Kiss and Pierre Bachelet, Bible stories, and a sticker with the words "Atomic Power, No Thanks." Boltanski easily could have given in to the sentimental undertow of these belongings, as had been the case in some of his earlier works. But here his selection of objects short-circuited nostalgia into the larger work of mourning for the defects of the two Germanies. A slip from the GDR State Bank declared the ban on exporting currency, and harked back to the regime's xenophobic insularity and tight control of travel. In the "West" vitrine, the cover of the 1979 "greatest guide for girls" revealed something of the West's sense of self-righteousness and privilege. Its title — *My World*. Ludwig and Boltanski both reinforce the limits between subject and object, and so place their found objects at one remove from the realm of things. Whereas the Open Depot maintains the distinction between the "then" of the so-called *Ostzeiten*, or Eastern times, and the now of the new Europe, *East West* attested to the distinct memories of postwar Berlin's two adolescences. In the post-*Wende* press to unify Germany, both of these projects enable the viewer to enact the tender rejection of mourning.[9]

Left melancholy

The Belgian curator Jan Hoet strongly favored *Economic Values,* and acquired the assemblage for the permanent collection of the Museum of Contemporary Art in Ghent, which he runs. When Hoet was artistic director of the FRG's Documenta IX in 1992, he used *Economic Values* to catalyze the international exhibition. This was the first Documenta to be held after German unification. Hoet organized the event around the theme of collective memory and ran it as a kind of conceptual lost-and-found department for the remainders of socialism. The exhibition and the catalogue essays reveal a certain nostalgic disappointment with the outcome of the *Wende*.[10] Like the bewil-

5.5 Christian Boltanski, *Ost West (East West)*, 1994, detail from *East*.

dered Magdeburgers in Kuckart's drama, Hoet seems overcome by the notion that something was lost in Europe's transition from a divided continent to a single market — something more than the Trabant automobiles and Lenin statues, more than employment guarantees or the threat of environmental ruin. What was the other Europe?, Documenta IX asked. To this we might counter, why might some Westerners have grown dependent on the notion that there exists some "elsewhere" beyond liberal democracy?

Although Beuys enjoyed a reputation as a defender of social justice and an insider of left-oriented political movements such as the Green Party and several other socialist initiatives, he spent little time in the Eastern Bloc. For *Economic Values* he relied on colleagues to ferry GDR products to his studio. From a massive collection of donated wares, Beuys selected only those that looked the most superannuated.[11] He passed over wares that evidenced the traces of sophisticated Western marketing strategies in favor of those packed in coarse, unbleached paper, printed with a single color, or perhaps two. Scant ornamentation illustrates the labels. In some cases all that is written is the name of the good — "Millet" or "Honey." In an interview, Beuys characterized the design of the products he displayed as that of *Behelfsverpackung* — the provisional or makeshift packaging used in situations of duress, such as those produced for military and relief operations. (Well before conceiving *Economic Values,* Beuys had created works that spoke of the need to heal Germany's wounded postwar civilization, but none of these had identified Eastern Europe as the agent or accomplice of such a recovery. Consider *Stuhl mit Fett* [1964] and *Das Rudel* [1969].) In *Economic Values* his selection process rendered the wares not as found objects but as poor things, that is, as examples of *die Reste,* or "remains," that many saw as integral to East Germany during the Cold War. To such minds the letters DDR did not signify the *Deutsche Demokratische Republik,* but rather *der dumme Rest:* the meager remainder of Germany's division.

Beuys set out his goods as melancholy reminders of the other Europe. Like a mourner's relic, these things, in themselves, are only trivial remainders, almost absurd. Yet they are not relics. Beheld by a mourner, a proper relic takes on a specific meaning. It is instilled with the power to signify the death of a loved one and, moreover, to ward off his return. An authentic relic, Pierre Fédida speculates, cannot be thrown away. Because it can no longer circulate in an exchange economy, it also cannot be substituted by some other object (as is the case in Beuys's work). Depleted of use value, the relic reminds the mourner of his power over the dead.[12] It fends off anxieties of death and the "ne plus" ("no longer") that awaits mortals, Fédida argues, keeping at bay any

5.6 Ankerplast bandages.

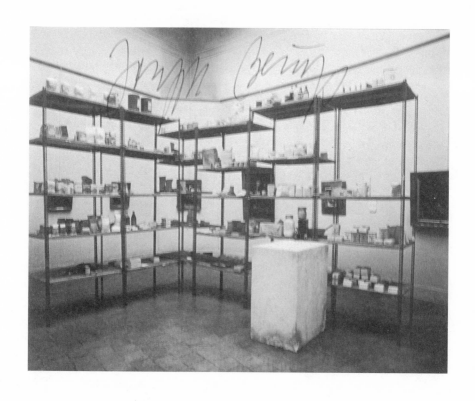

5.7 Joseph Beuys, *Wirtschaftswerte (Economic Values),* 1980. © 2002 Artists Rights Society (ARS), New York/VG Bild-Kunst, Bonn.

haunting visions of rot. This reliquary logic defines and legitimates the bequest of possessions from generation to generation: since the mourner can only appropriate the property of the mourned if he really *is* dead and gone, the relic's delivery marks the passing of time. *Economic Values* has little to do with the task of laying something to rest, however. Since Beuys's knowledge of these wares is secondhand, his installation does not preserve them as relics but rather fashions them as false souvenirs. To mourn, Freud argues in *Totem and Taboo,* is to kill off the dead: *"die Toten töten,"* as Fédida puts it in *La Relique et le travail du deuil.*[13] If the nostalgic takes something from its rightful owner, leaving him in the lurch, then the mourner strikes the final blow.[14] This distinction lays plain the difference between *Economic Values* and the Open Depot: if Beuys is a thief, Ludwig is a mercy killer.

Neither a thief nor a killer, Judith Kuckart is rather a borrower of sorts: she takes the title of her play from Albrecht Dürer's engraving *Melencolie I* (*Melancholia I; 1514). Like Dürer's icon, Kuckart's *Melancholia I, or The Two Sisters* reveals the affirmative traits of introspection and tranquility that, before Freud's time, were imagined to characterize the melancholic.[15] Indeed, the figure of Melancholia — as wingèd genius, as muse — has captured the attention of many thinkers. As Julia Kristeva maintains, this duality of melancholia presents a productive paradox contradiction: "if loss, bereavement, and absence trigger the work of the imagination and nourish it permanently as much as they threaten it and spoil it, it is also noteworthy that the work of art as fetish emerges when the activating sorrow has been repudiated" (*Black Sun* 9). Out of melancholia can come the making of art. Kuckart's temperamental Elsa Triolet character forges her writing in resistance to the melancholic mantle that would silence her voice. As *Melancholia I* takes up the antinomy described by Kristeva, it spans the distance between Beuys's nostalgia and Ludwig's mourning. Kuckart summons forth the erotics latent in Dürer's masterpiece. She sees Melancholia as a figure caught up in the dialectics between memory and love.[16]

The margins between melancholia and nostalgia are fluid at times, as some cultural critics have pointed out. Walter Benjamin is one example. In his 1931 essay "Linke Melancholie" ("Leftist Melancholia") Benjamin inveighs upon the writings of Erich Kästner in order, on a wider scale, to denounce the indecision and sloth that appeared to beset intellectuals in the 1930s — an epidemic, he contends, that produced fashions instead of schools, cliques instead of parties, and agents instead of producers.[17] The leftists of Kuckart's *Melancholia I* seem to succumb to the same malaise when they withdraw from the revolutionary front. Although Benjamin himself was a Marxist with melancholic

5.8 Albrecht Dürer, *Melencolia I (Melancholia I)*, 1514, engraving.

proclivities, in this essay he suggests that the left's fixation opposes "authentically" revolutionary longing. The radical gaze cast backward onto past failures and traumas is not retrograde, but rather promises redemptive hope. Benjamin's indictment of Kästner's writing could be extended to Beuys's nostalgia trip. Both Kästner and Beuys reduce revolutionary resistance to so many curios.

Helmut Dubiel picks up where Benjamin left off in "Leftist Melancholia." In his 1990 article "Linke Trauerarbeit" ("Leftist Mourning") he criticizes leftist intellectuals, particularly those from Western Europe, who cannot properly mourn the regime's collapse because they continue to romanticize the image of state socialism, even after 1989.[18] Although few Westerners had accurate impressions of life under socialism, Dubiel argues, they remained dependent upon the notion that there should exist some alternative to liberal democracy, some third way. Kuckart locates this idealized image of the East not only in contemporary culture, but also in the first decades of the twentieth century, when the surrealists translated the *Communist Manifesto* into their own idiom of subversive intent. In Scene 1 of *Melancholia I,* Elsa Triolet recalls the political and erotic energies that lay deep in the cultural divide between the concept of "Paris" and that of "Moscow." As a Parisian with strong connections to the East, Triolet knew that her reputation as "the chic Russian revolutionary" afforded her great social leverage. She claims to have used the "bait" of Stalinism to lure Louis Aragon's love. The couple won envious admiration; their liaison was "a monolith"—all the rage among Parisians who preferred to regard revolutionary action from a comfortable distance. For the radical chic, the revolution was something to be looked at ("Come on, we're going to watch the revolution"), not something with which to engage. Only when some gap — either temporal or spatial — intervened would the revolutionary project maintain its aura. Triolet asserts this in Scene 9:

Up close the revolution looks—unpleasant. Yes, unpleasant, if I say so myself. But from a chaise longue in Paris, the revolution is an Event, a Sensation, a splendid aesthetic feeling that arouses you. Aragon, play along!

Whence comes the appeal of revolutionary action? Triolet knows: the revolution is a lover whose absence makes the heart grow fonder.[19]

Beuys's gaze eastward takes on a more morbid cast. A study of loss, *Economic Values* remains a sullen warehouse, bereft of any compelling historical

5.9 Elsa, Lili, and Mayakovsky, *Melancholie I, oder Die zwei Schwestern (Melancholia I, or the Two Sisters)*, Berliner Ensemble, Berlin, dir. Jörg Aufenanger, 1996 (photo Jonas Maron).

narrative. Beuys's fetishization of the GDR is part and parcel of his artwork's disavowal of real history.[20] It is not that Beuys refuses to acknowledge the failure (then in progress) of the regime that produced the wares he installs. In actuality he accepts this failure, this loss, so wholly that he remains attached to the GDR not *in spite of* its failure, but *because of* it. This accords with the matter of preservation and decay that Beuys articulates in *Economic Values*. Over time, the contents of the packages he had collected began to spoil or slowly disappear, often as a result of pestilence. Beuys's colleagues note that the products' ostensible purity delighted him, since it affirmed that they had not been treated with preservatives. The packaging proved nearly as evanescent, quickly fading and disintegrating, even in the carefully controlled museum climate.

As a measure of conservation, Beuys replaced the packages' contents with more durable mixtures of sand and chalk that preserved the impression of weight and volume within the wrappers. Forestalling sedimentation, *Economic Values* holds its objects deep in its heart, where they seem both to live and to die, just beyond the edge of time. The dust gathering below the packet of peas takes on a life of its own, making the work immortal in its own death, emanating like a halo of decay.

Economic Values sets the accent squarely on the "Easternness" of the found objects Beuys selected.[21] To Western eyes (to date, the piece has been exhibited only in Western Europe), the assemblage offers a glimpse of what Beuys considered the genuine material culture of the GDR. Perhaps Beuys was aware of the ethnographic risk undertaken in *Economic Values,* for he signals his foreignness to the state socialist world. Into the installation Beuys inserted a piece of his own sculpture, a blocklike plaster cast he had produced in the sixties. Several steps were necessary to integrate the cast with the other elements. Beuys daubed the block's chipped edges with butter in a deliberately futile attempt to repair them. (If anything, the butter would accelerate the sculpture's decomposition, since its lipids would macerate the plaster.) He also marked each element of the assemblage with his own signature and the note "Economic Value 1," thereby elevating each element of the work into a readymade and integrating all the parts into a whole. But these interventions undermine themselves; Beuys's inscriptions partially erase the different histories of the elements. His sculpture, meanwhile, was resurrected from his own warehouse, an archival limbo that he himself had created. By eliding the "origins" of the various things collected, Beuys suggests that both his plaster cast and the (still extant) socialist material world have been disinterred from deep storage. Unlike Lud-

5.10 Joseph Beuys, *Wirtschaftswerte (Economic Values)*, 1980, detail. © 2002 Artists Rights Society (ARS), New York/VG Bild-Kunst, Bonn.

wig, Beuys tries to make the things his own. Unlike Boltanski, he does not return them to the owners, but guards them for eternity.

Beuys emphasized that the apparent simplicity of the goods assembled on his shelves betrays an inner richness and complexity. He links the installation to the aesthetics of *arte povera*, but still it is clear that Beuys imagines *Economic Values* as a bridge to Germany's "lost" other. Key for Beuys was the purported biological purity of the Eastern goods as well as the principles of recycling, which he presumed to motivate the manufacturers.[22] But if these were the only messages he wanted to convey, Beuys need not have procured packages of Eastern provenance. *Economic Values* is not an ecological reflection on the transience of nature. It is about the spoils of state socialism — the idealized Marxist alternative that many, Beuys included, imagined to inhere in the East. Beuys invests in the notion, similar to the radical chic of Kuckart's drama, that there exists some "elsewhere" beyond the Western market. He attempts to critique the FRG's postwar economy, but in the end the installation merely presents another gamut of commodity fetishes. A problem arises with Beuys's handling of the GDR object world. "You never know what you have until you lose it" — this seems to be the thinking of the work. Fixating on loss, Beuys loses his grip on real history, and so loses perspective on what real existing socialism really was.

Arrested development

To left melancholics from the West, the Socialist Bloc seemed a never-never land. Indeed, some Easterners themselves thought they were living in a time warp. But they had a cynical appreciation for the slow tempo of daily life. Heiner Müller was one such East German. A mordant Marxist and admirer of Beuys's work, he once remarked to Jan Hoet that "everything" in the GDR remained in the spell of "a constant state of anticipation." As he put it, East Germans had a "waiting-room mentality":

There would be an announcement: "The train will arrive at 18.15 and depart at 18.20"—and it never did arrive at 18.15. Then came the next announcement: "The train will arrive at 20.10." And so on. You went on sitting there in the waiting room, thinking, "It's bound to come at 21.05." That was the situation. Basically, a state of Messianic anticipation. There are constant announcements of the Messiah's impending arrival, and you know perfectly well that he won't be coming. And yet somehow, it's good to hear him announced all over again. (Müller and Hoet 96–97)

Kuckart's *Melancholia I* picks up on this tempo and conveys the odd rhythms that punctuate the post-*Wende* years. It sets real history against what Kuckart calls "in-between time." Although a good deal of her drama's action takes place in the early decades of the twentieth century, Kuckart's references to contemporary events create a temporal montage, such that the two "ends" of state socialism alternately counter and blend with one another. In Scene 7, set in the Moscow Hotel Lux (the favorite locale of the nomenklatura), one character announces that the drama will undertake a temporal leap *(Zeit-sprung)* into the nineties. Mayakovsky, Triolet, and Brik gather in the hotel lounge with the Magdeburg couple. A life-sized video image of Glenn Gould playing "A Russian Interlude" wanly radiates from one of the walls. Later in the drama, after Mayakovsky commits suicide, he returns to haunt Triolet and mourns the foregone conclusions of the derailed revolution. "It was too late then," he repeats like a mantra. Triolet lashes out at his acquiescence. "What now?" she insists. What to do in this in-between time when both love and the revolutionary impulse of communism seem to have withered away?

The answer, Mayakovsky tells her, is literature. He urges Triolet to find a literary channel for her political (and erotic) energies, much to her chagrin. When she discounts his encouragement as a thinly veiled rejection, Mayakov-sky replies that she can find love through writing: "I am the other side of the things you see, the vines of the tomatoes you eat, the underside of the beds in which you make love, the foundation of the houses you won't build, the cause of your actions. Because you didn't get me." Mayakovsky passes on his writerly bent, bequeathing to Triolet his idioms and cadences.[23] His death becomes a literary, textual impulse. Mayakovsky remains the unassimilable ele-ment after which she longs, the object in pursuit of which she can transgress the confines of melancholia, by writing. In his death, he becomes the absent source and cause of her actions, the impossible target of desire.

Surveying the melancholy time of the post-*Wende* period, Triolet begins to see the necessity — at once aesthetic and political — of contemplating and recording the linguistic changes wrought by the new Germany's transforma-tion. For a moment, Kuckart puts Triolet in the same position as the feminine subject of Dürer's *Melancholia I*. Head tilted, Melancholia's posture connotes that she is actively occupied with thoughts. Whereas Dürer captures a moment of absolute stillness, stopping time — the bell's clapper hangs straight down, the scale has found its equilibrium, the hourglass has come to rest — Kuckart's in-between time overlaps both the stillness of this engraved world and an as yet unknown future for Germany.[24]

5.11 Elsa reclines, *Melancholie I, oder Die zwei Schwestern (Melancholia I, or the Two Sisters),* Berliner Ensemble, Berlin, dir. Jörg Aufenanger, 1996 (photo Jonas Maron).

At the end of *Melancholia I* we both grieve Mayakovsky's suicide and see redemptive hope in Triolet's writing. This crossing of the threshold between mourning and melancholia recalls Benjamin once again: not the Benjamin of "Leftist Melancholia," but rather the one of *The Origin of German Tragic Drama* (1928) and the "Theses on the Philosophy of History" (1940).[25] True melancholy does indeed slacken and linger, but, arrested by this delay, Benjamin suggests, it promises both occult and allegorical insight. In Kuckart's drama, Triolet pauses in this depressed time, at once heavy-hearted and spiritually empowered. Recognizing that she never has (or could) possess Mayakovsky, she sets herself the task of writing her desire, and so moves on. Through literature, she releases the melancholy thing that interrupted desiring metonymy.[26]

Falling for it

Melancholia is something like lovesickness, Freud notes in "The Psychogenesis of a Case of Homosexuality in a Woman" (1920). Falling in love, the subject falls into the object.[27] At the bottom of his subjective dive, the melancholic marries death, his one true love.[28] In *Melancholia I* Kuckart stages two suicides and so traces out this melancholic trajectory. Mayakovsky's enigmatic death in Scene 14, foreshadowed in the beginning of the play, would seem to conclude the drama, but another character upstages this act in the final scene. This unnumbered scene, titled "Echo," concludes *Melancholia I* with a second suicide, one committed by a nameless, faceless East Berliner—a character whom Kuckart presents as a generic victim of postcommunist melancholy. Despite the wide differential separating this anonymous character from the singular figure of Mayakovsky, their lives converge in these acts of self-annihilation. This doubling, in turn, conjoins the two ends of state socialism that Kuckart stages in *Melancholia I*. Indeed, the dramatic tension of the play is suspended between these two deaths.

If the question as to what pushed Mayakovsky to take his life is left open, the second suicide in *Melancholia I* posits a more resolute explanation. A crowd of speakers recount the fatal fall:

—We walked over dismembered parts. On the way to Track Three.
—He wasn't old at all.
—Definitely unemployed.

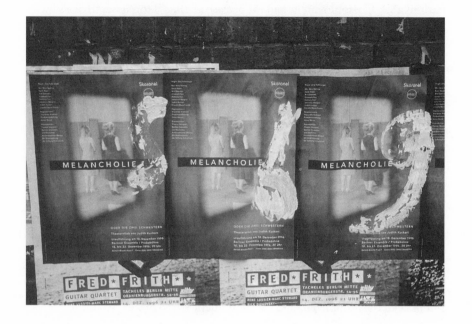

5.12 *Melancholie I* poster, Berlin.

—Out of lovesickness? You think so? No, I don't believe it.
—Not here in the East.

In this case, suicide on the grounds of romantic disappointment would be unthinkable. Unemployment and the sense of being "a foreigner in one's own country" would more likely lead a young and able-bodied person to ruin.[29] Strangers to themselves, Eastern Germans have been disenfranchised of their national ideals, and are left to sort among the fallout of the GDR.

What remains of the utopian imagination that sparked state socialism? We can credit Beuys, like Ludwig, for attending to a microhistory that was a critical element of European modernity. But the lesson of Beuys's *Economic Values* is that interest in this legacy can easily degenerate into idealization or morbid fascination with failure itself. *Melancholia I,* meanwhile, avoids the traps of nostalgia, but still defends the utopian impulse that fueled socialism. Kuckart's melancholia attests to both the losses of the second world and the dejection of the post-*Wende* present. Part of the politics of collective memory, the problem of historical remains is hardly unique to contemporary Berlin. Indeed it already festered in Paris in the early 1870s, during the same period when Bismarck first unified Germany. The Communards set out to remove the Vendôme Column from the center of Paris and to install it in a museum. But instead they toppled it, and the monument fell to pieces. With the collapse of communism, we come full circle. Shards of the revolutionary past file into the museum and onto the stage, where they flare up in memory, throbbing like phantom organs. Perhaps this persistence of the past resists the entrenchment of "posthistory." Perhaps it harbors a latent, utopian desire, a refusal to accept the fait accompli of late capitalism as the only imaginable frame of our world.

6. Disavowal

If, in the Cold War imagination, there were an emblem of the German Democratic Republic, it would be the Berlin Wall. And if there were an author whose work might be considered emblematic of East German literature, it would be Christa Wolf. Yet it is only in Wolf's last novel, *Leibhaftig* (*Incarnate;* 2002), that the Wall first figures explicity. In all her previous writing the barricade was an unspeakable thing. Although the division of Berlin prompted the author to write *Der geteilte Himmel* (*Divided Heaven*) in 1963, in this early novel she strategically avoids any direct reference to the events of August 1961. More than forty years after the building of the Wall and more than a decade after its dismantling, it would be easy to cite Wolf's blindspot in order to dismiss her work. Yet to do this would obliterate Wolf's unique perspective on the politics of memory that have, to a great extent, come to define current German thought. For contained within the politics of memory are the ciphers of disavowal. Indeed, few authors can offer a closer reading of these codes than Christa Wolf.

Although Wolf circumvents the blocking of the German-German frontier, this event haunts every page of *Divided Heaven* and provides a framework for the narrative through its conspicuous absence. Much of Wolf's writing

organizes itself around the tropes of walls and borders — their erection, their destruction. The political dimension of this trope is crucial to understanding not only her early works, but also those most recently produced. In terms of genre, Wolf engineers the narrative of *Divided Heaven* according to the aesthetic and political constraints of the socialist realist *Ankunftsroman,* or novel of arrival to conscious maturity. What happens when this conceptual matrix collapses? In *Incarnate* and *Medea: Stimmen* (*Medea: A Modern Retelling;* 1996), the narrative grid that structured *Divided Heaven* dissolves into a mesh of voices. Reading these three novels together, we can discern the conceptual and formal tensions that charge Wolf's most important post-*Wende* essays in *Auf dem Weg nach Tabou* (*Parting from Phantoms*; 1994): the dynamics not only between truth and disavowal, but also between knowledge and belief, fact and fiction.

Of the works examined in this study, Wolf's most closely follow the contours of second world culture. Her elaboration of literary subjectivity took form according to the constraints, on the one hand, of the GDR's official ideology of women's emancipation and, on the other, of state socialism's drab, workaday reality. Until 1989 Wolf published most of her work under the aegis of the GDR's Ministry of Culture. Not only did she write — especially in the first decades of her career— primarily for an audience of East German readers, she once sought election to the Party's Central Committee.[1] As a public intellectual, Wolf has been profoundly influenced by East German history. A "national author," she both enjoyed many privileges and endured state surveillance by the Stasi. Then, in the early nineties, just after she published "Was bleibt" ("What Remains"), an essay chronicling her years of observation, journalists uncovered documents proving that Wolf herself had collaborated with the same intelligence agency in the late fifties and early sixties.[2] While the mass media took this revelation as a cue to pursue a veritable witch-hunt, scholars and critics conducted their own subtle but thorough denunciation. Post-*Wende* shifts in German culture have tagged Wolf's work as the literary equivalent of a factory reject. This chapter passes her writing back through inspection — in search of as yet undetected qualities, in search of a critical supplement to Europe's first-world consensus of complacency.

Picture two scenes from the 1964 film *Divided Heaven,* based on Wolf's novel and produced in collaboration with her.[3] In the first scene, a factory organizer exhorts his collective to increase production. The face of one worker, Rita Seidel, hovers in the immediate foreground. Although her features are too

close to be clearly discerned by the camera, Rita's blurred head blots out part of the scene unfolding before her. In the second scene, one of the last in the film, Rita stands out in sharp focus, as a train whirs behind her. Like the film, the novel *Divided Heaven* both tells a story about the summer of 1961 and chronicles Rita's journey from the blurred margins of girlhood into the purported vanguard of socialist progress. Heeding the imperatives of industrial labor, Rita finds her place within the plans of the collective. The shift from blur to focus directs *Divided Heaven* to its prescriptive conclusion that real socialism could only thrive within the grid of the Eastern Bloc. At the same time, however, this shift also disavows what Wolf seemed to suspect already in this very early novel: to bring one figure into focus is to let another fall out of the picture. Wolf's optic can capture either the individual or the collective, but not both.

Divided Heaven climaxes in the summer of 1961 when Rita faces the decision of whether to join her fiancé, Manfred, in crossing the border to West Berlin at the Friedrichstraße checkpoint. She chooses to return home but, back in the factory, she suffers the full force of her decision to break off her engagement. When two railway cars race toward her, she faints in a moment of suicidal despair and falls onto the tracks. Since Rita's blackout happens when the Wall goes up, it allows her to conveniently exit from the political crisis.[4] By the time she regains consciousness, the Wall has redefined the Berlin cityscape and instilled itself into the minds of Germans as a symbol of a divided nation, a divided Europe, and a divided memory. This newfound clarity amplifies Rita's senses, such that she can fully perceive a world of contrasts — banks of vivid images that had long been only partially accessible to her. Her recovery consists in seeing her whole world with such precision. She reconstructs an archive of visual data — images that she can categorize and compare with this first, hitherto unnameable, vision. The new lines of political division in *Divided Heaven* parallel and support Rita's new line of sight; things "fall into focus" for her.[5] This refined optical faculty makes her want to see and know more. While still in hospital, she resumes her nightly reading sessions: she begins to take an interest, Wolf writes, "in the efforts of poets to pierce the darkness of things unsaid" (*Divided Heaven* 120). From visual curiosity emerges a literary desire that will beckon her back both to the brigade and to the vocation of teaching, the calling that first led her out of the country and into the city.

Wolf sets out in *Divided Heaven* to illustrate how, in the adversity of the early sixties, Rita, like her fellow East Germans, required both personal and political divisions. To do this, Wolf manipulates two levels of prohibition.

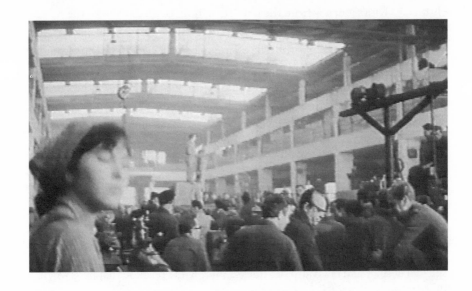

6.1 Blurred Rita, *Der geteilte Himmel (Divided Heaven)*, dir. Konrad Wolf, 1964.

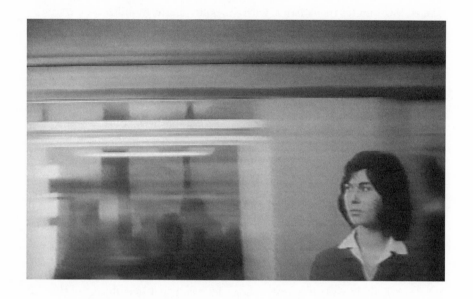

6.2 Focused Rita, *Der geteilte Himmel (Divided Heaven),* dir. Konrad Wolf, 1964.

One is Rita's subjective need for an external agent to stabilize her identity. The other level of prohibition is the GDR's decision to cordon itself off from the West. Only by sealing the passages through which Easterners were defecting to the West could the GDR guarantee its political survival. In *Divided Heaven,* Wolf unites the personal with the political: she mobilizes the traditional, Oedipal scenario of prohibition that secures subjective identity in order to legitimate the erection of the Wall. An exchange between Rita and Manfred signals this most emphatically. To Manfred, the question of division limits itself to national borders; "at least they can't divide the sky," he tries to reassure both Rita and (Wolf suggests) himself (*Divided Heaven* 198). But Rita feels the cut go through to the quick of her consciousness. It exceeds the fields of politics and geography: "The sky? This whole arch of hope and longing, love and grief? 'Oh yes,' she murmured. 'The sky divides first'" (*Divided Heaven* 198). Implicit here is the notion that it was legitimate to build the Wall, because prior to its construction the heavens were already divided. If the differing ideologies of the two Germanies were brought together in a single state, civil disorder would be the inevitable outcome. In other words, only with a divided earth could a divided heaven sustain itself.

The last decades of real existing socialism and the first years of unified Germany, particularly as Wolf narrates them, serve as privileged objects in the study of disavowed political commitment. Indeed, the GDR can perhaps be understood only belatedly, since its culture was the product of two disavowals. First, the state sought to erase the portrait of the fascist follower as the standard image of German identity and inscribe, in its place, the anatomy of the new socialist worker. Then, since unification, Easterners have been urged to efface the troubled socialist legacy, thus further blurring their collective identity. In *Incarnate,* Wolf's second post-*Wende* novel, she makes a belated visit to the last years of duress in divided Berlin. Recounting one woman's protracted hospitalization, Wolf makes illness a metaphor for the breakdown of the second world. The patient's proper name is never spoken, but Wolf invokes her under the sign of the body. She is *leibhaftig,* corporeal, material— a real live human body that registers the GDR's instability. Although the patient is taken to be a writer, her infirmity transports her to a place "where words are not enough."[6] Traversing the borders of consciousness, the dense narrative leads to a field beyond the formulas of *Divided Heaven.*

In her fever dreams the patient rises out of the Charité Hospital and surveys Berlin, opening herself to a cinematic wave of memories. Voices emerge from the past. The protagonist's point of view shifts from the first person

through the second to the third.[7] She passes over the modern ruins of East Berlin and explores the underground labyrinths of Germany's buried past. Her odyssey maps the asbestos-laden Palace of the Republic (built in 1973–74 and "designed for obsolescence" [Wolf, *Leibhaftig* 146]), and excavates the prewar cellars where Berliners hid from both bombs and deportation to the death camps. These moments of structural and ethical failure collapse into one another: the transit point at Friedrichstraße is "a slaughterhouse" (*Leibhaftig* 25); later, in the basement hideaway, she makes a jump cut from the war to 1989 and back again. Underground, the speaker is startled to find a sign that says "ruptured wall": "*MAUERDURCHBRUCH*. A stunned reflex, unnerved: Which wall? But these walls here collapsed a long time ago" (*Leibhaftig* 112). From this interjection of direct address, *Incarnate* moves among various narrative perspectives for the remainder of the novel. This subjective web enables a critical acknowledgment of Berlin's division, for the first time in Wolf's career. When the patient's immune system goes on strike, she is saved by a remedy that comes from the West. A messenger with a permanent visa is dispatched to West Berlin and delivers the crucial drug at the eleventh hour.

Divided memory

Published six years before *Incarnate, Medea* demonstrates the narrative flux of Wolf's last novel, but does not venture into the same arena of political critique. Here a series of voices relates the story. These various narrators —Jason, Akamas, Medea herself— transgress the borders established within realist narrative and thus reinforce the image of collapse as a guiding motif of *Medea.*[8] Recounting her travails between Colchis and Corinth, Medea realizes that she has long defended herself against the doubts that now haunt her memory with a protective barrier or "Schutzwall" (Wolf, *Medea: Stimmen* 35). As she comes to terms with her own past, these barriers become permeable:

We pronounce a name, and—since the walls are porous—we step into her time[. . . . W]e must venture into the deepest core of our misjudgment—of her and of ourselves— simply walk in, with one another, behind one another, while the crash of the collapsing walls sounds in our ears (Wolf, *Medea: A Modern Retelling* 1–2).

Oskar Negt and Alexander Kluge, Wolf's contemporaries, see Medea as a fury who erupts in the liminal space between Colchis, her home, and Corinth, her place of refuge.[9] Wolf concurs. In her own words, Medea stands

as "a woman on the border between two value systems."[10] Wolf gives fresh emphasis to the relationship between Medea and Glauce, King Creon's daughter. Through their friendship, the reader comes to see another dimension of Medea's personality. More than a medicine woman, more than a prophet, Wolf's Medea becomes a veritable hypnotist, a visionary of the past. She encourages Glauce to return to the site of a long-repressed memory: the murder of her sister Iphinoe. Medea explains that Glauce's struggle to bury her memories has only weakened her spirit. Her attempts to "reconcile irreconcilable things" ("Unvereinbares miteinander zu vereinbaren") draw her into the depths of depression (*Medea: A Modern Retelling* 114; *Medea: Stimmen* 151). Disavowal has made her ill.

To identify disavowal as an organizing trope in *Divided Heaven* and, later, *Medea* is to augment Julia Hell's founding psychoanalytic interpretation of Wolf's writing. In "Post-Fascist Body/Post-Fascist Voice: Christa Wolf's *Moskauer Novelle* and *Der geteilte Himmel*" Hell also identifies a constitutive split in Rita's character—a split of gender identifications (Hell 165). Among a range of readings that Hell considers, she ultimately chooses to see the novel "as a response to an unformulated trauma, as the sudden recognition of being firmly inscribed in a specific narrative and locked into its limited subject positions" (183). Significantly, Hell understands Rita's "locked" subjectivity as "hysterical" (183). This premise — grounded in the Freudian concept of neurosis — offers a useful perspective on the gap between Rita's imaginary (feminine) and symbolic (masculine) identifications. But it does not adequately address the dynamics of psychotic disavowal that charge so many of Wolf's works, especially those examined in this chapter. At one point Hell herself acknowledges the potential of a reading of *Divided Heaven* that would privilege the antagonisms between history and memory:

[L]ike many of those committed to the construction of an alternative socialist Germany, Wolf understood the building of the Wall as a means of giving reforms a chance within the GDR, so we might read this beginning—Rita's moment of not-being-conscious—as a stepping outside of the historical continuum (i.e., the GDR's history)[.] (183)

But immediately after opening this avenue of inquiry Hell returns to her line of argument about the novel's sexual politics. Over and against the blind spot of disavowal Hell emphasizes Rita's Oedipal dilemma. Thus, the deeply historical valency of Wolf's writing is only partly addressed. Let's examine the trope of

disavowal to gain a new perspective on the historical antagonisms that charge through Wolf's career— from *Divided Heaven* up through *Medea* and *Incarnate*.

In the early 1920s Freud began to consider the emotional consequences of the sort of split thinking that makes Iphinoe ill in *Medea*. Inquiring into the conditions of fetishism, he surmised that the persistence of two juxtaposed attitudes — what one believes against what one knows — exerts an enormous and even devastating impact on psychic life. In *An Outline of Psychoanalysis* (1940), Freud theorized this conflict as "the splitting of the ego."[11] But already in his study "On Fetishism" (1927) Freud had begun to imagine various founding moments of disavowal, the most important of which is the advent of castration anxiety.[12] When the child sees that his mother has no penis, he or she seeks out a fetish to cover over and reconcile his two contradictory attitudes toward reality. The child both takes the "external" reality into consideration (I see and know that my mother has no penis . . .), and disavows it, replacing it with what he desires (. . . but I believe she "has it," nonetheless). There is something like a fetish in Wolf's retelling of *Medea:* this is Medea's dress, handed down to Glauce. A graceful, flowing garment, the robe symbolizes Medea's knowledge and power. She would wear it, together with her priestess's fillet, when tending to the sick and suffering of Corinth. Although Medea presents the dress to Glauce as a token of their friendship and shared knowledge, Creon's machinations recharge the gift. The King plans to break Medea's marriage with Jason, and then to wed Jason to Glauce, further securing his power. The gown becomes a wedding dress. It beckons Glauce forth to be a bride.

Octave Mannoni's psychoanalytic reflections offer another perspective on *Medea*. The logic of disavowal—"je sais bien, mais quand même . . ." (I know full well, but still)—aligns with Glauce's split between knowledge and belief.[13] As Mannoni argues, a fetish stands for the disavowal of conscious knowledge; it embodies the expression "but still." Although Glauce acknowledges that Medea will fall victim to Corinth's corruption, she uses the dress to materialize her belief that the city is founded on justice.[14] When her fetishistic defense wears out, however, the dress she wears takes its toll. On the day of Medea's expulsion from Corinth, Glauce is confined to her palace chambers. At the first chance, the princess slips into Medea's dress and escapes into the courtyard. She winds her way to the wishing well, the very spot where Medea had coaxed from her the memory of Iphinoe's death. Two swift steps — Glauce mounts the rim — then a third; she falls into the void.

Wolf has restaged the melancholic fall at various points in her writing. Rita's dive onto the railway tracks in *Divided Heaven* delays production, but eventually this interruption binds her closer to the other members of her brigade. This moment becomes a factory second, as Rita's comrades visit her in the sanatorium to encourage her recovery. In *Incarnate* an ex-friend of the patient, named Urban, hangs himself after losing his high-ranking party position. Wolf recounts their earlier dispute about the GDR's crisis. Whereas Urban refuses to give up on socialism, even if all that remains of it is "a facade," the patient sees the GDR as an endgame. Just short of equivocation — again, this is Wolf's elusive style — she pauses, then remarks: "You know what it means when you only have false alternatives" (Wolf, *Leibhaftig* 182–83). She sees through the layers of disavowal that cloaked the Party.

As Wolf's other post-*Wende* texts have proliferated, this critical inquiry into left melancholia has sharpened. In *Medea,* Glauce's suicidal tendencies contrast with Medea's forthrightness — a stance that Wolf herself once assumed. In a letter to fellow author Volker Braun, written from the Getty Center in Los Angeles at the height of the public backlash against her, Wolf asks, "Where does the future lie? There's no way of knowing, and it's true that the old patterns — death, madness, suicide — have been used up."[15] Although these three avenues might have once been viable to other authors (she mentions Friedrich Hölderlin in this regard), they are now blocked. If Medea finds another exit from the deadlock of suicide, Wolf suggests, perhaps today's reader has something to learn from her. Of course Medea must pay her own price, that of exile. Corinth cannot accommodate Medea, the confident and prescient healer from the East, whose surplus of imagination threatens to undo the kingdom's fabric. By wreaking havoc in Corinth, Medea brings about the crisis that will cast her out. But instead of executing her, the Corinthians banish Medea to the wilderness. When Wolf's Medea learns that her sons have been murdered, she can do nothing but curse her enemies. Malediction may be all that remains to her ("Was bleibt mir"), but Medea's rage forges a foundation of resistance, a place from which to speak (Wolf, *Medea: Stimmen* 236).

To speak, yes, but to whom? Medea's statement, "Where can I go," which begins her concluding utterance, is at once indicative and interrogative. It reads as a question without a question mark. The subsequent line repeats and reinforces this split rhetoric: "Is it possible to imagine a world, a time, where I would have a place" (Wolf, *Medea: A Modern Retelling* 186). In her rejoinder— "There's no one I could ask. That's the answer." — she envisions what had, until

then, no place on earth. Medea finds herself alienated from both her family and her new home, much as Wolf was when she wrote to Braun from her place of "exile." Yet this homelessness might afford a critical vantage point. Like Medea, Wolf refuses to be at home in the present. To disavow the past, she warns, is to forfeit the future itself.

This refusal to be at home only in the present is an important component of what Wolf has termed "subjective authenticity." In a 1974 interview in the *Weimarer Beiträge*, Wolf describes subjective authenticity as that which has been shaped by a singular lived experience — the trace of the author's perspective.[16] Wolf attempts to sustain such authenticity within her textual matrix. Failure, to her mind, would be to obliterate her own personal history with the voice of an invisible, omniscient narrator. When Wolf describes the authenticity of literature, she does not have in mind the standard narrative imagination that "tells stories," but rather the author's capacity as a real person to reinvent herself as the narrator. What she calls the "the fourth dimension" of the narrator's voice inspires the utopian imagination. It harbors the potential for an authentic collective in which reader and writer might unite forces.[17]

This literary project extends most forcefully into Wolf's post-*Wende* texts, *Medea* and *Incarnate*; indeed, these narratives give literary form to many of the ideals and events of Wolf's own lived experience. Yet, at the same time, the protagonistic voices of Medea and the patient in *Incarnate* are part of the literary fiction. They recount the narrative from a position of temporal distance or displacement, but they are not identical with Wolf's real voice. The protagonists' individual points of view articulate their fictional subjectivity. This distinguishes the two last novels from *Divided Heaven*, which is almost exclusively narrated from a position of omniscience. Yet even within the conventions of the *Ankunftsroman*, Wolf seemed aware of this fourth dimension. In *Divided Heaven*, Rita's interest in poetry's power "to pierce the darkness of things unsaid" anticipates the parallel that Wolf would draw in her letter to Braun thirty years later (*Divided Heaven* 120). How to navigate the blurred contors of the postcommunist landscape when equipped with only "an uncertain inner compass?" she asks (Wolf, *Parting from Phantoms* 221). This faulty compass, however, may have always been her only real tool. Wolf's literary endeavor "to say I" has been one of her most significant conceptual interventions, after all. The difficulty of avowing her unique subjectivity against the collective current has never diminished. This process is still as much like "digging in a dark tunnel" as it was when she began writing (*Parting from Phantoms* 221). Although Wolf concedes that it is an unfinishable project, she

still urges the vocation of "articulating our own position" upon herself as well as others.

Wolf has long maintained that subjective authenticity sustains not only the literary imagination, but also utopian hope. Indeed, this brings us to the margin between authenticity and disavowal that structures so much of her work, in that, as Wolf argues, literature embodies truths that the historical document cannot articulate. She notes that one of the most pressing tasks of contemporary authors is to "rewrite" the history of the GDR, which is fraught with contradiction because it has been delivered down to us through either incomplete foreign sources (historical studies published in Western Europe and North America) or the often compromised annals that party officials edited. In a 1993 essay about this legacy, Wolf takes on a tone resonant with that of Medea. She insists, "I say: No, 'the truth' about this time and about our lives must come from literature" (Wolf, *Parting from Phantoms* 242). This statement accords with another from a 1991 exchange with Jürgen Habermas. Here Wolf identifies literature as the practice that helped her to work her way out of bias, prejudice, and inhibition. "When you write, you can't lie," she tells Habermas, "or you get blocked" (*Parting from Phantoms* 122). Wolf's response invokes the "What Remains" controversy at every turn, even though Habermas himself never mentions it in his opening letter. Yet her unwillingness or inability to speak of the truth without setting off the term in quotation marks (she writes "the truth," not the truth) only makes the matter of Wolf's fraught Stasi collaboration more salient. Did Wolf compromise the security of other citizens when she served as an "inofficial collaborator" in the GDR's early years? Did she miss crucial opportunities to speak out against the repressive regime, especially in the late 1970s and 1980s when her own literary success might have granted her a provisional *carte blanche*? This ambivalence returns in *Incarnate*, when the patient finds herself in a "Zwischenreich" at the threshold between two realms: "Here I feel well. Why exactly, I can't ask, but something in me knows the answer: because [. . .] all distinctions cease. Good and bad, true and untrue, right and wrong are of no consequence" (Wolf, *Leibhaftig* 142).

Habermas writes off the process of dismantling socialism as a "nachholende Revolution" (catching-up revolution). He sees it less as a world-historical event than an instance of a stunted civil society struggling to match the success of its Western counterpart.[18] Habermas defends his conviction that Eastern Europe's entire twentieth century — from October 1917 to the rethinking of democracy in Prague and Leipzig in the late 1980s — is of no

consequence to the West. He dismisses the role of state socialism within the latest stages of European modernity and consigns it to the dustbin of history. As we see in *Medea,* Wolf, too, commits her own acts of disavowal: specifically, she exculpates Medea of the responsibility for her sons' deaths. Wolf explains away Euripides' account of Medea's crimes as the ideological residues of Western patriarchy, and so verges upon a double disavowal, one that strikes close to her own "home." One could argue that Wolf reanimates Medea in order to stage a cathartic disavowal. For her own part, Wolf has yet to fully account for her complicity with the GDR regime both as a Stasi collaborator, and, more generally, as an author favored by the censors.

The Medea complex

When the second world began to present itself as *ein Rest,* a remainder to be either mourned or forgotten, Wolf turned to the heroines of ancient Greece, a culture in which mourning (*Trauerarbeit*) is a labor divided by gender. (In the symbolic memory work of Greek premodernity, the task of mourning fell upon women. Traditionally, women were expected to perform the grief of the entire community through weeping and the singing of laments. Usually the mourning family paid for these rituals. The classical figures Medea and, earlier, Cassandra presented themselves as ideal protagonists for the stories Wolf wanted to tell.)[19] In 1984 Wolf published *Cassandra,* an allegory of the East-West arms race. Since writing this novel, Wolf has been concerned to problematize the modern imperatives that engineered not just capitalist industry, but socialism as well, even if it means departing from her vulgar Marxist conviction in the emancipatory potentials of collective labor. If, in an early text such as *Divided Heaven,* Wolf understands the working collective as the only catalyst of authentic solidarity — the engine of all redemption, collective as well as individual — in *Medea* she turns away from this injunction. Here she explores the margins of society — that which has been rejected from the collective. This decentering, exilic trajectory of memory work runs deeply in Wolf's writing, extending into and constellating together the works considered in this chapter with *Nachdenken über Christa T.* (*The Quest for Christa T.*; 1968), *Kindheitsmuster* (*Patterns of Childhood*; 1976), and *Kein Ort. Nirgends* (*No Place on Earth*; 1979), in particular.

In *Medea,* Wolf's notion of patriarchy as the progenitor of crisis resembles that which Max Horkheimer and Theodor W. Adorno identify as modern man's will to dominate. Their *Dialectic of Enlightenment* looks back

to the mimetic arts and practices of premodern cultures, particularly those of classical mythology, as an escape from the spiral of enlightened destruction. Wolf, likewise, surveys Greek literature to salvage its outcast and misunderstood antiheroines — the resistant vanguard of women who practiced crafts of prophecy and healing, even at the risk of death. This tendency calls for the privileging of sexual politics that Hell effects so successfully. Yet perhaps Wolf's Medea complex propels the reader too far from the concerns of the collective, today. Images of solidarity, images of a working circle all but disappear from *Medea*. Medea becomes so absorbed in her efforts to hypnotize Glauce and draw her into the past that she risks losing touch with her own social reality. As Medea's spiritual healing becomes more and more like hypnosis, Wolf reinvents the seeress as a proto-psychoanalyst. Here Wolf's inattention to the problem of labor at both the formal and the theoretical level warns — prematurely — of the defeat of efforts to redefine the material productive process itself.

That the socialist second world, with its myopia of industrial production and its command economy, failed to build a thriving collective is tragically clear. The collapse of the Eastern Bloc has taught us that it is not possible to simply reembrace the Marxist theory of political economy. But the wholesale rejection of collective production is no less false. In *Medea*, Wolf reduces the memory of collective labor into the sheer work of memory, and so initiates such a false reconciliation. Wolf's stance suggests that today, in postindustrial culture, the only agency that can form a collective is the labor of remembrance. Yet if we put the recollection of work into reverse gear and apply ourselves exclusively to the work of memory, we risk sublating collective mourning (*kollektive Trauerarbeit*) into the only "labor" that can bring full satisfaction in our contemporary condition of melancholia. This wager, then, risks disavowing the remaining potential of material labor as a collective experience. In this regard, *Medea* comes dangerously close to the sort of psychiatrization of social malaises that signals the exhaustion of revolutionary possibility. The therapeutic probing of the individual's traumatic memories replaces any reference to concrete social relations.

The two images of Rita mentioned at the beginning of this chapter, one in which her figure blurs in the foreground, the other in which the background blurs behind her, give visual form to the impossibility of making one "big" picture, an impossibility that Wolf herself perhaps did not see when she wrote

Divided Heaven. At this early point in her career, Wolf kept the operations of blurring and division separate. Only through division and prohibition could her characters find clarity and purpose. But as Wolf began to articulate more deeply the voice of subjective authenticity — notably in *Patterns of Childhood* in the seventies, and then, more recently, in *Medea* — she undermined the opposition between fiction and autobiography, and produced a moment of literary dissonance. In Wolf's work the blur does not simply stand for something negative or for a subjective distortion of truth or reality. This dissonance, rather, is objective. It signals that reality itself is unfinished or indistinct, and so contests any conviction that the whole is the truth.[20]

What then to make of the fact that, in *Divided Heaven,* Wolf's protagonist disclaims the ineluctability of this sort of dissonance? Rita's disavowal of this limit of perception, like her disavowal of the Berlin Wall, finds its fetish in the image of the wicked West. Wolf illustrates this by likening the brightly colored sidewalk parasols at West Berlin's Café Kranzler to poisonous toadstool caps (*Divided Heaven* 189). This is just one of Wolf's many images of depraved consumer capital. On an elemental level, a fetish is the supplement that the subject adds to make his or her worldview appear whole. Only through designating an object as a fetish can disavowal be enacted. As a negative gesture, disavowal depends on the appropriation of a positive object. Rita needed the fetish of a protofascist Federal Republic in order to keep in focus her desired vision of European political reality, a vision which, more often than not, appears delusional. Renouncing this fetish would blur her world beyond recognition.

Whereas *Divided Heaven* locates collective experience solely in the real socialism of the GDR, *Medea* shifts this experience to the realm of the imagination. Here collective hope, paradoxically, sustains itself in the absolute solitude of the writer. Wolf's Medea withdraws from social reality only to imagine a new collective form. For Jason she risks everything dear to her, a decision that determines her tragic destiny. Her unspeakable love for this man from Corinth drives her to forsake Colchis, her parents, her entire known world, only to be forced to forfeit Jason himself in the end. This double forfeiture links *Medea* to two other recent formations in European culture. First there is Solidarity's unwitting role in the distortion of socialist politics in Poland, dramatized by Andrzej Wajda in the films *Man of Marble* and *Man of Iron* (discussed in chapter 2). Then there is the double loss that can be delineated in Wolf's own life, at least in the biography that she has sketched out for her

readers in recent essays. In Wolf's oscillation between fiction and autobiography, she ends up in a no-man's-land between the two. With nothing more than her writing to support her, she stands alone.

If *Divided Heaven* situates the individual within the master plan of collective labor, *Medea* excludes the subjective voice of the author from this plan. Neither of these novels offers a viable model of mediation between subjective authenticity and collective memory. There are two short essays that Wolf wrote in the early nineties, however, which do enable such mediation—"Selbstanzeige" ("Self-Indictment"; 1994) and "Nagelprobe" ("Trial by Nail"; 1991). What is more, these texts avoid the aporias of disavowal. "Self-Indictment" (the brief introduction to *Parting from Phantoms,* a collection of works that records Wolf's own postcommunist Passion play) redefines the role of the author. Literature, Wolf explains here, should be worked. It should be seen as a site of collective labor. "My ideal of writing would be a sort of collaboration," she begins, ". . . many people and things would write along with me; what is most subjective would knit inseparably with what is most objective, just as in real life'" (Wolf, *Parting from Phantoms* 1). Weaving together the subjective and the objective, such a text would show a person "without distortion but not stripped bare." This precarious balance could only be achieved within a collective of readers and writers, for only in this way would a pen follow life's traces as exactly as possible. The hand grasping it, in Wolf's words, "would be my hand and yet not mine" (*Parting from Phantoms* 1). This affirmation of cooperative work—which harks back to Wolf's prescient "Lesen und Schreiben" ("Reading and Writing"; 1971)—reemerges with equal force in *Incarnate.* Kora Bachmann, the anesthesiologist, does more than just administer narcotics. Like an emissary, she escorts the delirious patient through the German Hades. The collective means of their mnemonic passage work a cure: the patient only recovers by collaborating ("Mitarbeit") with the team of doctors. "It was hard work with you," Kora confesses at the end (Wolf, *Leibhaftig* 156, 184). Their cooperation conjoins writing with medicine. The pain that one registers in the body, the other senses in the soul. "We have the same job," Kora observes (160).

Negt and Kluge have also called for this kind of collective project in their works *Public Sphere and Experience* and *History and Obstinacy.* Redacted as montages of diverse texts and images, both books call upon the reader to invest a supplement of his or her own labor (*Zuarbeit*) into the tasks of signification. The reader, then, becomes a user; the books things to be used. Wolf's envisaged text suggests a comparable use value. Such a document or manual (*Ge-*

brauchsbuch) leaves channels open through which the reader can enter.[21] These points of literary indeterminacy accord with the factory seconds that Negt and Kluge want to recall in their research, for both insist upon the subject's resistance to predication in either labor or culture.[22] Just as the subject defies total commodification, so does it resist full identity with a literary work. If, in postindustrial Europe, the actual factory no longer affords us critical access to the dead labor of the millions who have come before us, perhaps the literature that avows the intractable moments of solidarity — such as those captured in *Divided Heaven* and *Incarnate* — can lay the foundations for a counter public sphere (*Gegenöffentlichkeit*).

Already in the early, tumultous years after the *Wende,* Wolf's writing began to intensify. In *Parting from Phantoms,* the obdurate blur that Rita sought to efface in *Divided Heaven* returns as a site of literary dissonance. The faculties engaged in these texts are not mimetic. Their "gaze" is "stricken yet unclouded by the residue of unclarified resentments" (Wolf, *Parting from Phantoms* 1). Wolf comes closest to this sort of vision in her 1992 essay "Trial by Nail," which she first presented as a lecture in New York's Goethe Haus and then published in the catalogue of Günter Uecker's exhibition *Aufbruch* (*Awakening*) at the Erker Galerie in Sankt Gallen, Switzerland. Here Wolf touches upon Uecker's sculpture *Kleines Weißes* (*Small, White Thing;* 1958–59), a wooden tablet studded with nails. She uses it as a point of departure for her own indictment — a self-investigation that takes the form of an album of visual motifs culled from both German art and literature.

Meditating on Uecker's sculpture, Wolf conducts an inquisition of her own identity. Her inspection begins with an examination of nails themselves: she identifies them alternately as the tools that join objects together, such as the planks of a house, or as the spikes that crucify a person sentenced to death. *Small, White Thing* prompts Wolf to recall another, similar object, a "nail fetish." A page torn out of a German magazine pictures a head-shaped form bristling on one side with a stand of nails. The nails pry open the mouth, to speak perhaps, or to cry out. Specks of light cast off their flattened heads illuminate the left eye, making it shine back at the viewer. The image releases a series of associations — forced entry, the destruction of what is most precious, the compulsion to join in a dialogue. Wolf adds two more elements to this montage-portrait: a definition of the word "fetish" ("an artificial inanimate object that is venerated and to which magic powers are ascribed"), and the photo's caption (Wolf, *Parting from Phantoms* 130). It reads: "The nail fetish from the Congo serves to mediate between the living and the dead. It protects

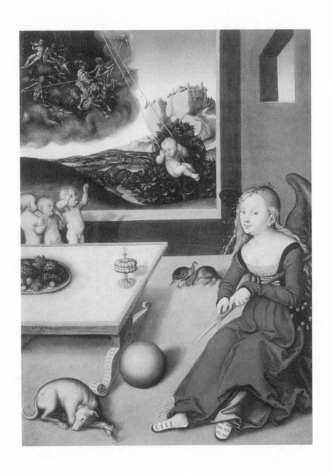

6.3 Lucas Cranach the Elder, *Melancholie (Melancholia)*, 1532, oil on wood. Musée d'Unterlinden, Colmar.

the innocent and punishes the guilty. Each nail holds a message, tells its own story."[23] Her essay "Trial by Nail" becomes both medium and message. While it registers some of the most striking images of pursuit and persecution in German literature and art (Grünewald's icon of crucifixion, the *Isenheimer Altar* [1512–15], for example, as well as the "little nails" ["Näglein"] of Brahms's *Lullaby*), the essay also puts Wolf herself on trial.

Central to Wolf's crusade is Lucas Cranach the Elder's *Melancholie* (*Melancholia*; 1532), a painting with peculiar fetishist intensity.[24] In fact, although "Trial by Nail" was written for Uecker's exhibition, Wolf offers no direct reading of his work, but rather devotes her attention to the Cranach, searching the painting for clues to her own world that *Small, White Thing* alone cannot deliver. Regarding the painting, Wolf focuses on Cranach's juxtaposition of the seated Melancholia figure and the image of a hunting scene that hangs just behind her. Wolf feels the hunters' hot breath, hears their hue and cry, imagines that the hunt is already upon her. She projects herself into the scene and risks a glance back at the faces of her aggressors. Shocked to see her own image, which she does not want to recognize, she realizes that she has been passing sentence on herself all along. "It's true, isn't it," Wolf asks, pointing toward her self-indulgences, "all our good deeds and desire to preserve our innocence are in vain?" (Wolf, *Parting from Phantoms* 134). A desperate question, but one that nevertheless is central to the psychic life of many of Wolf's protagonists.

The conclusion of "Trial by Nail" drives home the point that Wolf's troubled elegy is bound up with the task of writing a requiem for communism. Here she composes a little poem under the rubric *The Principle of Hope*, Ernst Bloch's monumental tract of Marxist philosophy, which emerges in many of Wolf's texts.[25] If Wolf's conviction in Marxism survives beyond the *Wende*, it is nonetheless tempered by her own ordeals as the first German victim of the postcommunist purges. As a coda, Wolf writes:

> *The Principle of Hope*
> Nailed
> to the cross of the Past.
> Every movement
> drives
> the nails
> into the flesh.[26]

At the cross of the past, the trial of Marxist philosophy intersects with Wolf's own acid test. She places herself on the same crux where the endangered heroines of her writing find themselves, the place where the progress of history impinges upon the individual subject. Wolf forces upon herself the question of how to inscribe her literary signature into the world. As Medea asserts in her own final words, this question can only be put to oneself; there is no one else to ask (Wolf, *Medea: A Modern Retelling* 186). In "Trial by Nail," Wolf extends this literary inquisition into her own past, a process that vacillates between paroxysms of self-reproach and the transubstantiation of writing's labor into a philosophy of hope.

Medea's final concession, that rage is all which remains to her, echoes Wolf's infamous chronicles in "What Remains."[27] But both *Medea* and "What Remains" refer to an earlier, founding moment in German literature, Hölderlin's poem "Andenken" ("Remembrance"). In the last months before Hölderlin slipped into mental illness, he composed this poem, which lyricizes the lasting potency of poetry. "Was bleibet aber stiften die Dichter," he wrote. What remains shall be written—and established—by the poets.[28] In *Medea*, Wolf sustains Hölderlin's insight, building from the heroine's words a provisional site from which to speak. What accounts for the poignancy of "Trial by Nail," particularly when set in context with the "What Remains" controversy, is the doubling of Wolf's intimate self-examination and her awareness of being under state surveillance. The gaze that the Stasi casts upon her reifies Wolf's own doubts about her collaboration. Through her surveys, she detects new barriers on the sites of past demolition. Critics who dismiss Wolf's post-*Wende* writing as belated attempts at exculpation miss a key feature of the works, one that testifies to Wolf's authorial integrity. Far from assuming the role of a *schöne Seele* subjected to totalitarian observation, Wolf turns her knowledge of surveillance against herself. And she, more than anyone else, knows how to do the damage.

AFTERWORD

When, about ten years after the collapse of state socialism, employment rates appeared to rise across the continent, some politicians leapt at the chance to proclaim that Europe had weathered the storm of transition, that history was no longer out of joint. German Finance Minister Hans Eichel credited his government for guiding workers off factory floors and into part-time jobs in the digital economy. "They used to say, 'the smokestacks are really smoking,'" Eichel quipped, 'but now it's better said that 'the mice are clicking away.'"[1] Although unforetold opportunities await Europeans working in the new information economies, what they stand to lose is the common space of the shop floor. With each mouse click, another factory lamp blinks out. In the postindustrial moment, workers are less likely to share shift hours or to labor under the same environmental constraints. They tend to work in isolation and to be employed on a casual basis. As more Eastern states join the European Union, the number of workers who assemble daily at central worksites continues to drop. Multinational unification finds its inverse in the dispersal of laborers; indeed, to a large extent European unification depends upon such dislocation.[2] Leaders like Eichel express their satisfaction with the latest statistics, but the dismantling of the collective workplace poses a complex

challenge to socialist politics. As factories and plants are shut down, the site of culture becomes an important meeting ground for the collective. Indeed, the end of the Industrial Revolution reveals truths that the left has yet to fully acknowledge: culture's potential for social change exceeds that of the workspace. After the socialist crisis of the eighties and nineties, we can appreciate more than ever the centrality of literature and art to the European public sphere. An examination of the requiems for communism discloses the politics of memory in its current modes: nostalgia, mourning, melancholia, and disavowal.

Christa Wolf's writing occupies a central place in this project. Her career extends from the days of heavy industry and collective labor and into the contemporary, postindustrial moment. Her writing, from the sixties to the present, is alert to the Germanies' shifting labor and gender politics. This literary bridge affords us a keen perspective on Europe's second sex as well as its second world. But as vivid as this prospect is, it is also on the brink of obscurity. New formations surge into the cultural field — from the first world, from the third — and blot out the oblique slant that Wolf, for one, casts back onto the global horizons. These aesthetic drifts are matched and stirred by theoretical tendencies, as the contact between Wolf and Habermas makes clear.

Habermas stuck to matters of political history in his letters to the author. But other critics have gone a step further, extending Habermas's notion of the Eastern European "catching-up revolution" into the fields of literature and art to designate its cultural counterpart: belated modernism.[3] Wolf herself was one of the first targets of this aesthetic critique. In the backlash following the "What Remains" controversy, critics not only scrutinized her three-decade delay in attesting to her collaboration with the State Security; they also dismissed her literary experiments in subjective authenticity, branding them as unoriginal. "Obsolete," they charged, "dead on arrival." If Wolf's novels amounted to nothing more than a vain attempt to catch up with aesthetic movements already past their prime, so the logic went, why should anyone bother to read her?

Instead of resigning ourselves to this rhetoric, we could take the question more seriously and reconsider Wolf's writing, as well as other works that seek to critically recount Europe's second world and the experience of collective labor. Such reflection might reveal alternatives, both political and aesthetic, to the complacencies of the late capitalist culture industry. For socialism and capitalism were both forged in the factory; Europeans from the East as well as the West carry this shared legacy into the new millennium.[4] Given that indus-

trial modernization fueled European modernism, the literature and art that it shaped across the continent merits an examination more attenuated than critics of Habermas's orientation are willing to grant it. As fellow Western Europeans like Beuys, Duras, Harrison, and Kuckart have noted, the second world encompassed not only defunct doctrines, but also political and aesthetic strategies that are still viable. Its history persists as a critical wedge, even as its literary and visual culture is occluded by the accelerating exchange between the first and third worlds.

Europe's postindustrial turn is also a cultural turn.[5] Of the emergent tendencies in this new era, two appear most influential. On the one hand, the proliferation of market advertisement, the Internet, satellite television, and DVD technology evidences the transition from a remarkably literary popular culture to an emphatically visual one.[6] On the other hand, antagonisms have intensified not only among different nationalities and classes but also between the sexes. Although these two discrete tendencies have registered across the continent, they have figured most prominently in Eastern Europe. In the past decade, the icons of consumerism have filed anew into urban centers. To say that the papering-over of cities like Dresden and Budapest has left them indistinguishable from Düsseldorf or Brussels is only to repeat a banal platitude. Concomitant with the surfeit of advertising and corporate signage is a growing literary deficit: many publishing houses established in the postwar years have been shut down or, in at least one Polish case, have switched their market from poetry to pornography. Roland Barthes, in his own work of mourning, *Camera Lucida* (1981), has written about the diverse effects of the multiple image. As the photograph serializes and stuns our culture, he warns, civilizations merge into a dystopia of consumption, where "only the cry of anarchisms, marginalisms, and individualisms" can emerge.[7] Of course the photograph, as Barthes himself affirms, is not simply an artifact of social decay. It is also a medium of cultural and aesthetic expression that can be mobilized to foster collective memory, as several of the artworks considered in this study demonstrate. Yet what are we to make of Barthes's warning? Is there any historical correspondence between the cultural siege of commercial photography and the festering of social antagonisms in Europe today? Ethnic hatreds are not all that run rife in the East. In these transitional economies, sexual oppression, too, wears on and, in some ways, grows more insidious. The eruption of these tensions harks back to Nietzsche's prescient insight that Europe's real barbarians would come into view "only after tremendous socialist crises."[8]

AFTERWORD

Today, joblessness provides the clearest indication of the last socialist crisis, particularly as it affects women. One of the most visible characteristics of state socialist society was the presence of women workers in the public sphere. Now their disproportionate (and massive) unemployment is a pronounced element of Eastern European life.[9] It is as if the serial photo has replaced the laboring woman. Both the concierge once posted at every institutional door and the tractor-driver-heroine of socialist realism have nearly vanished from sight. The matter of women's labor has been pushed to the margins. While the correspondence among these cultural and economic shifts remains to be analyzed, the least we can say is that they have all intensified after the crisis in socialism.

If an aporia persists at the juncture between gender and production (in its various modes: biological, cultural, and industrial), then "the woman question" remains inadequately addressed, long after Engels and Bebel framed it. Sexual difference continues to charge every aspect of European life. Perhaps the ideal of the fully empowered working woman, like the "illusion" of a socialist society, was always already lost, even in the first decades of the twentieth century. But what of the writing and art that nonetheless undertakes to mourn the loss of this working woman?[10] If mourning is a labor that is performed, perhaps — as Mayakovsky's ghost might have told Triolet in *Melancholia I* — this figure can be engendered in cultural memory, so that she will emerge in a moment yet to come. After all, sometimes it is only through loss that we can really find something.[11]

Of the works examined in this book, those by Kaplan, Wajda, Kuckart, and Wolf best attenuate the links between gender and memory, labor and loss. Taken together, these texts prompt readers to open new lines of inquiry. How is the labor of memory divided by gender? More specifically, how will the visual turn that has followed upon Europe's socialist crisis influence feminist cultural politics? To reframe the woman question is not necessarily to suppose that the cause of female laborers is lost without the support of socialist programming. Some recent works suggest that the figure of the working woman still animates the European imagination. *Trois couleurs: Bleu (Three Colors: Blue;* 1993), the first installment of Krzysztof Kieślowski's three-part series, is one of these. Like many of the projects examined in this book, *Blue* also takes up the work of mourning, yet it stands apart in that it does not make overt references to Europe's second world, but rather looks beyond it. *Three Colors* takes as its inspiration the tricolor flag of the French Revolution and its democratic impulse — "liberté, égalité, fraternité." 1789 is thus the key date for

Kieślowski, not 1989, or even 1917. Although *Blue* locates itself at the moment of contemporary European unification, it engages questions of labor and gender in a way that reactivates some concerns central to the socialist project. After surviving her husband and daughter in an automobile accident, Julie, the heroine of *Blue,* tries to forget her painful loss. Alone, she moves to Paris and leaves her identity behind with her family's material effects. But her memories haunt her, particularly those of the music that had defined her shared life. Strains of the unfinished "Concerto for the Unification of Europe," a score that her husband had been composing at the time of his death, return to her from the past. Julie steels herself against her desire to remember the concerto and all that attends it, yet ultimately cedes to her friends' appeals not only to complete the composition, but also to end her seclusion, if only provisionally.

Kieślowski leaves open the end of *Blue.* Julie might withdraw into solitude once again, or might remain in the public sphere, but one thing is clear: the desire to finish the concerto enters her into the collective to engage the work of mourning. In a sense, where so many women have been cast out, Julie reenters the working circle. The women of *Brassed Off* and *Man of Iron* lose their jobs, much like the real women workers of Eisenhüttenstadt's and Nowa Huta's steel mills. Christa Wolf's Medea is exiled into the wasteland and kept from practicing her vocation. Meanwhile, Rita of *Divided Heaven* nearly succumbs to suicide, and John Berger's Lilac is murdered and falls completely out of the picture. The final scene of *Blue* delivers a different outcome. As the camera pans across all the characters — first Julie, then the others — Julie's concerto resounds and draws together image, music, and text. The words of Paul's letter to the Corinthians come to the fore:

For now we see in a mirror, dimly, but then we will see face to face. Now I know only in part; then I will know fully, even as I have been fully known. And now faith, hope, and love abide, these three; and the greatest of these is love. (1 Corinthians 13)

Blue dramatizes the pursuit of liberty, but as the film reaches its conclusion, Julie realizes that her path to individual freedom moves through the site of the collective, through love. Only by meeting the Pauline imperative to love others will she find herself again — even if it means she will never completely dislodge the spurs of the past.[12] Her musical work of memory invokes her into the collective, perhaps for a moment, perhaps for longer.

Julie's "Concerto for the Unification of Europe" not only marks the cusp of her mourning, it also signals the transition from two Europes to one. With

7.1 Julie composing, *Bleu (Blue),* dir. Krzysztof Kieślowski, 1993.

unification comes a series of challenges to women working in all sectors of the economy — the field of "high culture," the market proper, and the gray zone that flourishes between them. Some critics claim that Europe's passage from an industrial into a postindustrial, media society can also serve as a path away from the hierarchies of masculinist hegemony and into a more human- ist, or even feminist, cultural network.[13] Yet this prophecy rests on the assumption that the industrial collective was the province of exclusively male solidarity. The strongest memory works of the past few decades withstand this misconception, for they sustain the hope that the circles of workers, writ- ers, and readers will continue to overlap and intersect across gender lines, even as the other Europe merges into the first world Infobahn of digital tech- nologies. This traffic remains a collective labor, one more arduous than that of passively receiving a media stream. The working memory instilled into recent literature and art encompasses the breakdowns and lulls that Negt and Kluge locate in dead labor. As a result, the faulty circuits and factory seconds of industrial culture might not readily transfer into Habermas's patterns of com- municative action. But even those who insist that it was not until 1989 that Europe resumed full speed on the tracks toward global empire might still con- cede that the second world detour should be more thoroughly chronicled. The requiem for communism — in literature, in art — prompts this task.

To posit that the visual turn enacts a turn away from historical conscious- ness is not to state a universal thesis about visual culture as such. Rather, this claim contends that, in the digital age that awaits Europe, we tend to expe- rience vision merely as exposure to a flow of images. Negt and Kluge's collages in *History and Obstinacy* and Wolf's culled images in "Trial by Nail" anticipate this way of seeing, and offer narratives that at least offset it, even if they do not subvert it. Like the netscape, these works engage the seductive pull of pictures, but at the same time, they also attest to the collective tasks of read- ing and writing. These works occupy the space between the subjective and the objective. They point toward an as yet uncharted public sphere, which lies adjacent to the field of communicative exchange that both union leaders and new media visionaries have envisaged but never fully actualized. *History and Obstinacy* and "Trial by Nail" are anchored in the rough terrain of Europe's industrial wastelands. Yet they are also attuned to the smooth world of imma- terial labor whose millennial ascendance Michael Hardt and Antonio Negri have recently mapped. Negt and Kluge, like Wolf, use literary devices of frag- mentation and direct address to both initiate participation and resist the regulating pulsations of much new media. Wolf's texts, in particular, disclose

the factory's trace on the human body and materialize Europe's troubled industrial past; her subjective authenticity consists of an irreducibly corporeal tissue. The needles of "Trial by Nail" draw behind them fibers of dead labor from the second world. Studied closely, dropped stitches can be seen in the places where the bobbin lost traction — the delicate lines that skip across the work's surface are bound at the back by distressed knots and masses of thread.

In the postindustrial moment, Marxists might expect that some critical leverage could be derived out of such incompatible factory seconds. Perhaps this foreign matter could reenter the public sphere and disrupt capital's totalizing drive; once inside the profit machine, the dead labor interred in literature and art could come to life. However, even if this subversive potential dwells in second world culture, it is also, at the same time, held in check by a counter tendency. For since the market depends on a constitutive outside to keep its engine running, its autopilot could eventually take for fodder even the indigestible refuse of the communist requiem. Much as the left would like to lay claim to resistant forces of the nonidentical other, capital can also exploit such difference in its own interests. If alterity fuels consumption, as Adorno suggested at the height of the Cold War in *Negative Dialectics,* one of the most difficult lessons of the past few decades has been that capital can mobilize both communist collapse and stock market crisis to regenerate itself. Acknowledging culture's attachment to capital opens up two possible routes. Either the left can resign itself to this reality and incorporate as a new melancholy object the stubborn bond between literature, art, and the market. Or, alternatively, writers and artists can activate the collective, cultural forms which would enable that same obstinacy to be uttered as protest.[14]

The most insightful second world literature holds suspect Stalin's crudely materialist dogma, but it manifests fidelity to Marx's preliminary insights. In *The German Ideology* Marx describes the collective process of material production. Not simply an instrumental action executed to meet external goals, production is the self-expression of human essence, he argues. Men and women do not produce merely to satisfy their material needs. Production is so fundamental to life that speech itself — the prime human faculty — is grounded in collaboration. Humans start to distinguish themselves from animals as they begin "to *produce*":

By producing their means of subsistence, men are indirectly producing their actual material life. [. . .] This mode of production must not be considered simply as being the reproduction of the physical existence of the individuals. Rather it is a definite form of

activity of these individuals, a definite form of expressing their life.[. . .] As individuals express their life, so they are.[15]

One goal of socialist politics is to liberate this productive force from the constraints of capital. Only in this way could labor promise the fulfillment that Hegel envisioned in his elaboration on the building of memorials in the *Phenomenology of Spirit.*[16]

After the collapse of communism, after the exhaustion of the welfare state, the insistence on labor's emancipatory potential appears conclusively discredited. Yet while the search continues for alternative strategies, we must ask how to navigate the transit from collective, material production to a life channeled by the symbolic exchange of the global cybereconomy. Postindustrial and postcommunist societies in Europe have already registered the first shocks of this shift: as full digital agency is effectively limited to privileged individuals, the rest are left to feel shut out from the future. Bereft, many un- and underemployed workers turn to either retrograde communist ideologues or right-wing populists, whose leaders seem to be the only ones still concerned with the laborers' collective plight.[17] However, the political lesson of the works analyzed in this book is that the opposition between the brave new (media) world and the extremists' reaction to it is of little matter. What threatens to disappear from the new Europe is the concrete site of collective labor and, not least, the sense of solidarity that materialized there. This loss can no more be recompensed by any virtual community than it can be requited by a return to traditional values or submission to leftist melancholia.

The cultural remains of the second world register the dialectics of collective memory that wend from nostalgia to mourning to disavowal. In the strongest of these texts and artworks, remembrance resists repudiation — but not in the simple sense by which the work of mourning would complete our view of the past. Any narrative that claims to reconcile socialism's gains with its foregone losses obliterates our own complicity in its forfeiture. The pretense of mastering second world history, in fact, enacts the most perfidious disavowal — that of disowning the wounds that form the crux of experience. Authentic memory does not reconstitute a homogeneous image of the past. It reawakens antagonisms that thwart the resolution of — and in — any narrative.

NOTES

INTRODUCTION · THE SECOND WORLD

I. Dubravka Ugresic finds the debates on collective memory to be significantly influenced by the recent transitions in Europe. She maintains that "things with a past, particularly a shared one, are not as simple as they might first appear from the perspective of the collector. In this post-communist age it seems that 'Easterners' are most sensitive to two things: communality and the past." Dubravka Ugresic, "The Confiscation of Memory," *New Left Review* 218 (1996): 29.

2. The term "second world," like its counterparts, "first world" and "third world," is a product of the Cold War. In the early fifties when the European and North American superpowers sought to extend their spheres of influence, demographer Alfred Sauvy introduced the notion of three "worlds." In an article in *L'Observateur* he designated the contested, nonindustrialized regions of the global South as a "tiers monde" or "third world." From Sauvy's expression were extrapolated the "first world" of the United States and its capitalist allies and the "second world" of the Soviet Union and its satellites. This schema became prevalent at the Bandung Conference in 1955; in 1959 the journal *Tiers monde* was established. Soon thereafter these expressions passed into general usage.

With the end of the Cold War the terms first, second, and third world began to lose their signifying value. As Michael Hardt and Antonio Negri note, the notion of a third

world came under scrutiny as early as the 1970s, when debate unfolded over the concept of a "free space" outside the conflict among the US, the USSR, and China. Although the three-worlds schema was always an inadequate and volatile ideological convention, it nonetheless enjoyed a certain legitimacy in pre-1989 politics and culture. As a result, the expression "second world" retains its fraught currency in the analysis of the literature and art that recounts the culture forged and stalled by heavy industry.

Alfred Sauvy's article appeared as "Trois mondes, une planète," *L'Observateur,* no. 118 (14 August 1952): 14. For an analysis of the three-world schema, see Michael Hardt and Antonio Negri, *Empire* (Cambridge: Harvard University Press, 2000), 333–34; and Immanuel Wallerstein, "De Bandoung à Seattle: 'C'était quoi, le tiers-monde?'" *Le Monde diplomatique* (August 2000): 18–19.

3. In the preface to *Empire,* Hardt and Negri point out that the second world is disappearing in the new political order of globalization. "[T]he spatial divisions of the three Worlds (First, Second, and Third) have been scrambled," they note, "so that we continually find the First World in the Third, the Third in the First, and the Second almost nowhere at all" (xiii). Although Hardt and Negri caution that "capital seems to be faced with a smooth world" (xiii, 332–36), and warn against the "friction free" capitalism idealized by Bill Gates (296), they do not consider any potential within the second world (either in its history or its culture) to disrupt this global flow. Rather, they look toward "the multitude"—which alternately consists of "the poor" (156–59), intellectuals (276–79), and other groups—to function within and against "Empire" (60–66).

4. To name only the greatest differences in these four cultures: in the postwar period Britain and France were challenged by the processes of decolonization, the Germanies struggled to come to terms with the legacies of Nazism, and Poland fought to assert national identity over territory that had been repeatedly partitioned. The conditions set by these histories persist up to the present. Recently, however, scholars and critics have begun to illuminate the bridges that link Eastern and Western European culture and society. Susan Buck-Morss set a high standard for East-West comparisons in *Dreamworld and Catastrophe: The Passing of Mass Utopia in East and West,* a study that delineates the similarly utopian bent of high modernism and industrial modernity in Russia and the United States. She argues that the exhaustion of industrial modernity links the recent histories of Western and Eastern Europe. In her words, "the cultural forms that existed in 'East' and 'West' (to use the Eurocentric terminology of the Cold War) appear uncannily similar. They may have differed violently in their way of dealing with the problems of modernity, but they shared a faith in the modernizing process developed by the West that for us today has been unalterably shaken." Susan Buck-Morss, *Dreamworld and Catastrophe: The Passing of Mass Utopia in East and West* (Cambridge: MIT Press, 2000), x. Likewise, in *Empire* Hardt and Negri maintain that, despite the enormous differences between East-

ern and Western Europe (with regard to the advent of capitalism, losses in the two world wars, integration in the world market, and freedom of expression), "the proletariat in [. . .] the Soviet bloc managed by the nineteen sixties and seventies to pose the very same problems as the proletariat in the capitalist countries": that is, a labor crisis ("refusal of work") that forced their governments into a cycle of crisis, reform, and restructuring (Hardt and Negri 278).

5. Although this book's goal is to delineate the points of contact among works of collective memory in Britain, France, Germany, and Poland, the many nationalist divergences among these societies in the postwar period certainly merit consideration. In both Eastern and Western Europe, communist principles were imagined and expressed through a filter of local traditions, often giving nationalist slants to the various socialist formations in these four countries. Just as Arthur Scargill summoned forth British cultural heritage to inspire coal miners in the strikes of 1984–85, New Labor continues to invoke national traditions in Britain. Historian Pierre Nora and his collaborators have exposed the ways in which *gauchistes* appropriated French national traditions: the rhetoric of French Communist Party member and prominent philosopher Roger Garaudy would not have had its compelling thrust without his defense of Joan of Arc and Saint Theresa or his proud references to the great cathedrals of Amiens and Rouen. Likewise, Maurice Thorez also depended upon nationalist icons when he chaired the Communist Party. East German historians claimed the revolutionary legacies of the Reformation and the Peasant Rebellions as part of socialist history, and ministers of cultural politics in the GDR commanded industrial engineers to depart from the International direction of architecture and design and "folkify" the look of the built environment. They wanted to establish a comfortable distance from the high modernist legacies that linked them to the FRG. And in Poland even Solidarity leaders brandished the moustaches and swagger of prewar nationalists like Józef Piłsudski.

Recent works that examine the nationalist charge of leftist formations in Europe include Robert Leach, *British Political Ideologies* (London: Prentice Hall, 1996), especially the chapters "Laborism and Socialism" and "Nationalism"; Pierre Nora, *Realms of Memory: Rethinking the French Past,* ed. Lawrence Kritzman, trans. Arthur Goldhammer (New York: Columbia University Press, 1996); Jan Herman Brinks, *Paradigms of Political Change: Luther, Frederick II, and Bismarck: The GDR on Its Way to German Unity* (Milwaukee: Marquette University Press, 2001), especially the chapter "The GDR Historical View of the Reformation and the Peasants' War as Constituting 'Early Bourgeois Revolution'"; Andrzej Walicki, "Intellectual Elites and the Vicissitudes of 'Imagined Nation' in Poland: Coping with the Problem of Nation in Poland," in *Intellectuals and the Articulation of the Nation,* ed. Ronald Grigor Suny and Michael D. Kennedy (Ann Arbor: University of Michigan Press, 1999); and Erica Benner, *Really Existing Nationalisms: A Post-Communist View from Marx and Engels* (Oxford: Clarendon, 1995).

6. The exhaustion of the welfare state and the disintegration of state socialism have also had a significant impact on left cultural and political formations in other parts of Europe, particularly Italy and Scandinavia. Whereas Nanni Balestrini's novel *Vogliamo tutto!* (1971) initiated the tendency of leftist ressentiment, Antonio Negri's more recent political philosophy stands apart from the swan songs written by other Italian communists. See Félix Guattari and Antonio Negri, *Communists Like Us: New Spaces of Liberty, New Lines of Alliance* (New York: Semiotext(e), 1990); and Antonio Negri and Jim Fleming, *Marx beyond Marx: Lessons on the Grundrisse* (South Hadley, Mass.: Bergin & Garvey, 1984). The novels of Per Wahloo and Maj Sjowall are notable in this context, as is Lars von Trier's film *Dancer in the Dark* (2000), as it recounts the tragedies of a Czech communist factory worker forced to emigrate to the United States in order to protect her son.

For an overview of the broader political response to 1989 in Europe, see *West European Communist Parties after the Revolutions of 1989,* ed. Martin J. Bull and Paul Heywood (New York: St. Martin's, 1994), especially the chapters by Philip Daniels and Martin J. Bull, "Voluntary Euthanasia: From the Italian Communist Party to the Democratic Party of the Left"; Paul Heywood, "The Spanish Left: Towards a 'Common Home?'"; and Maria Teresa Patricio and Alan David Stoleroff, "The Portuguese Communist Party: Perestroika and Its Aftermath."

7. For a presentation of the concept of immaterial labor, see Paolo Virno and Michael Hardt, *Radical Thought in Italy* (Minneapolis: University of Minnesota Press, 1996). For an elaboration of "immaterial capital" and "the immaterial economy," see André Gorz, *Reclaiming Work: Beyond the Wage-Based Society,* trans. Chris Turner (London: Polity, 1999) 87–88, 104–115. A good introduction to the question of work in the media age is Ken Ducatel, Juliet Webster, and Werner Herrmann, *The Information Society in Europe: Work and Life in an Age of Globalization* (Lanham, Md.: Rowman and Littlefield, 2000).

8. See Hardt and Negri, 60–66. For a sober look at the collapse of socialist employment programming, see Bo Stråth, ed., *After Full Employment: European Discourses on Work and Flexibility* (Brussels: PIE Lang, 2000).

9. Oskar Negt and Alexander Kluge, *Öffentlichkeit und Erfahrung* (Frankfurt: Suhrkamp, 1972); trans. Peter Labanyi, Jamie Owen Daniel, and Assenka Oksiloff as *Public Sphere and Experience: Toward an Analysis of the Bourgeois and Proletarian Public Sphere* (Minneapolis: University of Minnesota Press, 1993). Oskar Negt and Alexander Kluge, *Geschichte und Eigensinn* (Frankfurt: Suhrkamp, 1981). *Geschichte und Eigensinn* has not been translated into English; throughout this text I refer to it as *History and Obstinacy.*

10. Negt and Kluge, *Public Sphere and Experience,* 50–51.

11. Negt and Kluge's "public sphere" encompasses alternatives or counter public spheres within it. Miriam Hansen reveals the affinity between the words *glasnost* and *Öffentlichkeit* in her essay on Negt and Kluge's *Public Sphere and Experience*. See Miriam Hansen, "Foreword," in Negt and Kluge, *Public Sphere and Experience*, ix, xxxix.

12. In Europe a broad range of historical analyses have been written on the collapse of state socialism. A survey of the works published in any one country demonstrates the diversity of approaches. Take France. In *The Black Book of Communism* (1999), editor Stéphane Courtois accuses communism for its crimes, rating its agents more evil than those of fascism. François Furet provides a liberal assessment of communism's failure in *The Passing of an Illusion* (1999) and envisions 1989 as the culmination of an era that began with the French Revolution. In *La Complication* (1999), Claude Lefort assumes an anti-totalitarian stance more complex than that of Furet; he concedes that many elements central to the current liberal consensus (healthcare, pensions, etc.) were originally demanded and secured by socialists. Meanwhile, Pascal Bruckner dismisses the nostalgia of some on the left in *La Mélancholie démocratique* (1990). See Stéphane Courtois, ed., *The Black Book of Communism: Crimes, Terror, Repression*, trans. Jonathan Murphy and Mark Kramer (Cambridge: Harvard University Press, 1999); François Furet, *The Passing of an Illusion: The Idea of Communism in the Twentieth Century*, trans. Deborah Furet (Chicago: University of Chicago Press, 1999); Claude Lefort, *La Complication: Retour sur le communisme* (Paris: Fayard, 1999); and Pascal Bruckner, *La Mélancholie démocratique* (Paris: Éditions du Seuil, 1990).

13. See Daniel Lagache, "Le Travail du deuil," in *La Psychanalyse* (Paris: Presses universitaires de France, 1967).

14. Since 1989, Germany has been at the vanguard of the effort to establish truth commissions for crimes committed under state socialism. In 1990 theologian Joachim Gauck established the Federal Commission for the Records of the State Security Services of the Former GDR (Der Bundesbeauftragte für die Unterlagen des Staatssicherheitsdienstes der ehemaligen DDR). Poland took some time to follow suit, and in 1998–99 founded the National Remembrance Institute (Instytut Pamięci Narodowej)—a commission for "the prosecution of crimes against the Polish nation," particularly those committed from 1944 to 1989.

The most thorough study of Gauck and the Gauck Authority, to date, is Norbert Robers, *Joachim Gauck: Die Biografie einer Institution* (Berlin: Henschel, 2000). An early work that documents Polish efforts at determining accountability is *Akty terroru i przemocy: Grudzień 1984* (Warsaw: Niezależna Oficyna Wydawnicza, 1985). Two of the best reflections on jurisprudence and juridical reconciliation in Poland are Maria Los's "In the Shadow of Totalitarian Law: Law-Making in Post-Communist Poland," in *Totalitarian*

71

and Post-Totalitarian Law, ed. Adam Podgorecki and Vittorio Olgiati (Aldershot: Dartmouth Press, 1996); and Adam Michnik's fascinating "Acumen of the Irreconciled: A Few Conjectures on Dictatorship," in *Human Rights and Revolutions,* ed. Jeffrey N. Wasserstrom, Lynn Avery Hunt, and Marilyn Blatt Young (Lanham, Md.: Rowman & Littlefield, 2000).

15. We could not fully grasp the political dimensions of either the National Socialist movement or its aftermath without an analysis of fascist and postfascist aesthetics. Advances in these fields of scholarship have been mutually determining. The growing fascination with novelists and poets identified with fascism such as Céline, Jünger, and Pound deepens our interest in the structures of Europe's prewar historical reality. Meanwhile, the authors of socialist realism balance on the rim of history's dustbin, where they threaten to pull with them into the abyss any text animated by the socialist imagination, Western or Eastern, from the thirties to the nineties. Discerning the textual pleasures of socialist realism is a complex and, in many cases, futile exercise. (Here I am inclined to agree with Theodor W. Adorno and Max Horkheimer that, with a few exceptions, socialist realism was less a literary genre than a mechanism engineered to transform the Soviet economic base. Like the triumph of the bourgeois class and the dictatorship of the proletariat, socialist realism left intact cultural structures of domination.) But the successors to this movement, the late socialist and postsocialist generations of the past two or three decades, radically diverge from socialist realist dictates. The most advanced literature of this period demonstrates virtuosity, formal intervention, and, not least, a writerly diversity so broad that it resists the limits of any single style.

One of the most compelling accounts of socialist realist aesthetics in the Soviet Union and beyond is Thomas Lahusen and Evgeny Dobrenko's *Socialist Realism without Shores* (Durham: Duke University Press, 1997). Although the critique of postsocialist culture in Germany and Poland has taken a slow start, a number of well-researched and insightful works stand out: Julia Hell's *Post-Fascist Fantasies: Psychoanalysis, History, and the Literature of East Germany* (Durham: Duke University Press, 1997); Ingrid Dinter's *Unvollendete Trauerarbeit in der DDR-Literatur: Ein Studium der Vergangenheitsbewältigung* (New York: Peter Lang, 1994); the study of GDR design published by the Neue Gesellschaft für Bildende Kunst, *Wunderwirtschaft: DDR-Konsumkultur in den 60er Jahren* (Cologne: Böhlau, 1996); Janina Falkowska's *The Political Films of Andrzej Wajda: Dialogism in "Man of Marble," "Man of Iron," and "Danton"* (Providence: Berghahn Books, 1996); and Annette Insdorf's *Double Lives, Second Chances: The Cinema of Krzysztof Kieślowski* (New York: Miramax Books, 1999).

16. Charles S. Maier, "Heißes und kaltes Gedächtnis. Zur politischen Halbwertzeit des faschistischen und kommunistischen Gedachtnisses," Das Gedächtnis des Jahrhunderts, Institut für die Wissenschaften vom Menschen, Vienna, 9–11 March 2001 <http://www.univie.ac.at/iwm/t-22txt5.htm>.

17. The point in *Requiem for Commuinsm* is not to negate the critique of totalitarian histories, but rather to develop new lines of inquiry that will complement this formidable body of research by offering new perspectives on socialist and postsocialist culture. Thus, for example, although this project owes a great debt to Hannah Arendt for her insights on mass violence in *On Totalitarianism* and *Eichmann in Jerusalem,* it also takes issue with Arendt's theorization of labor. Texts that trace out the more radical breaks with Arendt's thought, particularly among the European left, include Claude Lefort, *The Political Forms of Modern Society: Bureaucracy, Democracy, Totalitarianism,* trans. John B. Thompson (Cambridge: MIT Press, 1986); and Ernst Vollrath, "Hannah Arendt bei den Linken," *Neue politische Literatur,* 3, (1993): 361–72.

18. In most works of Eastern European Area Studies, the question of how to compare Eastern and Western European socialist formations (both political and cultural) does not play a significant role. Nevertheless, the recent shift in emphasis in the series *International and Area Studies,* published by the Center for Slavic and East European Studies at the University of California at Berkeley, suggests that channels for comparative study are opening. Compare Victoria E. Bonnell, *Identities in Transition: Eastern Europe and Russia after the Collapse of Communism,* International and Area Studies 93 (Berkeley: Center for Slavic and East European Studies, 1996); and John Zysman and Andrew Schwartz, *Enlarging Europe: The Industrial Foundations of a New Political Reality,* International and Area Studies 99 (Berkeley: Center for Slavic and East European Studies, 1998).

19. Today scholars use the terms "postindustrial" and "posthistorical" with increasing frequency, but a consensus on the meaning of these terms has not yet been reached. Daniel Bell differentiates postindustrial development (the processing of information and knowledge) from the industrial sort (the fabrication, manufacture, and conversion of raw materials into finished products). While industrial society used the machine to master nature and harness human power, postindustrial society is organized around the dissemination of information for purposes of social control, business efficiency, demand management, and scientific innovation. Its challenge is not just to secure well-being, but to explore new modalities (telecommunications, genetic engineering) in order to enlarge that well-being.

"Posthistory," in its most radical and politically consequent form (articulated most notably by Francis Fukuyama), is the notion that liberal, capitalist democracy institutes the ultimate organization of civil society. There are no longer any substantial ideological wars to be waged, so the thinking goes, only isolated moments of local resistance that are condemned to eventual failure. Another, more postmodern and pessimistic version of this notion refers to the assumption that today, with the global impact of the mediatized and digitalized "society of spectacle," individuals are losing the proper sense of historical memory as well as their own historicity. The fact that so much past and present data is immediately retrievable from the multitude of data banks stalls us in a timeless present.

Thus, the actual dynamism of our contemporary moment occurs against the background of a (perceived) "sameness," in which the real past is reduced to "retro" artifice. See Daniel Bell, *The Coming of Post-Industrial Society* (New York: Basic Books, 1976).

20. In *Dissolution: The Crisis of Communism and the End of East Germany,* Charles S. Maier surveys documents that record both the prescient attempts of Eastern European engineers to corner the cybermarket, and the private concessions of defeat that the researchers eventually made. Charles S. Maier, *Dissolution: The Crisis of Communism and the End of East Germany* (Princeton: Princeton University Press, 1997), 74. See also "Die Innovationstragfähigkeit der Planwirtschaft in der DDR—Ursachen und Folgen," *Deutschland Archiv* 26 (7 July 1993): 807–18.

21. G. W. F. Hegel, *Phenomenology of Spirit,* trans. A. V. Miller (Oxford: Oxford University Press, 1977) 422–25.

22. Hannah Arendt, *The Human Condition* (Chicago: University of Chicago Press, 1998), 80, n. 3. Bo Stråth deploys the genealogy of the terms "work" and "labor" to make a strong argument in favor of working communities. See Bo Stråth, "The Concept of Work in the Construction of Community," in Stråth, ed., *After Full Employment,* 65–106.

23. For Arendt's take on Hercules' twelve heroic labors, see Arendt, *The Human Condition,* 101.

24. Karl Marx, *Capital,* vol. 3 (New York: Vintage, 1977), 958–59. Arendt cites the original German (*The Human Condition,* 104).

25. In her perceptive analysis of the Arendtian concept of political action, Julia Kristeva also isolates the human body as the site of great tension and caution in *The Human Condition.* The woman's body is especially problematic in Arendt's thought, Kristeva argues, as it "incarnate[s] the body at work" and is deployed as a "primary expression of biological life" (62). This order—*zoē*—is not only that degree zero "from which the human being must extricate himself in order to establish his uniqueness" (56), Kristeva argues, but also "the principal paradigm of alienation" (63). All the body can experience "in this universe of 'burdens'" (63) is pain. See Kristeva, "'Who' and the Body," in *Hannah Arendt: Life Is a Narrative* (Toronto: University of Toronto Press, 2001), 55–72, esp. pp. 56, 63; and Arendt, *The Human Condition,* 112. Linda M. G. Zerilli presents a useful perspective on body politics in Arendt's writing in "The Arendtian Body," in *Feminist Interpretations of Hannah Arendt,* ed. Bonnie Honig (University Park: Pennsylvania State University Press, 1995), 167–93.

26. In *History and Obstinacy, Zeithof* designates the historical time and space of the factory. This is "neither clocked time, nor the psychic time that ticks from childhood into the

workplace, nor the time of history that labor itself has produced." What sets in gear the specific time *(Eigenzeit)* of industrial production are the correspondences among the machines, the workers, and one's own body, as well as the negotiations between factory regulations and "the worker's intuition." Negt and Kluge, *Geschichte und Eigensinn,* 208 (my translation). See also Heinrich Popitz, *Technik und Industriearbeit: Soziologische Untersuchungen in der Hüttenindustrie* (Tübingen: Mohr, 1976), 107ff.

27. In 1993, two American choreographers performed their own funeral for communism in New York. Bill T. Jones and Amy Pivar alternately assumed a range of roles in the work *A Requiem for Communism* — most notably V. I. Lenin and Rosa Luxemburg, but also Jones's partner, Arnie Zane, who had died of AIDS. Jones and Pivar danced a eulogy for what they had lost at the end of the century: not only the last hopes for both a socialist alternative and a singular prospect for international solidarity, but also a particular vision of collective and collaborative work. The works examined in the present study echo another set of requiems that emerged in the 1980s, namely the mourning work that commemorated AIDS deaths. Douglas Crimp's essay "Mourning and Militancy" stands out in the field of theory (*October* 51 [Winter 1989]: 3–18). Meanwhile, Tony Kushner's plays in the *Angels in America* series, *The Millennium Approaches* (1993) and *Perestroika* (1994), brought mourning work for socialism and AIDS onto one stage.

28. Paul Ricoeur, "Entre la mémoire et l'histoire," Das Gedächtnis des Jahrhunderts, Institut für die Wissenschaften vom Menschen, Vienna, 9–11 March 2001 <http://www .univie.ac.at/iwm/t-22txt1.htm>.

CHAPTER I · THE COLLECTIVE

I. See François Furet, *The Passing of an Illusion: The Idea of Communism in the Twentieth Century,* trans. Deborah Furet (Chicago: University of Chicago Press, 1999).

2. Georg C. Bertsch, Ernst Hedler, and Matthias Dietz, eds., *SED: Schönes Einheits Design* (Cologne: Taschen, 1990), 5.

3. Lewis A. Coser edited the most recent translation of these two works, which he published together under the title *On Collective Memory,* ed. and trans. Lewis A. Coser (Chicago: University of Chicago Press, 1992). My citations refer to an earlier translation, *The Collective Memory,* trans. Francis J. Ditter Jr. and Vida Yazdi Ditter (New York: Harper and Row, 1980).

Like Halbwachs, filmmaker Claude Lanzmann and, more recently, historian Pierre Nora have also made compelling arguments about memory's spatial dimension. Whereas Lanzmann calls the places of traumatic or "limit" events *non-lieux de mémoire,* Nora makes

the larger point that all memories are "set" within space. See Pierre Nora, *Realms of Memory: Rethinking the French Past,* trans. Arthur Goldhammer (New York: Columbia University Press, 1996).

4. Negt and Kluge, *Geschichte und Eigensinn,* 208.

5. As Boris Groys argues in *The Total Art of Stalinism,* Soviet planners sought to collectivize social space and develop a cultural hagiography of the collective or deindividualized image. Obeying the mandate to centralize state power, these administrators harnessed the potential of both the factory worksite and communal housing unit, and used these spaces to catalyze collective identity among workers. Boris Groys, *The Total Art of Stalinism: Avantgarde, Aesthetic Dictatorship, and Beyond,* trans. Charles Rougle (Princeton: Princeton University Press, 1992), 49. For an analysis of the literary complement to this centralization, see Hans Gunther, *Die Verstaatlichung der Literatur* (Stuttgart: J. B. Metzler, 1984); and Katerina Clark, *The Soviet Novel: History as Ritual* (Chicago: University of Chicago Press, 1981).

6. Andreas Ludwig and the Open Depot have no relationship to the Museum Ludwig in Cologne or to its founders, Peter and Irene Ludwig. Andreas Ludwig has coedited a catalogue related to the Open Depot; see *Alltagskultur der DDR: Zur Ausstellung 'Tempolinsen und P2',* ed. Jörg Engelhardt, Petra Gruner, and Andreas Ludwig (Berlin: Bebra, 1996).

7. Guest books were a common sight in GDR museums, as were notebooks for recording comments and complaints for the managers of many institutions, such as schools, hospitals, and shops. Citizens were meant to understand that they played a decisive role in policy making and that administrators would take seriously their public criticism.

8. For an overview of gender relations before and after the postcommunist turn, see Heike Trappe, *Emanzipation oder Zwang? Frauen in der DDR zwischen Beruf, Familie und Sozialpolitik* (Berlin: Akademie Verlag, 1995); and Martin Diewald and Karl Ulrich Mayer, eds., *Zwischenbilanz der Wiedervereinigung: Strukturwandel und Mobilität im Transformationsprozess* (Opladen: Leske + Budrich, 1996).

9. After unification, state officials revised the budgets and planning of Brandenburg's museums and memorials to coordinate with the directives already in place in the FRG. They also considered a proposal to significantly expand the Sachsenhausen memorial site, a project that would reappropriate all of the camp's former territory. The renovated memorial would thus encompass buildings that currently house several dozen Oranienburg citizens.

Sachsenhausen was originally conceived as a prototype prison camp, in which the proximity of the camp grounds to the administrators' offices and homes would ensure model management and optimal efficiency. Yet when Sachsenhausen became a memorial

site, it only included the camp grounds proper, since the administrative and living quarters had already been appropriated by the GDR's People's Army. Architect Daniel Libeskind (who designed Berlin's Jewish Museum) proposes to reinclude these inhabited zones in the new Sachsenhausen memorial. Realizing these plans would make Sachsenhausen the first camp memorial to disclose the fluid and essential link between a concentration camp and the rest of the city that surrounded and maintained it. The memorial would demonstrate that Sachsenhausen was not a prosthesis to the otherwise normal body of Oranienburg, but rather that it functioned as one of its vital organs.

Libeskind proposed to trace out the original grounds of the camp with low-lying markers, but to leave the enclosed space empty—a testament to the losses incurred there. The city eventually accepted his proposal, but only with substantial modifications. In the project that is currently under way, only half of the grounds will be left fallow, while the other half will be developed to support a residential community. In 1996 a group of Oranienburgers protested that Libeskind's plan to incorporate the outlying SS buildings would only serve to glorify the officers' memory and would thus risk inciting neofascist fervor. The dispute remains unresolved. For research on the debates about the competing histories of national and state socialism in Oranienburg, I am indebted to Andrew Piper.

10. In this essay Annette Simon dispassionately recalls both her engagement with an oppositional student group and the price she paid for supporting Czechoslovak dissidents in the seventies. Simon's family enjoyed considerable prestige in the GDR (her parents are the writers Gerhard and Christa Wolf), but that notwithstanding she was excommunicated from the inner sanctum of what some might have called federal favor, what many others would have called state control. Annette Simon, *Versuch, mir und anderen die ostdeutsche Moral zu erklären* (Giessen: Psychosozial-Verlag, 1995).

11. Like "archive," the words "autarchy" and "menarche" also derive from *arkhein,* a verb that the *Oxford English Dictionary* considers to be "of unknown origin." "Archive," *Oxford English Dictionary,* 1989 ed. For a prolonged reflection on this etymology, see Jacques Derrida, *Archive Fever: A Freudian Impression,* trans. Eric Prenowitz (Chicago: University of Chicago Press, 1996), 1–5.

12. Nora's debt to Halbwachs is clear in his essay "Between Memory and History," in *Realms of Memory.* Dominick LaCapra differs with Nora's (and, by extension, Halbwachs's) "pathos-charged" opposition between memory and history, arguing that memory is a "crucial source for history" in that it can critically supplement documentary sources. See Dominick LaCapra, *History and Memory after Auschwitz* (Ithaca: Cornell University Press, 1998), 19.

13. In the late nineties the Lenin bust and its cover were spirited away without ceremony. But while the case remained in place, it began to take on its own significance. The fate of

this Lenin bust is comparable with that of the pedestal of Dzerzhinskii's monument in Moscow. As Mikhail Yampolsky notes, the base was left standing after the statue of the KGB leader was hauled off on the night of August 21–22, 1991: "A monument was detached from a pedestal that was recognized to be historically more valuable than the monument itself." Yampolsky asks, "to what is the pedestal a monument, if there is no figure on top of it? The answer is, apparently, the stability of time[.]" Mikhail Yampolsky, "In the Shadow of Monuments: Notes on Iconoclasm and Time," trans. John Kachur, *Soviet Hieroglyphics: Visual Culture in Late Twentieth-Century Russia,* ed. Nancy Condee (Bloomington: Indiana University Press, 1995), 97. Like the pedestal (without Dzerzhin-skii), the case (with or without Lenin) designated a place for the accumulation of time. If, as Yampolsky maintains, the aim of the Soviet regime was "the immediate achievement of an ahistorical condition (Communism)," then the lingering of the Lenin case could be seen as a subtle extension of the USSR's twilight years (Yampolsky 106).

For a fascinating study of monuments and mourning in Russia, Romania, and Yugoslavia—a veritable necrology of postsocialism—see Katherine Verdery, *The Political Lives of Dead Bodies: Reburial and Postsocialist Change* (New York: Columbia University Press, 1999).

14. Derrida uses the expression "tender rejection" to describe the work of mourning in his memoirs for Paul de Man. He writes of mourning as "an aborted interiorization" that shows "respect for the other as other." This movement of renunciation "leaves the other alone, outside, over there in his death, outside of us." Jacques Derrida, *Mémoires: For Paul de Man,* trans. Cecile Lindsay, Jonathan Culler, and Eduardo Cadava (New York: Colum-bia University Press, 1986), 35.

15. Oskar Negt and Alexander Kluge, *Public Sphere and Experience: Toward an Analysis of the Bourgeois and Proletarian Public Sphere,* trans. Peter Labanyi, Jamie Owen Daniel, and Assenka Oksiloff (Minneapolis: University of Minnesota Press, 1993), 277.

CHAPTER 2 · SOLIDARITY

1. For an overview of the forces that shaped social policy in the postcommunist transi-tion in Poland, Hungary, the Czech Republic, Slovenia, and Slovakia, see Zsuzsa Ferge, "Welfare and 'Ill-Fare Systems in Central-Eastern Europe," in *Globalization and European Welfare States: Challenges and Change,* ed. Robert Sykes, Bruno Palier, and Pauline M. Prior (New York: Palgrave, 2000), 127–52.

2. Andrzej Wajda himself can be seen as a Polish romantic. He has stated that the roman-tic artist had to be "more than a maker"; he needed to be "the conscience of the nation, a prophet, a social institution." Quoted in Bolesław Michałek and Frank Turaj, *The Modern*

Cinema of Poland (Bloomington and Indianapolis: Indiana University Press, 1988), 136. In *Man of Marble* and *Man of Iron*, as well as his other films (most particularly the 1958 *Ashes and Diamonds*), Wajda depicts his protagonists as national martyrs defending Poland against the immorality of Germany and Russia. Long under partition, "Poland" was only sustained through its literature and art for lengthy periods of the eighteenth through twentieth centuries. Polish writers and artists thus invested themselves with the power and responsibility to govern a "cultural republic" in the times when Poles did not exercise political autonomy.

3. Stakhanovite workers were honored and rewarded for model diligence and productivity. The term "Stakhanovite" is derived from the name Aleksei Grigorievich Stakhanov (1906–1977), who is credited with beginning a movement among workers and peasants to increase production in the Soviet Union in the mid-1930s. Although the Soviet press celebrated the movement, historians later demonstrated that Stakhanovite achievements were widely propagandized. Where workers received the most advanced equipment and the most favorable conditions, they produced superior results that would not likely have been matched by conventional production methods.

4. Abortion law is particularly volatile in Poland. During the past decade, legislation on reproductive rights has been in flux. In the name of "civil disobedience," Solidarity urged its members to withold tax payments as a protest against the pro-choice legislation still extant in the early nineties. Today the Democratic Left Alliance, the coalition that grew out of the former Communist Party, is the only party in Parliament with a pro-choice platform. See Eleonora Zielińska, "Between Ideology, Politics, and Common Sense: The Discourse of Reproductive Rights in Poland," in *Reproducing Gender: Politics, Publics, and Everyday Life after Socialism,* ed. Susan Gal and Gail Kligman (Princeton: Princeton University Press, 2000).

5. In 2002 the activist group Women on Waves planned to anchor their "abortion ship" just off Poland's Baltic coast. There, outside the purview of Polish law, its physicians would be able to administer the abortion drug RU-486 to visiting patients. Legal disputes in other countries, however, have impeded their plans.

6. Adam Michnik, "The Wajda Question," *Salmagundi* 128–29 (Fall 2000–Winter 2001): 137–79.

7. The best-researched works available on the censorship of Polish cinema and literature in the 1970s and 1980s include Leszek Szaruga, *Wobec totalitaryzmu: kostium koscielny w prozie polskiej wobec cenzury* (Szczecin: Ottonianum, 1994); and *Z historii walki o wolność słowa w Polsce: Cenzura w PRL w latach 1981–1987* (Cracow: Towarzystwo Autorów i

Wydawców Prac Naukowych Universitas, 1990). See also Jane Leftwich Curry, ed. and trans., *The Black Book of Polish Censorship* (New York: Vintage Books, 1984).

8. For a thorough elaboration of narrative operations in cinema, see David Bordwell, *On the History of Film Style* (Cambridge: Harvard University Press, 1997), and the seminal *Narration in the Fiction Film* (Madison: University of Wisconsin Press, 1985).

9. The influence of feminist film theory are manifest in this chapter. The critical frame of reference is established by these texts: Laura Mulvey, "Visual Pleasure and Narrative Cinema," *Screen* 16, no. 4 (Autumn 1975): 6–18; and Kaja Silverman, "The Fantasy of the Maternal Voice: Female Subjectivity and the Negative Oedipus Complex," in *Acoustic Mirror: The Female Voice in Psychoanalysis and Cinema* (Bloomington: Indiana University Press, 1988), 101–40.

10. Janina Fałkowska remarks upon the negative reception of Agnieszka's character by older spectators, who found her too cynical and unladylike. The review by Bożena Sycowna, which Fałkowska cites in her useful study *The Political Films of Andrzej Wajda*, provides a good example of this response. Sycowna writes: "Agnieszka is not a nice protagonist. [. . .] She decides to make a film about the 1950s not because this is the time of her father which she wants to recount. It is not entirely true. She acts from a very egotistic point of view, as she wants to have a catchy story for her diploma film." Bożena Sycowna, "Człowiek z marmuru," in *Powiększenie* (Cracow: Studenckie Centrum Kultury Uniwersytetu Jagiellońskiego Rotunda, 1981). See Janina Fałkowska, *The Political Films of Andrzej Wajda: Dialogism in "Man of Marble," "Man of Iron," and "Danton"* (Providence: Berghahn Books, 1996), 122.

11. Sexual politics have attracted Wajda's attention at several points in his career. In his 1996 feature *Panna nikt* (*Miss Nobody;* based on Tomek Trzyna's novel), Wajda took on the problems of femininity and postcommunist transition, but with even less success than in the Solidarity epic. The film chronicles a girl's maturation as she moves from the Polish countryside to Warsaw and is corrupted by the forces of competition. Where Wajda could have inflected his film with the subtlety that charged his early productions, he instead offers only reduced, wooden characters — especially in the case of the three girls who dominate the film. Wajda's attempts to portray the drama of female adolescence (including making and breaking friendships and experimenting with witchcraft) are flat and uncompelling; but the weakest moment of *Miss Nobody* — when Marysia has her first period — suggests not only that Wajda has lost his touch as a director, but that he is also losing touch with lived reality.

12. The Solidarity poster child provided another key image for the movement in the eighties. Supporters put up images of a small child, born in 1980, who held up his fingers

in victory and symbolized the growth of Solidarity. Every year a recent photograph of the child would be made into a new poster with the inscription "Solidarity Two Years Old," "Solidarity Three Years Old," etc.

13. Krystyna Janda would seem to concur with my point about the change in her character. In an interview in *Cinéaste,* she claims, "My development is obvious in *Man of Iron,* which came four years after *Man of Marble.* My Agnieszka changed. . . . For example, I knew Agnieszka would not enter the shipyard, I knew that, as a woman, I should stay with the child. We considered for a long time whether I should participate in the strike. And Andrzej (Wajda) said, "No, because now you have to make yourself over into another symbol—the mother who protects the future. Because that's how it ought to be. This is already the next stage in the historical development." Michael Szporer, "Woman of Marble: An Interview with Krystyna Janda," *Cinéaste* 18, no. 3 (1991): 14. Fałkowska also cites this text (*The Political Films of Andrzej Wajda,* 119).

14. For a key study of woman as kinship token, see Gail Rubin, "The Traffic in Women: Notes on the Political Economy," in *Toward an Anthropology of Women,* ed. Rayna Reiter (New York: Monthly Review Press, 1975), 157–210.

15. Although the committee also demanded freedom of expression, it was only to the extent that this freedom would comply with the existing constitutional guarantee of free speech and a free press. The other grievances included in the manifesto issued from a patently socialist stance: improved work conditions, full medical care, a second day of rest on Saturday. Solidarity's list of demands included one that, although it appeared consistent with socialist principles, actually aligned with the bourgeois social vision supported by the Catholic Church. Grievance number 18, which demanded a three-year paid maternity leave, would function to the detriment of working women, as it furnished employers with a convenient defense against the hiring of "potentially less reliable" women applicants.

For the complete list of Solidarity's demands, see *Protokoły Porozumień Gdańsk, Szczecin, Jastrzębie. Statut NSZZ "Solidarność"* (Warsaw: KAW, 1980), and Peter Rainer, *Independent Social Movements in Poland* (London: LSE/Orbis, 1981) 486–88.

16. For another delineation of Solidarity's socialist roots, see Timothy Garton Ash's essays "Inside the Lenin Shipyard: Workers, August 1980" and "Democratic Communism?" in Timothy Garton Ash, *The Polish Revolution: Solidarity, 1980–82* (London: Granta, 1991).

17. I borrow the notion of leftist melancholia from Walter Benjamin, who coined it in his essay "Linke Melancholie," in Walter Benjamin, *Gesammelte Schriften,* vol. 3 (Frankfurt: Suhrkamp, 1972), 279–83.

1. For a contemporary perspective on nostalgia, particularly within the context of post-Soviet Russia, see Svetlana Boym, *The Future of Nostalgia* (New York: Basic Books, 2001), xvi. Two key texts on the notion of nostalgia are Jean Starobinski, "The Idea of Nostalgia," *Diogenes* 54 (Summer 1966): 81–103, and Vladimir Yankelévitch, *L'Irréversible et la nostalgie* (Paris: Flammarion, 1974).

2. Tony Harrison, *Prometheus* (London: Faber and Faber, 1998), viii.

3. Leslie Kaplan, *L'Excès-l'usine* (Paris: POL, 1982). This work has not been translated into English; throughout this text I refer to it as *Factory Excess.*

4. Michael Hardt and Antonio Negri suggest the feminist potentials of biopower and immaterial labor in their section "Biopolitical Production" in *Empire.* Michael Hardt and Antonio Negri, *Empire* (Cambridge: Harvard University Press, 2000), 23–30.

5. In *Keeping a Rendezvous* John Berger's *ostalgisch* tendencies come through in full force. His book includes several essays on both the collapse of communism in Eastern Europe and the fate of solidarity among unionized miners in Britain. See John Berger, *Keeping a Rendezvous* (London: Penguin, 1992).

6. Bryan S. Turner's essay "A Note on Nostalgia" offers a useful insight on the "homelessness" that afflicts John Berger, in both *Into Their Labors* and *Ways of Seeing,* as well as Jean Baudrillard. Bryan S. Turner, "A Note on Nostalgia," *Theory, Culture and Society* 4 (1987): 153.

7. Most of the criticism of *Once in Europa* turns around this point. See Fred Pfeil, "Between Salvage and Silvershades: John Berger and What's Left," *Triquarterly* 88 (Fall 1993): 230–45; Geoff Dyer, *Ways of Telling: The Work of John Berger* (London: Pluto, 1986), 118–27; and Michael Messmer, "Apostle to the Techno/Peasants: Word and Image in the Work of John Berger," in *Image and Ideology in Modern/PostModern Discourse,* ed. David Downing and Susan Bazargan (Albany: SUNY, 1991), 199–227.

8. John Berger, *Lilac and Flag* (New York: Pantheon, 1990), 117.

9. John Berger, "Keeping a Rendezvous," *Nation,* 7 May 1990, 625.

10. John Berger, *Once in Europa* (New York: Pantheon, 1987), 164.

11. Unless otherwise noted, all translations in this chapter are mine.

12. Kaplan recalls, "It took me ten years to be able to say something which was not anecdotal, which was not miserably fatalist. I think that, in effect, at the beginning I wanted to write the factory, to write that place." Marguerite Duras and Leslie Kaplan, "Duras, Kaplan: *L'Excès-l'usine*," *L'autre journal* 5 (15 May 1985): 54.

13. Duras and Kaplan, 56. Duras and Kaplan's thoughts on the feminization of industrial labor merit comparison with Hannah Arendt's writing on the etymology of the terms "labor" and "work" in *The Human Condition,* to which I refer in the introduction. See Hannah Arendt, *The Human Condition* (Chicago: University of Chicago Press, 1998), esp. 79–93.

14. Duras and Kaplan, 58.

15. See the section on "The Blocking of Social Experience in the Proletarian Context of Living" in Oskar Negt and Alexander Kluge, *Public Sphere and Experience: Toward an Analysis of the Bourgeois and Proletarian Public Sphere,* trans. Peter Labanyi, Jamie Owen Daniel, and Assenka Oksiloff (Minneapolis: University of Minnesota Press, 1993), 28–32.

16. Mary Hopkin, "Those Were the Days." By Gene Raskin. Essex Music Ltd, 1968.

17. Prometheus's defiance inspired many of the great romantics, as Harrison notes in his prologue. In *The Politics of Paradise: A Vindication of Byron,* Michael Foot (a former leader of the Labor Party) writes that Heine identified Byron with Prometheus himself. Harrison cites Heine: like Prometheus "[h]e defied miserable men and still more miserable gods." In honor of Byron, Mazzini wrote that the dead poet seemed "a transformation of that immortal Prometheus, [. . .] whose cry of agony, yet futurity, sounded above the cradle of the European world." For all these references, see Harrison, *Prometheus,* xv–xvi.

18. See Oskar Negt, *Arbeit und menschliche Würde* (Göttingen: Steidel, 2001), 474. In his section on "The Wound of Auschwitz," Negt also reflects upon the historical problem of technology and stresses the value of efficiency and precision within the project of German genocide. His emphasis on the terms "smooth" and "friction-free" in the works of Arendt and Adorno echoes Negt's earlier collaborations with Alexander Kluge. The fetishization of technology subtended the slightest thought of any final solution, Negt insists; Adolf Eichmann, the "engineer of dead freight" is thus a prototype of this mindset. In his official apology, Eichmann considered himself responsible only for the smooth direction of traffic ("reibungsloser Verkehr"), not for that which was inflicted upon the human cargo ("menschliches Frachtgut") transported to the camps. Adorno sharpens this insight, and heightens its salience, when he writes of the Nazi collaborators who

dispatched the victims efficiently ("reibungslos") to Auschwitz, and then "forgot" what awaited them there (Negt, *Arbeit und menschliche Würde* 481). Negt cites Hannah Arendt, *Eichmann in Jerusalem: A Report on the Banality of Evil* (New York: Penguin, 1964); and Theodor W. Adorno, *Erziehung zur Mündigkeit* (Frankfurt: Suhrkamp, 1970), 100.

19. In March 1984 Margaret Thatcher announced the closure of twenty coal mines and the loss of twenty thousand jobs. Miner's union president Arthur Scargill called for an immediate strike, an action that would draw itself out for more than a year. This strike triggered violent clashes between and among police and union demonstrators, and cut deep divisions into the British people. Scargill, a stalwart Marxist, won popular support with his insistence that coal was central to British tradition: it catalyzed both a unique way of life in Britain and the country's industrial revolution. Following 1979's winter of industrial discontent, Thatcher developed an antagonistic view of both the coal industry and the labor unions that strove to foster it. She targeted union militancy as the cause of the country's postwar decline; it fomented strikes, hampered productivity, and gave Britain an unfortunate reputation as "the sick man of Europe." The miners' union was a centerpiece in the labor edifice that her conservative government sought to dismantle. Aware of this, Thatcher crafted a careful plan to decommission England's collieries. Thatcher's critics suspect that she dispatched government agents to infiltrate and destabilize the union. But acrimony had already been spreading among the miners since the first weeks of the movement: Scargill had refused to hold a national ballot of the miners before calling them out on strike — an imperious tactic that would open up fault lines within the union. This discord led some demoralized miners to break the strike and return to the collieries in the spring of 1985. Scargill recognized that the strike had exhausted itself, but he refused to publicly admit defeat. He organized grand parades of brass bands to usher the workers back to the pits, but many feared that the labor movement was convulsing in its final agonies. Once infighting had ignited, no amount of fanfare could restore the unions to their former might. For other accounts of the miners' strike, see Roy A. Church, *Strikes and Solidarity: Coalfield Conflict in Britain* (Cambridge: Cambridge University Press, 1998); and Jean Stead, *Never the Same Again: Women and the Miners' Strike, 1984–85* (London: The Women's Press, 1987).

20. Turner also allows for the sort of subversive nostalgia that we see Herman deploy in *Brassed Off.* Although his essay implies that the nostalgic paradigm typically assumes a conservative form, Turner remarks, "we have also to recognize that nostalgia may play a highly ambivalent role in social criticism and political protest. By converting the past into a Utopian homestead, nostalgia may lay the foundations for a radical critique of the modern as a departure from authenticity" (Turner 154).

21. Max Horkheimer and Theodor W. Adorno, *Dialectic of Enlightenment*, trans. John Cumming (New York: Continuum, 1974), 35.

22. Fredric Jameson offers this translation of *das Unwiederbringliche* in his study of Adorno (Jameson, *Late Marxism: Adorno, or, the Persistence of the Dialectic* [London: Verso, 1990], 130). John Cumming, the translator of *Dialectic of Enlightenment*, rendered *das Unwiederbringliche* as "that which is unrepeatable." Horkheimer and Adorno, *Dialectic of Enlightenment*, 34.

23. Against the notion of an objective dichotomy between silence and sound, John Cage identified an essential crux between intentional hearing and the diversion of attention to sounds. "Silence," he maintained, "is not acoustic." He considered *4'33"* a silent frame filled with nonintentional environmental sounds. See John Cage, "Experimental Music" (1957), in *Silence* (Middletown, Conn.: Wesleyan University Press, 1961) 8; and David Revill, *The Roaring Silence* (New York: Arcade, 1992), 164.

24. Jean-Pierre Vernant, *Mortals and Immortals: Collected Essays*, ed. Froma Zeitlin (Princeton: Princeton University Press, 1991), 104.

25. The question of the Sirens' silence has elicited a rich array of critical responses, including Tzvetan Todorov, *The Poetics of Prose*, trans. Richard Howard (Oxford: Basil Blackwell, 1977); Pietro Pucci, *Odysseus Polutropos: Intertextual Readings in the "Odyssey" and the "Iliad"* (Ithaca: Cornell University Press, 1987); and Renata Salecl's synthesis of these analyses in her psychoanalytic reading, "The Sirens and Feminine Jouissance," *differences* 9, no. 1 (Spring 1997): 14–35.

26. Jameson articulates a similar argument about Adorno's distinction between art and the individual artwork in *Aesthetic Theory*. See Jameson, *Late Marxism* 130; and Theodor W. Adorno, *Aesthetic Theory*, ed. Gretel Adorno and Rolf Tiedemann, trans. Robert Hullot-Kentor (Minneapolis: University of Minnesota Press, 1997), 20, 182.

27. In *The Origin of Negative Dialectics*, Susan Buck-Morss offers a close analysis of Adorno's views on dialectical materialism and suggests that he continued to defend Marx's schema of "feudal, bourgeois, and classless epochs" after writing *Dialectic of Enlightenment* and well into the 1950s. See Buck-Morss, *The Origin of Negative Dialectics: Theodor W. Adorno, Walter Benjamin and the Frankfurt Institute* (New York: Free Press, 1977), 60–62, 230 n. 134; and Russell Jacoby, "Towards a Critique of Automatic Marxism: The Politics of Philosophy from Lukács to the Frankfurt School," *Telos* 10 (Winter 1971): 140–46.

28. If Berger's dystopic vision of factory life begins to resemble that of Kaplan as he moves from *Once in Europa* to *Lilac and Flag*, his sensibilities in another drama, *A Question of Geography* (London: Faber, 1987; coauthored with Nella Bielski, premiered at the Théâtre National de Marseille), likewise recall Kaplan's *Factory Excess*. Conceived during

the decade when Berger worked on *Into Their Labors,* this drama about life in the Soviet gulag Magadan anticipates many of the perspectives on the socialist requiem that Berger articulates in *Lilac and Flag.* It also taps into the trope of music. In *A Question of Geography* the characters while away their lives in the harsh Kolyma "zone" inhabited by former prisoners of the Magadan labor camp. Igor Gertzmann, a one-time violin virtuoso, despairs that he and the other ex-convicts have been thrown out of time. Forced labor has divested them of historical experience; this loss cuts through every aspect of the life that remains to them. When he first arrived at Magadan, Igor had drawn upon his musical formation — Bach's Prelude in F minor, "Death and the Maiden," Mozart concertos — and replayed these memories to fend off the horrors of the camp. "With all those bars in your head," he explains, "you forget the barbed wire, you forget everything else" (Berger and Bielski 15). But soon the gulag muted Igor's memory; it emptied music from his soul and filled it with the silence of "pure geography." Without a sense of time, in Magadan there is no music and no sense (16).

Berger and Bielski confront with humility and respect the problem of how to measure the brutality of the Soviet labor camp. The silence of Magadan becomes a delicate metaphor for the massive damage inflicted not only upon its individual prisoners, but also upon the larger society which both supported and depended upon forced labor — the industrial apocalypse that Stalin aimed to realize. But whereas *A Question of Geography* seeks adequate means to trace out the horizons of this real trauma, *Into Their Labors* seems less deft in comparison. For in his trilogy Berger minimizes the many considerable
differences between the labor camp and the experience of factory work. As is the case in *Factory Excess,* industrial labor loses its temporal anchor in *Once in Europa* and *Lilac and Flag,* and factory workers are consigned to historical oblivion. Against this, the symbolic act of *Brassed Off* reintroduces a critical measure of temporality. Here music — the purest aesthetic expression of time — reactivates our perception of history. The catalogue that Herman summons forth carries the same nostalgic resonances as those selected by Berger and Kaplan. But the score's subjective mode of deployment enables *Brassed Off* to register persistent antagonisms that might otherwise appear to have reached a postindustrial standstill.

29. Harrison's relegation of cleaning to Io would appear to concur with Hannah Arendt's denigration of (women's) bodily labor (Arendt, *The Human Condition,* 93–102).

30. Karl Marx, *Capital,* vol. 3 (New York: Vintage, 1977), 875. Negt and Kluge use the equivalent expression "original expropriation" instead of "primitive accumulation."

31. Christopher Pavsek draws upon this argument about the emergence of capital to distinguish Negt and Kluge's Marxism from that of Slavoj Žižek in *For They Know Not What They Do: Enjoyment as a Political Factor* (London: Verso, 1991) and Ernesto Laclau in *New Reflections on the Revolution of Our Time,* trans. Jon Barnes (London: Verso, 1990). Žižek and

Laclau assume that, after capitalism established itself in the act of primitive accumulation, "the process of capitalist accumulation was driven by its own laws — that is to say that it generated its own conditions of existence" (Laclau 25). Pavsek argues that Negt and Kluge (against Žižek and Laclau) abandon "the associated beliefs and hopes for the immanent and necessary collapse of capital by its own logic, the eventual sublation of the principle of private property, and the inevitable success of socialism." For Negt and Kluge, capital constantly reenacts original expropriation within itself. Christopher Pavsek, "*History and Obstinacy:* Negt and Kluge's Redemption of Labor," *New German Critique* 68 (Spring/Summer 1996): 155–57. See also Negt and Kluge, *Geschichte und Eigensinn*, 35.

32. Hardt and Negri provide an example of this sort of celebration in the conclusion of *Empire.* They write, "[I]n postmodernity we find ourselves [. . .] posing against the misery of power the joy of being. This is a revolution that no power will control — because biopower and communism, cooperation and revolution remain together, in love, simplicity, and also innocence." Hardt and Negri, *Empire,* 413.

33. Horkheimer and Adorno, 295; Negt and Kluge, *Public Sphere and Experience,* 246. As Fredric Jameson notes, Negt and Kluge cite this passage from *Dialectic of Enlightenment* in *Public Sphere and Experience.* Jameson, "On Negt and Kluge," *October* 46 (Fall 1988): 175.

CHAPTER 4 · MOURNING

1. Jacques Derrida touches upon this sense of loss in *Specters of Marx: The State of the Debt, the Work of Mourning, and the New International.* Indeed there are several points of contact between Derrida's reflections on Marxism and the project at hand — first at the level of terminology, and also by way of the engagement with *Hamlet.* But where *Specters of Marx* stages an encounter among four minds — Shakespeare, Paul Valéry (the "political economy of spirit"), Maurice Blanchot (the essay on "Marx's Three Voices"), and Heidegger (his notion of the gift) — this chapter draws upon Freud's "Mourning and Melancholia" by way of Jacques Lacan's invocation of *Hamlet.* Derrida's main concern is to heed the injunction of a communist future. This chapter takes a reverse temporal direction; its stance toward the socialist crisis is a retrospective one. See Jacques Derrida, *Specters of Marx: The State of the Debt, the Work of Mourning, and the New International,* trans. Peggy Kamuf (New York: Routledge, 1994), especially 3–48.

2. Freud's term *Trauerarbeit* (mourning work) is comparable to *Traumarbeit* (dream work), which was one of his central concerns. Sigmund Freud, "Mourning and Melancholia," in *The Standard Edition of the Complete Psychological Works of Sigmund Freud,* vol. 14, trans. and ed. James Strachey (London: Hogarth, 1995), 243. Hereafter I refer to *The Standard Edition* as *SE.*

3. Jacques Lacan, "Desire and the Interpretation of Desire in *Hamlet*," trans. James Hulbert, *Yale French Studies* 55–56 (1977): 37. Cf. Lacan, *Le Désir et son interprétation: Séminaire 1958–59* (Paris: L'Association freudienne internationale, 1984), 352.

4. Lacan, "Desire and the Interpretation of Desire in *Hamlet*," 38; Lacan, *Le Désir et son interprétation,* 353.

5. For a fuller analysis of Whiteread's *Holocaust Monument,* see Rebecca Comay, "Memory Block: Rachel Whiteread's Proposal for a Holocaust Memorial in Vienna," *Art and Design* 12, nos. 11–12 (July–August 1997): 64–75. James E. Young and Andreas Huyssen, both of whom have written on the status of the monument in contemporary culture, have also published essays on Whiteread. See James E. Young, "Memory, Countermemory, and the End of the Monument," in *At Memory's Edge: After-Images of the Holocaust in Contemporary Art and Architecture* (New Haven: Yale University Press, 2000), 90–119; and Andreas Huyssen, "Sculpture, Materiality and Memory in an Age of Amnesia," in *Displacements: Miroslaw Balka, Doris Salcedo, Rachel Whiteread* (Toronto: Art Gallery of Ontario, 1998). The definitive catalogue on Whiteread's memorial is Simon Wiesenthal, ed., *Projekt: Judenplatz Wien* (Vienna: Paul Zsolnay, 2000).

6. In interviews, Whiteread noted that this recent project was an extension of *Untitled (Room),* a similarly formal piece that she created while a fellow of the German Academic Exchange Service in Berlin. "*Room* was actually made from a fictional space," Whiteread explains. "I made a plywood mold for the room, as if it were a prop. It had one window, one door, and just looked completely blank. It didn't even have a light switch or any electrical bits in it." Craig Houser, "If Walls Could Talk: An Interview with Rachel Whiteread," in *Rachel Whiteread: Transient Spaces,* ed. Lisa Dennison and Craig Houser (New York: Guggenheim Museum Publications, 2001), 55.

7. Rosalind Krauss, Lynne Cooke, and Mignon Nixon situate Whiteread's sculpture at the end of a minimalist genealogy. See Rosalind Krauss, "Rachel Whiteread: Making Space Matter," *Tate* 10 (Winter 1996): 32–36; Lynne Cooke, "Rachel Whiteread," *Burlington Magazine* 137, no. 1105 (April 1995): 273–74; and Mignon Nixon, "Bad Enough Mother," *October* 71 (Winter 1995): 71–92.

8. Before Whiteread made *House,* Anthony Vidler had thematized both the body and the home in the built environment. See Anthony Vidler, *The Architectural Uncanny: Essays in the Modern Unhomely* (Cambridge: MIT Press, 1992).

9. Whiteread's sculpture references the work of a whole host of artists. She herself has emphasized the influence of several sculptors—Tony Smith above all, but also Carl Andre, Richard Serra, and Eva Hesse. Although Whiteread acknowledges the parallels between

her casting process and Bruce Nauman's procedure for *Cast of the Space under My Chair,* she maintains that her work takes up a different conceptual problematic. For Whiteread's remarks on influence, see Houser in Dennison and Houser, eds., *Rachel Whiteread: Transient Spaces,* 56. Two important texts on Nauman's casts are Bruce Nauman and Joan Simon, "Breaking the Silence: An Interview with Bruce Nauman," *Art in America* 76, no. 9 (September 1988): 141–203; and Reto Krüger, "Einige Bemerkungen zu den Abgußarbeiten," in *Bruce Nauman: Werke aus den Sammlungen Froehlich und FER,* ed. Götz Adriani (Ostfildern-Ruit: Hatje Cantz, 1999), 27–38. A key essay on cast impressions is Georges Didi-Huberman, "L'Empreinte comme processus: Vers la modernité en sculpture," especially the subsection "Formes mortifiées: L'Empreinte comme deuil." Georges Didi-Huberman, *L'Empreinte* (Paris: Éditions du Centre Georges Pompidou, 1997), 73–105.

10. Benjamin H. D. Buchloh and Brian Hatton situate Dan Graham's work within postwar American art, focusing on his use of architecture as medium. See Benjamin H. D. Buchloh and Dan Graham, "Four Conversations: December 1999–May 2000" and Brian Hatton, "Dan Graham in Relation to Architecture," both in *Dan Graham: Works 1965–2000,* ed. Marianne Brouwer (Düsseldorf: Richter Verlag, 2001).

11. Gouaches that Whiteread made while living in Berlin are documented in Friedrich Meschede, ed., *Rachel Whiteread: Gouachen* (Stuttgart: Cantz, 1993).

12. Rolf-E. Breuer, foreword to Dennison and Houser, eds., *Rachel Whiteread: Transient Spaces,* 21.

13. Thomas Krens, preface and acknowledgments to Dennison and Houser, eds., *Rachel Whiteread: Transient Spaces,* 23.

14. Krens, 23.

15. The following texts give an overview of the public response to *House* and the debates it set off about social policy: Rachel Barnes, "No More House Work: With *House,* Rachel Whiteread Joined Politics, Art, and Anger," *Guardian,* 8 April 1995, 28; Mark Cousins, "Inside Outcast," *Tate* 10 (Winter 1996): 36–41; Michael Kimmelman, "How Public Art Turns Political," *New York Times,* 28 October 1996, C 15, C 18; Doreen Massey, "Space-Time and the Politics of Location," *Architectural Design* 68 (March–April 1998): 34–38; and, most recently, Anthony Vidler, "Full House: Rachel Whiteread's Postdomestic Casts," in *Warped Space: Art, Architecture, and Anxiety in Modern Culture* (Cambridge: MIT Press, 2000), 143–50.

16. In "Mourning and Melancholia" Freud defines mourning as "the reaction to the loss of a loved person, or to the loss of some abstraction which has taken the place of one, such as one's country, liberty, an ideal, and so on" (*SE* 14:243).

17. For another approach to the social issues surrounding *House,* see Lisa Dennison, "A House is Not a Home: The Sculpture of Rachel Whiteread," in Dennison and Houser, eds., *Rachel Whiteread: Transient Spaces,* 31–62.

18. Neil Thomas has documented the process of casting *House.* See Thomas, "The Making of *House:* Technical Notes," in *House: Rachel Whiteread,* ed. James Lingwood (London: Phaidon, 1995).

19. *East London Advertiser,* 4 November 1993, unpaginated.

20. See Neal Benezra, "Rachel Whiteread: A Sense of Silence," in *Distemper: Dissonant Themes in the Art of the 1990s,* ed. Neal Benezra and Olga Viso (Washington: Smithsonian Institution, 1996), 104–14; and Hans Pietsch, "Rachel Whiteread: Der Blick ins Innere der Dinge," *Art* 2 (February 1999): 46–55.

21. In "The Neuro-Psychoses of Defence" (1894), Freud describes repudiation *(Verwerf-ung)* as a defense mechanism. He writes, "Here, the ego rejects *(verwirft)* the incompatible idea together with its affect and behaves as if the idea had never occurred to the ego at all" *(SE* 3:58). Jean Laplanche and Jean-Bertrand Pontalis compare Freud's use of *Verwerfung* with his use of the terms *Ablehnen* (to fend off, to decline) in "From the History of an Infantile Neurosis" (1918) and *Aufheben* (to suppress, to abolish) in "Psycho-Analytic Notes on an Autobiographical Account of a Case of Paranoia" (1911). See Jean Laplanche and Jean-Betrand Pontalis, *The Language of Psycho-Analysis,* trans. Donald Nicholson Smith (New York: Norton, 1973), 166–69.

22. In *Desire and Its Interpretation,* Lacan refers to his previous elaboration on foreclosure in *The Psychoses,* where he posits that the gesture of foreclosure crosses over from the Symbolic to the Real. See Lacan, "Desire and the Interpretation of Desire," 38; and Lacan, *Le Désir et son interprétation,* 353.

23. The French expression for a housing foreclosure is *saisir un bien hypothéqué.* It has no etymological relationship to *forclusion,* the psychic action of foreclosure.

24. See J. Ford, *The Consequences of Mortgage Arrears and Possessions in a Depressed Housing Market* (Manchester: Joseph Rowntree Foundation Housing Research Findings, 1994).

25. See Mark Kleinman, *Housing, Welfare and the State in Europe: A Comparative Analysis of Britain, France, and Germany* (Cheltenham: Edward Elgar, 1996), 21.

26. For another take on Matta-Clark's project in Milan, see Joan Simon, interview with Gerry Hovagimyan, *Gordon Matta-Clark: A Retrospective,* ed. Mary Jane Jacob (Chicago:

Museum of Contemporary Art, 1985), 88. See also Dan Graham, "Gordon Matta-Clark," *Kunstforum International,* no. 4 (October–November 1985): 114–19; and Daniel Soutif, "Gebt mir ein bißchen Zeit, schnell!," *Kunstforum International,* no. 150 (April–June 2000): 340–46.

27. Pamela M. Lee, *Object to Be Destroyed: The Work of Gordon Matta-Clark* (Cambridge: MIT Press, 2000), 163. My reading of Matta-Clark's *Arc de Triomphe for the Workers* has been enabled by Lee's scholarship.

28. I borrow the expression "makeshift memorial" from John Miller's description of Robert Smithson's *Partially Buried Woodshed* (1970), which he compares with the work of Dan Graham. See John Miller, "Now Even the Pigs're Groovin'," in Brouwer, ed., *Dan Graham,* 373.

Like Matta-Clark's building cuts, Smithson's work is another important precursor to Whiteread's sculpture. To make *Partially Buried Woodshed,* Smithson dumped cartloads of earth on an abandoned outbuilding on the campus of Kent State University. Smithson's concern was to "allegorize architecture's transience," to make entropy visible. See Alison Sky and Robert Smithson, "Entropy Made Visible," in *Robert Smithson: Collected Writings,* ed. Jack D. Flam (Berkeley: University of California, 1996), 309. As in the case of *House,* the historical moment of *Partially Built Woodshed* has overdetermined its reception. Shortly after Smithson left the site, National Guardsmen shot and killed four students demonstrating against the Vietnam War on the school's campus. Subsequently, community members began to consider the artwork a "de facto memorial" to the massacre, as John Miller noted (Miller 373). Years later, university administrators razed the artwork and covered its place with a parking lot.

29. Lee, *Object to Be Destroyed,* 163. Lee references her concept of the "workless community" to both Georges Bataille's *Inner Experience* and Heidegger's groundwork on being toward death. The expression "workless community" suggests that "communities are organized around the commonality of each member's finitude or loss." It is not cooperative experience (i.e., work, common interests) that brings individuals into the workless community, but rather the "mutual recognition of the finitude or radical otherness of the community's members, witnessed in the other's passing" (Lee 262 n. 1). Lee mentions the productive comparisons between *Arc de Triomphe* and the following texts: Georges Bataille, *Inner Experience,* trans. Leslie Anne Boldt (New York: SUNY Press, 1988); and Martin Heidegger, *Being and Time,* trans. Joan Stambaugh (Albany: SUNY Press, 1996). For an examination of the formative role of work in the social construction of meaning, community, and cohesion (particularly as Smith, Weber, and Marx have theorized it), see Bo Stråth, "The Concept of Work in the Construction of Community," in *After Full Employment: European Discourses on Work and Flexibility,* ed. Bo Stråth (Brussels: PIE Lang, 2000), 65–106.

30. Key works on the German Autumn of 1977 include Stefan Aust, *The Baader-Meinhof Group: The Inside Story of a Phenomenon,* trans. Anthea Bell (London: Bodley Head, 1987); *Germany in Autumn,* dirs. Rainer Werner Fassbinder, Heinrich Böll, Edgar Reitz, Alexander Kluge, Volker Schlöndorff, et al., Filmverlag der Autoren, 1981; and Thomas Elsaesser, "The Red Army Faction, *Germany in Autumn,* and *Death Game,"* in *Giving Ground: The Politics of Propinquity,* ed. Joan Copjec and Michael Sorkin (London: Verso, 1999).

31. The three volumes of Oskar Negt and Alexander Kluge's *Geschichte und Eigensinn* are *Entstehung der industriellen Disziplin aus Trennung und Enteignung, Deutschland als Produktionsöffentlichkeit,* and *Gewalt des Zusammenhangs.*

32. My translation, based on Jacob and Wilhelm Grimm, *Household Tales,* vol. 2, trans. Margaret Hunt (London: George Bell, 1884), 125.

33. Oskar Negt and Alexander Kluge, *Geschichte und Eigensinn* (Frankfurt: Suhrkamp, 1981), 768.

34. Fredric Jameson offers a survey of these translations in his essay "On Negt and Kluge." Jameson adds "self-will" to the list, for it not only "restores the component of 'ownness or primal property,'" but also complements this sense of stubbornness with the connotation of a drive. "Self-will" conveys the impulse to pursue an "autonomous line of force." Fredric Jameson, "On Negt and Kluge," *October* 46 (Fall 1988): 158

35. Hegel draws upon Sophocles' Theban plays to elaborate both the nature and dissolution of "true spirit" in Greek ethics. G. W. F. Hegel, *Phenomenology of Spirit,* trans. A. V. Miller (Oxford: Oxford University Press, 1977), 266–89.

36. Negt and Kluge, *Geschichte und Eigensinn,* 770.

37. Quotations are drawn from E. F. Watling's translation of *Antigone.* See Sophocles, *Antigone,* in *The Theban Plays,* trans. E. F. Watling (London: Penguin, 1974).

38. Cf. Negt and Kluge, *Geschichte und Eigensinn,* 769. In her examination of gender in *Antigone,* Judith Butler discloses how "kinship founders on its own foundering laws of kinship." Judith Butler, *Antigone's Claim: Kinship between Life and Death* (New York: Columbia University Press, 2000), 82. Another recent feminist interpretation of Hegel's Antigone is Kimberly Hutchings's *Hegel and Feminist Philosophy.* In "Re-thinking the Second Sex," Hutchings proposes that Hegel does not identify "a transcendent path 'beyond'" mourning (as Butler or Luce Irigaray would have it), but rather "follow[s] through the logic of despair." Kimberly Hutchings, *Hegel and Feminist Philosophy* (Cambridge: Polity, 2003), 105. Although Negt and Kluge reveal the politics of mourning in *Antigone,* their attempts to

valorize Antigone as a protofeminist insurgent for the "millions of women who are oppressed by the double shift [of domestic and paid labor]" fall short (Negt and Kluge, *Geschichte und Eigensinn,* 770). One might surmise that Kluge, especially, was seeking to redeem his work on gender, difference, and women's labor (for example, the projects *Gelegenheitsarbeit einer Sklavin* [1975] and *Die Patriotin* [1979]), which had been denounced as essentialist by several feminists in Germany and abroad. Indeed, this feminist backlash might have impeded a wider reception of Kluge's work in North America. For gendered critiques of Kluge in English, see Helke Sander, "'You Can't Always Get What You Want': The Films of Alexander Kluge," *New German Critique* 49 (Winter 1990): 59–68; Heidi Schlüpmann, "Femininity as Productive Force: Alexander Kluge and Critical Theory," *New German Critique* 49 (Winter 1990): 69–78; and J. O'Kane, "History, Performance and Counter-Cinema: A Study of *Die Patriotin,*" *Screen* 26 (1983): 2–17.

39. When speaking of the dispossessed in *Antigone,* Negt and Kluge use the expression *kollektives Geschichtsverhältnis,* or "collective conditions of history," which could be compared with collective, historical consciousness (Negt and Kluge, *Geschichte und Eigensinn,* 770–71).

40. Sophie Calle's *The Detachment* is discussed in Chapter 1, "The Collective."

41. In *The Language of Psycho-Analysis,* Laplanche and Pontalis refer to Freud's elaboration of displacement, in which he supposes that the operation plays a central role in the psychic work of representation and symbolization. "Representability" is facilitated, they maintain, when "a transition is effected, through displacement, between an abstract idea and an equivalent lending itself to visualization." Therefore it is precisely through this transfer that "psychical interest is transformed into sensory intensity" (Laplanche and Pontalis 123). This same transition takes place in a redoubled way when Whiteread casts a form and then throws away the thing that molded it. The viewer conceives the transition from the abstract idea (the domestic space, dream life, death, etc.) into a material object (a mattress). Then, at this material level, the viewer sees the cast displace the mold. Through this double displacement Whiteread renders the idea of loss as a sensory experience.

42. Houser 52.

43. Lacan, "Desire and the Interpretation of Desire," 23; Lacan, *Le Désir et son interprétation,* 338.

44. Sigmund Freud, "Letter to Ludwig Binswanger, 12 April 1929," in *The Letters of Sigmund Freud,* ed. Ernst L. Freud, trans. Tania and James Stern (New York: Basic Books, 1960), 386.

45. See Lacan's reflections on the "objet petit a" in "In You More Than You," in *The Four Fundamental Concepts of Psycho-Analysis*, trans. Alan Sheridan (New York: Norton, 1979), 263–76.

CHAPTER 5 · MELANCHOLIA

1. Volker Braun, "Das Eigentum," in *Von einem Land und vom anderen. Gedichte zur deutschen Wende*, ed. Karl Otto Conrady (Frankfurt: Suhrkamp, 1993), 51. For an analysis of melancholia in Braun's writing, see Wolfgang Emmerich, "Status Melancholicus. Zur Transformation der Utopie in der DDR-Literatur," in *Literatur in der DDR: Rückblicke*, ed. Heinz-Ludwig Arnold and Frauke Meyer-Gosau (Munich: Edition Text + Kritik, 1991), 232–45; and Horst Domdey, "Volker Braun und die Sehnsucht nach der Grossen Kommunion. Zum Demokratiekonzept der Reformsozialisten (in der DDR)," *Deutschland Archiv* 11 (1991): 1771–74. Unless otherwise indicated, all translations in this chapter are mine.

2. Judith Kuckart, *Melancholie I, oder Die zwei Schwestern*, dir. Jörg Aufenanger. Berliner Ensemble, Berlin; 18 December 1996. Translated and cited with permission of the author.

3. Sigmund Freud, "Mourning and Melancholia," in *The Standard Edition of the Complete Psychological Works of Sigmund Freud*, vol. 14, trans. and ed. James Strachey (London: Hogarth, 1995), 245. This edition is cited hereafter as *SE*.

4. Jacques Hassoun draws upon Freud's description of the melancholic's confusion, bringing it to bear on Vladimir Yankélévitch and Benito Feijo's work on "le je-ne-sais-quoi." See Jacques Hassoun, *La Cruauté mélancolique* (Paris: Aubier, 1995), 64; Vladimir Yankélévitch, *Le Je-ne-sais-quoi et le presque-rien* (Paris: Seuil, 1980), 11; and Benito Feijo, *Le Je-ne-sais-quoi*, trans. Catherine Paoletti (Paris: Éditions de l'Éclat, 1989).

5. See Jürgen Habermas, "The New Opacity: The Crisis of the Welfare State and the Exhaustion of Utopian Energies," in *The New Conservatism: Cultural Criticism and the Historians' Debate*, trans. Shierry Weber Nicholson (Cambridge: MIT Press, 1989).

6. Andreas Huyssen asks why Germans and other Europeans seem to fixate on the past in his recent study of cultural memory, *Twilight Memories: Marking Time in a Culture of Amnesia* (New York: Routledge, 1995).

7. In chapter 1, "The Collective," the operations of collective memory in Ludwig's Open Depot are analyzed.

8. For a theoretical reflection on the distinction between the "thing" and the "object," see Julia Kristeva's study of melancholia, *Black Sun: Depression and Melancholia* (New York: Columbia University Press, 1989), esp. 11–16.

9. I borrow the expression "tender rejection" from Jacques Derrida, who introduced it in his memoirs for Paul de Man. Jacques Derrida, *Mémoires: For Paul de Man,* trans. Cecile Lindsay, Jonathan Culler, and Eduardo Cadava (New York: Columbia University Press, 1986), 35.

10. When Jan Hoet invokes *Economic Values* in his Documenta memoirs, he recalls his experiences in the Eastern Bloc as "powerfully melancholic." He describes life there as a "physical correlative to melancholy," a mode in which "you learn something about depression." Heiner Müller and Jan Hoet, "Insights into the Process of Production—A Conversation," in *Documenta IX,* ed. Jan Hoet (Stuttgart: Edition Cantz, 1992), 96.

11. For a description of Beuys's selection process, see Klaus Staeck and Gerhard Steidl, eds., *Joseph Beuys: Das Wirtschaftswertprinzip* (Heidelberg: Edition Staeck, 1990), 7. For an inflected reading of Beuys's career that has informed this essay, see Benjamin H. D. Buchloh, "Reconsidering Beuys, Once Again" and "Beuys, the Twilight of the Idol," in *Joseph Beuys: Mapping the Legacy,* ed. Gene Ray (New York: DAP, 2001), 75–89, 199–211. Bettina Funcke has recently made a series of compelling arguments that counter aspects of the Buchlovian take, shall we say, of Beuys. Drawing on Kierkegaard's *Entweder-Oder* and Boris Groys's *Unter Verdacht,* Funcke demonstrates that Beuys's self-idealization as artist, as hero, was a consciously ironic strategy of his work. Beuys pitched his project to performatively destabilize two notions of postwar subjectivity—that any German could remain under the sway of a *Führer,* Hitler or some other, and that any member of the art world could stay under the spell of abstract expressionism and its elected genius, Jackson Pollock. Bettina Funcke, "Scharlatanerie als Strategie," unpublished manuscript, 2003.

12. See Pierre Fédida, "La Relique et le travail du deuil," *Nouvelle Revue de Psychanalyse* 2 (Fall 1970): 249–54, esp. 249.

13. In *Totem and Taboo* Freud speaks of "die Tötung des Totem." Pierre Fédida revises this expression for "killing the dead" into "die Toten töten." See Fédida 249, and Sigmund Freud, *Totem und Tabou: Studienausgabe,* vol. 9 (Frankfurt: Fischer, 2000), 425.

14. Jacques Hassoun's characterization of the melancholic accords with my point. Drawing a distinction between two types—the melancholic and the assassin—he writes: "If the assassin is the one who kills to make recognizable his guilt (and, as a result, to elicit a sense of remorse), the melancholic is the one who, devoured by pathetic remorse and

nostalgia . . . , will strive *(s'évertuer)* to destroy others and himself as well" (Hassoun 76; my translation).

15. In Western culture, the condition of melancholia has been charged affirmatively at some points, and negatively at others. In Greek medicine, melancholy was considered the specific depression of intellectuals; it was associated with the overabundance of black bile. Anxiety and depression were the expressions of melancholia. While melancholia was typically conceptualized as a malady or pathology, some also understood it as a heightened sensitivity to reality. As Klibansky, Panofsky, and Saxl note in *Saturn and Melancholy,* the Stoics came to regard melancholia less as an illness, and more as a hazard of intellectual life. Raymond Klibansky, Erwin Panofsky, and Fritz Saxl, *Saturn and Melancholy: Studies in the History of Natural Philosophy, Religion and Art* (London: Nelson, 1964).

More generally, melancholy was associated with a number of moral virtues. Some seventeenth-century poetic discourses on melancholia emphasize the ethical value and heightened sensibilities of the condition. In *The Anatomy of Melancholy* (1621), Robert Burton surveys the flawed melancholic soul but also illuminates the benificent and philosophical dimensions of his spirit. In *Observations on the Feeling of the Beautiful and Sublime,* Kant describes the philosophical and moral inclinations of the melancholic. Above all, Kant saw the melancholic as one soberly aware of our finite existence. In *Melancholy and Society,* Wolf Lepenies identifies the novel as the literary form of sublimation for bourgeois melancholy in the eighteenth century. See Robert Burton, *The Anatomy of Melancholy: What it is, with all the kinds, causes, symptomes, prognostickes and several cures of it* (1621), ed. Lawrence Babb (East Lansing: Michigan State University Press, 1965); Immanuel Kant, *Observations on the Feeling of the Beautiful and Sublime,* trans. John T. Goldthwait (Berkeley: University of California, 1960); and Wolf Lepenies, "Reflection and the Inhibition of Action," in *Melancholy and Society,* trans. Jeremy Gaines and Doris Jones (Cambridge: Harvard University Press, 1992), 142–63. For an overview of critical thought on melancholia, see Bryan S. Turner, "A Note on Nostalgia," *Theory, Culture and Society* 4 (1987): 147–49.

16. Kuckart's take on Melancholia resembles that of Giorgio Agamben, who also registers the erotic charge of Dürer's engraving. See Giorgio Agamben, *Stanzas: Word and Phantasm in Western Culture,* trans. Ronald Martinez (Minneapolis: University of Minnesota Press, 1993) 18.

17. Two of Erich Kästner's best-loved books are *Die verschwundene Miniatur* (1935) and *Emil und die Detektive* (1929). See Walter Benjamin, "Linke Melancholie," in *Gesammelte Schriften,* vol. 3 (Frankfurt: Suhrkamp, 1972) 279–83.

18. Helmut Dubiel, "Linke Trauerarbeit," *Merkur* 496 (June 1990): 482–91.

19. These lines from *Melancholia I* evoke Kant's claim that, although the French Revolution inflamed the masses' basest passions and fomented destruction, as a social event it conferred the sublime feeling that freedom was in fact possible for Europe's enlightened public. See Immanuel Kant, *The Conflict of the Faculties*, trans. Mary J. Gregor (Lincoln: University of Nebraska Press, 1992), 153.

20. Psychoanalysis links the concept of disavowal closely to that of fetishism. The fetish embodies a disavowal. Without entering into the complex relationship between Marxist and Freudian notions of fetishism, one should nonetheless remark how the leap from concrete social analysis to the critique of instrumental reason impacts upon the status of commodity fetishism. See, for example, Wolfgang Fritz Haug, *Kritik der Warenästhetik* (Frankfurt: Suhrkamp, 1971).

21. Although a few of the packages included in *Economic Values* were produced in the FRG, packets from the GDR, Poland, and the Soviet Union form the bulk of the goods amassed on the shelves and make the greatest visual impact.

22. In an interview with playwright Heiner Müller, critic Ulrich Dietzel refers to a conversation he once had with Beuys. The artist explained that his attraction to the products of state socialist industry lay in the "voluptuous creativity" that they embodied. Müller agrees with this characterization and describes GDR material culture as a sort of "treasure trove" *(Fundgrube)* in which Beuys could explore and indulge his "material sensitivities." See Ulrich Dietzel, "Gespräch mit Heiner Müller," in Staeck and Steidl, eds., *Joseph Beuys: Das Wirtschaftswertprinzip*, 27–28. A longer version of this interview was first published as Heiner Müller, "Was gebraucht wird: Mehr Utopie, mehr Phantasie und mehr Freiräume für Phantasie. Ein Gespräch mit Ulrich Dietzel," *Sinn und Form* 4 (1985): 1193–1217.

23. Following Fédida, we could see Triolet's inherited signifiers as relics, for they attest to "the visibility of the hidden" *(la visibilité du caché)*. Considering the meaning of burial within mourning, he, like Kuckart, summons forth the notion of "the other side of things" *(une représentation visuelle de l'envers des choses)* to describe the underworld that the relic represents. Fédida defines the relic as follows: "A material fragment extracted from an absent body, the relic enables one to see what is hidden. . . . As is the case when children ask questions about the disappearance of the deceased, burial defines 'the hidden' at the level of a search for visual representation of the undersides of things as well as the search for their subterranean forms" (Fédida 251).

24. Maxime Préaud also reads Dürer's *Melancholia I* as a study of stillness. She writes: "Time has stopped; or, rather, one can no longer measure it, because one objectively

knows that it passes, but both in the image and subjectively everything is motionless and quiet." Préaud, *Mélancolies* (Paris: Herscher, 1982), 6 (my translation).

25. See Walter Benjamin, *The Origin of German Tragic Drama,* trans. John Osborne (London: Verso, 1985); and Benjamin, "Theses on the Philosophy of History," in *Illuminations,* trans. Harry Zohn (New York: Harcourt Brace, 1968).

26. Kristeva argues that the interruption of "desiring metonymy" prevents the working out of loss within the psyche. Sublimation — "through melody, rhythm, semantic polyvalency, the so-called poetic form" — undoes the melancholic hold (Kristeva, *Black Sun* 14).

27. Freud, "The Psychogenesis of a Case of Homosexuality in a Woman," *SE* 18:145–72.

28. Balbure writes about the suicidal tendencies of the melancholic: "In a certain sense [the melancholic's] suicide corresponds to the logical outcome of his desiring condition. The love of the ego is granted its loss, the subject lacks to lack, without any lasting intervention of anxiety, and gradually empties out. As he is nothing more than an empty envelope, the slightest glimmer of desire that flickers within him gives him just enough energy to scale a parapet or mount a window sill to finally accomplish that which should be done, that is, to finish his journey and meet his only lover: death." Brigitte Balbure, "La Mélancolie," *Le Discours Psychanalytique* 1 (February 1989): 158 (my translation).

29. Julia Kristeva writes forcefully about both depression and unemployment in *Black Sun.* See Kristeva, *Black Sun,* 8–9.

CHAPTER 6 · DISAVOWAL

1. Julia Hell includes a useful overview of this period, as well as an insightful reading of *Divided Heaven,* in *Post-Fascist Fantasies.* See Julia Hell, *Post-Fascist Fantasies: Psychoanalysis, History, and the Literature of East Germany* (Durham: Duke University Press, 1997), 138.

2. See Christa Wolf, "What Remains," in *What Remains and Other Stories,* trans. Heike Schwarzbauer and Rick Tavorkian (New York: Farrar, Straus and Giroux, 1993). Jörg Magenau's biography of Christa Wolf (especially the chapters "Perspektivlos und ineffizient. Margaretes Gespräche mit der Stasi" and "Einfach zu naïv: Muh und mäh, oder Die Frage, was bleibt?") offers the most recent account of Wolf's Stasi dealings. Jörg Magenau, *Christa Wolf: Eine Biographie* (Berlin: Kindler, 2002). For an early overview of the "What Remains" controversy, see Thomas Anz, ed., *"Es geht nicht um Christa Wolf": Der Literaturstreit im vereinten Deutschland* (Munich: Edition Spangenberg, 1991).

3. Christa Wolf (together with her husband Gerhard Wolf) not only adapted *Divided Heaven* into the DEFA scenario, but also consulted with Konrad Wolf on the direction and editing of the film. Later she collaborated on the cinematic realization of several additional texts of hers, including *Fräulein Schmetterling* (1965–66) and *Selbstversuch* (1972). For a fine analysis of the film *Divided Heaven,* see Katie Trumpener, *The Divided Screen: The Cinemas of Postwar Germany* (Princeton: Princeton University Press, forthcoming).

4. According to Jacques Lacan, fainting — the sudden onset of unconsciousness — is the reaction to a traumatic surplus of sensation. In *The Four Fundamental Concepts of Psycho-Analysis* Lacan borrows Aristotle's concept of *tuché* to describe the sort of "missed encounter" that Rita confronts in this section of *Divided Heaven.* Within the logic of psychoanalysis, this reaction abjures agency. It is more a blackout than a bearing of witness, for real trauma — like real ecstasy — exceeds the subject's capacity to witness it. See Jacques Lacan, "Tuché and Automaton," in *The Four Fundamental Concepts of Psycho-Analysis,* trans. Alan Sheridan (New York: Norton, 1979), 53–65.

5. Christa Wolf, *Divided Heaven,* trans. John Becker (Berlin: Seven Seas, 1965), 128.

6. Christa Wolf, *Leibhaftig* (Munich: Luchterhand, 2002), 5. Unless otherwise indicated, all translations are mine.

7. Here the "du" is another figure — the husband — not the protagonist herself, which is the case in *Kindheitsmuster* (*Patterns of Childhood*).

8. Wolf's earlier novel *No Place on Earth* explores the narrative space beyond objective realism that we reencounter in *Medea.* See Christa Wolf, *No Place on Earth,* trans. Jan van Heurck (New York: Farrar, Straus and Giroux, 1982). I cite from the English translation of Wolf's *Medea: A Modern Retelling,* trans. John Cullen (New York: Doubleday, 1998), as well as the original *Medea: Stimmen* (Munich: Luchterhand, 1996).

9. See Oskar Negt and Alexander Kluge, *Geschichte und Eigensinn* (Frankfurt: Suhrkamp, 1981), 745–49.

10. Christa Wolf, "Von Kassandra zu Medea," in *Hierzulande Andernorts: Erzählungen und andere Texte, 1994–98* (Munich: Luchterhand, 1999), 167.

11. See Sigmund Freud, "The Splitting of the Ego as a Mechanism of Defence," in *The Standard Edition of the Complete Psychological Works of Sigmund Freud,* trans. James Strachey, vol. 23 (London: Hogarth, 1995), 271–78 (edition cited hereafter as *SE*); as well as Freud, *An Outline of Psychoanalysis,* trans. James Strachey (New York: Norton, 1963). Feminists have contested Freud's understanding of disavowal, and have articulated a new field of

inquiry over the question of "female fetishism." See, for example, Naomi Schor, "Female Fetishism: The Case of George Sand," in *The Female Body in Western Culture: Contemporary Perspectives,* ed. Susan Rubin Suleiman (Cambridge: Harvard University Press, 1986), 363–72; Emily S. Apter, *Feminizing the Fetish: Psychoanalysis and Narrative Obsession in Turn-of-the-Century France* (Ithaca: Cornell University Press, 1991); Kaja Silverman, *Male Subjectivity at the Margins* (New York: Routledge, 1992); and Laura Mulvey, *Fetishism and Curiosity* (London: British Film Institute, 1996).

12. See Freud, "On Fetishism," *SE* 21:149–58.

13. See Octave Mannoni, "Je sais bien, mais quand même," in *Clefs pour l'imaginaire, ou, l'autre scène* (Paris: Seuil, 1969), 9–33.

14. To argue that the fetishist fully accepts perceived reality ("la réalité constatée"), Mannoni presents the example of Freud's patient who, in repudiating the encounter which proved to him that the woman does not have a penis, *does not* maintain the belief that she really has one. Rather the patient attaches himself to a fetish *because* she has none. "Not only is the encounter not effaced," Mannoni contends, "but it becomes ineffaceable; it leaves behind an indelible stigmatum which marks the fetishist forever" (Mannoni 9–33).

200

15. Christa Wolf, letter to Volker Braun, in Wolf, *Parting from Phantoms: Selected Writings, 1990–94,* trans. Jan van Heurck (Chicago: University of Chicago Press, 1997).

16. Hans Kaufmann, "Gespräch mit Christa Wolf," *Weimarer Beiträge* 6 (1974): 90–112.

17. See Joachim Walther, "Christa Wolf," in *Meinetwegen Schmetterlinge: Gespräche mit Schriftstellern* (Berlin: Buchverlag Der Morgen, 1973), 114–34.

18. See Jürgen Habermas, *Die nachholende Revolution* (Frankfurt: Suhrkamp, 1990). See also Andreas Huyssen's analysis of this work and its impact, "After the Wall: The Failure of German Intellectuals," in *Twilight Memories: Marking Time in a Culture of Amnesia* (New York: Routledge, 1995), 36–66, especially 45–46. For Habermas's later take on German unification, see *Die Normalität einer Berliner Republik: Kleine politische Schriften VIII* (Frankfurt: Suhrkamp, 1995).

19. Christa Wolf, *Cassandra: A Novel and Four Essays,* trans. Jan van Heurck (New York: Farrar, Straus and Giroux, 1984). Wolf has rewritten the stories of Cassandra and Medea, but not that of Antigone. Given her concern with memory and mourning, why would Wolf make this choice? German writers and filmmakers returned to the Sophocles drama several times in the 1970s and 1980s, and Antigone still persists in the literary

imagination as the figure of authentic mourning and true fidelity—the one who mourns unspeakable loss. Perhaps Wolf passed her by because Antigone had already been appropriated by what she perceived as the dominant intellectual tradition. Notable revisions of *Antigone* in recent German culture include Volker Schlöndorff's segment of *Germany in Autumn,* dirs. Rainer Werner Fassbinder, Heinrich Böll, Edgar Reitz, Alexander Kluge, Volker Schlöndorff, et al., Filmverlag der Autoren, 1981; Negt and Kluge, *Geschichte und Eigensinn,* 769–71; and Heiner Müller, *Stücke: Medeamaterial* (Berlin: Henschel, 1988). Müller's drama *Medeamaterial* presents a hybrid Medea/Antigone figure. In chapter 4, "Mourning," I consider Antigone's role in Negt and Kluge's thought.

20. The dissonance that Wolf posits between the subject and object aligns with Adorno's notion of the "priority of the objective" *(der Vorrang des Objektiven).* In *Negative Dialectics* Adorno argues that this priority simultaneously limits subjectivity and creates its conditions of possibility. Subjectivity only exists as the struggle with some elusive and resistant object; were a subject to totally penetrate objectivity, the constitutive tension between subject and object would disappear. The aesthetic consequences of this insight are crucial. Adorno sees the artist not as a master playing imaginary games, but rather as a subject striving to discern the inherent logic of his or her material. The dissonance in Wolf is, similarly, both subjective and objective at once. Thwarting subjective hold, this spur frustrates any attempt to perceive a transparent, aesthetic totality. It is at this point of dissonance that the subject can inscribe himself or herself into the work of art. See Theodor W. Adorno, *Negative Dialectics,* trans. E. B. Ashton (New York: Continuum, 1983), 171–86.

21. Negt and Kluge, *Geschichte und Eigensinn,* 5. For Negt and Kluge's own elaboration of the "subject-object relationship," see page 209.

22. Kluge's short stories *Lernprozesse mit tödlichem Ausgang* and *Lebensläufe* seek to illustrate such resistance, particularly as it foiled the Fascist attempt to thoroughly exploit labor capacities. See Kluge, *Lernprozesse mit tödlichem Ausgang* (Frankfurt: Suhrkamp, 1973), and *Lebensläufe* (Frankfurt: Fischer, 1964). Christopher Pavsek makes the same point in his essay "*History and Obstinacy:* Negt and Kluge's Redemption of Labor," *New German Critique* 68 (Spring/Summer 1996): 160–61.

23. Wolf provides no bibliographic information for this image, but she notes that the object belongs to the collection of Barbier Müller, in Paris. Christa Wolf, "Self-Indictment," in *Parting from Phantoms,* 1.

24. On the matter of fetishism in Cranach's paintings, see Josephine Le Foll, "Cranach fétichiste," *Beaux Arts Magazine* 126 (September 1994): 79–86.

25. Wolf makes her most important references to Ernst Bloch in her novel *Patterns of Childhood,* trans. Ursula Molinaro (New York: Farrar, Straus and Giroux, 1980). When she conceived this memoir in the seventies, repression and censorship had long plagued the GDR. Restrictions mandated at the Eleventh Plenum of the Central Committee of the Socialist Unity Party in 1965 and Wolf Biermann's expatriation in 1976 counted among these clampdowns. Despite these events, Wolf still looked to Marxism as a beacon, convinced, like Bloch, that this was the only possible philosophy of hope.

26. Wolf, "Trial by Nail," in *Parting from Phantoms,* 135.

27. Andreas Huyssen observes that the "What Remains" controversy served to "freeze" critical reception of Wolf's work. It was as if her entire career culminated and imploded in those diaries. See Huyssen, *Twilight Memories,* 60–66.

28. Friedrich Hölderlin, *Gedichte* (Frankfurt: Deutscher Klassiker Verlag, 1992).

AFTERWORD

1. "Eichel spart nicht mit Lob für sich und die Politik der Bundesregierung: Starkes Wirtschaftswachstum, sinkende Arbeitslosigkeit, Inflation unter Kontrolle," *Frankfurter Allgemeine Zeitung* (28 October 2000), 1. For a cautious assessment of the digitalization of Eastern European economies, see Jürgen Blitzer, "The Eastern European Computer Industry: National Champions with a Screwdriver," in *The Globalization of Industry and Innovation in Eastern Europe: From Post-Socialist Restructuring to International Competitiveness,* ed. Christian von Hirschhausen and Jürgen Blitzer (Cheltenham: Edward Elgar, 2000), 257–82.

2. For an introductory critique of industrial relations and the weakening of collective bargaining after Maastricht, see Wolfgang Lecher and Hans-Wolfgang Platzer, "Global Trends and the European Context," in *The European Union: European Industrial Relations,* ed. Wolfgang Lecher (London: Routledge, 1998), 1–17.

3. See Jürgen Habermas, *Die nachholende Revolution* (Frankfurt: Suhrkamp, 1990). For an overview of the German debates on belated modernism, see Wolfgang Thierse, *Zukunft Ost: Perspektiven für Ostdeutschland in der Mitte Europas* (Berlin: Rowohlt, 2001); and Herfried Münkler, ed., *Furcht und Faszination: Facetten der Fremdheit* (Berlin: Akademie der Wissenschaften, 1997).

4. Susan Buck-Morss argues that it was the exhaustion of industrial modernity that linked the histories of Western and Eastern Europe at the end of the twentieth century: "the cultural forms that existed in 'East' and 'West' (to use the Eurocentric terminology

of the Cold War) appear uncannily similar. They may have differed violently in their way of dealing with the problems of modernity, but they shared a faith in the modernizing process developed by the West that for us today has been unalterably shaken." Susan Buck-Morss, *Dreamworld and Catastrophe: The Passing of Mass Utopia in East and West* (Cambridge: MIT Press, 2000), x.

5. For an elaboration of this condition, see Fredric Jameson, *The Cultural Turn: Selected Writings on the Postmodern, 1983–1998* (London: Verso, 1998).

6. This visual turn has already been considered by scholars of post-Soviet society. For example, see Denis Berger, "Que reste-t-il de la perestroïka?" *Futur antérieur* 6 (1991): 15–20. Likewise Nancy Condee describes post-Soviet Russian culture as one that values "'the look' over 'the read,' visual display over the verbal imaginary." In her introduction to *Soviet Hieroglyphics* and in her essay "The ABC of Russian Consumer Culture: Readings, Ratings, and Real Estate," coauthored with Vladimir Padunov, she maintains that the explosion of mass literature (i.e. comics and pornography) has influenced high literature (the "author's book"), such that the market has acquiesced "to a set of cultural priorities that stressed visuality[. I]n the shift from book culture to visual culture, even the book itself becomes retrospectively 'visualized.'" Nancy Condee, introduction to *Soviet Hieroglyphics: Visual Culture in Late Twentieth-Century Russia,* ed. Nancy Condee (Bloomington: Indiana University Press, 1995), ix–x; see also Nancy Condee and Vladimir Padunov, "The ABC of Russian Consumer Culture: Readings, Ratings, and Real Estate," in *Soviet Hieroglyphics,* 130–72.

7. Roland Barthes, *Camera Lucida: Reflections on Photography* (New York: Hill and Wang, 1981), 119.

8. Friedrich Nietzsche, *The Will to Power,* trans. Walter Kaufman and R. J. Hollingdale (New York: Vintage, 1968), 465.

9. The definitive English study on the condition of women in the new federal states of Germany is Brigitte Young, ed., *Triumph of the Fatherland: German Unification and the Marginalization of Women* (Ann Arbor: University of Michigan Press, 1999). A recent German analysis of gender in transitional society is Regina Kroplin, ed., *Ostdeutsche Frauen im gesellschaftlichen Transformationsprozess: Eine Untersuchung zur Situation der Frauen im Beruf und in der Familie in der DDR und die Fortsetzung geschlechtsspezifischer Segregation im Transformationsprozess* (Düsseldorf: Hans-Bockler-Stiftung, 1998). For a more general overview of sexual politics in Eastern Europe, see Barbara Einhorn, *Cinderella Goes to Market: Citizenship, Gender, and the Women's Movement in East Central Europe* (London: Verso, 1993). Other studies about the connections between gender and collective identity in the postcommunist state include Barbara Rocksloh-Papendieck, *Verlust der kollektiven Bindung:*

Frauenalltag in der Wende (Pfaffenweiler: Centaurus Verlag, 1995); and Irene Dölling, ed., *Ein alltägliches Spiel: Geschlechterkonstruktion in der sozialen Praxis* (Frankfurt: Suhrkamp, 1997).

10. In her influential work on melancholia and gender, Judith Butler radicalizes Freud's notion that the ego is the repository of the subject's lost (prohibited) identifications; she uses it to account for the emergence of sexual identity itself. One becomes a woman (or a man) by disavowing one's primordial libidinal object (the parent of the same sex) and then by identifying with the lost object. Can we say the same about the identity of those nostalgic for a socialist ideal that never really came into existence? The obverse could be the case. Perhaps a left melancholic invests into the failures of socialism as a lost object precisely insofar as his or her own life is only inconsistently informed by socialist principles. This case opposes the one imagined by Butler, for one chooses as the libidinal object something that one could no longer be. See Judith Butler, *Gender Trouble: Feminism and the Subversion of Identity* (New York: Routledge, 1990).

11. In *Camera Lucida* Barthes expresses the peculiarities of the lost and found object; he touches upon the sense that "you never know what you have until you lose it." Reflecting upon a photograph of his dead mother, he finds her by acknowledging the distance that falls away between his life and her death. "History," he writes, is constituted "only if we look at it — and in order to look at it, we must be excluded from it" (Barthes 65).

12. Alain Badiou makes a keen point about Pauline temporality. Faith, hope, and love occupy three different moments: faith — the past; hope — the future; and love — the present. Paul proclaimed both his faith that Christ had risen and his hope for a future of human salvation. Leading a Christian life, he loved others as he loved God. Badiou also extends this temporal schema onto Marxist political theory as follows: faith that the proletariat had already engaged the means for revolution, hope for the realization of communism, and the patient expression of love through collective diligence. Alain Badiou, *St. Paul: La fondation de l'universalisme* (Paris: Presses Universitaires de France, 1997), 79–86.

13. Cf. Juliet Webster, "Today's Second Sex and Tomorrow's First? Women and Work in the European Information Society," in *The Information Society in Europe: Work and Life in an Age of Globalization,* ed. Ken Ducatel, Juliet Webster, and Werner Herrmann (Lanham, Md.: Rowman and Littlefield, 2000), 119–40. For a more critical account of contemporary gender politics in Europe, see Jane Lewis, ed., *Gender, Social, and Welfare State Restructuring in Europe* (Aldershot: Ashgate, 1998). Hardt and Negri privilege the feminist potentials of immaterial labor in the section on biopolitical production in *Empire*. See Michael Hardt and Antonio Negri, *Empire* (Cambridge: Harvard University Press, 2000), 23–30.

14. Christopher Pavsek advances a similar argument about resistance and cultural revolution in *"History and Obstinacy: Negt and Kluge's Redemption of Labor,"* *New German Critique* 68 (Spring/Summer 1996): 163.

15. Karl Marx, "The German Ideology," in *The Portable Karl Marx*, ed. and trans. Eugene Kamenka (Harmondsworth: Penguin, 1983), 164.

16. G. W. F. Hegel, *Phenomenology of Spirit*, trans. A. V. Miller (Oxford: Oxford University Press, 1977), 422–25.

17. Jean-Marie Le Pen and Jörg Haider have sought to elicit the support of the unemployed in France and Austria with the argument that immigrant workers have taken their jobs. Leaders of Poland's former communist party (the Democratic Left Alliance, or SLD) have switched to a similar conservative path. Although Germany's Party of Democratic Socialists (the PDS, which is the reformed Socialist Unity Party of the GDR) has countered this sort of racialized rhetoric, it has stirred up anti-Western sentiment. PDS officials have struggled to come to terms with the legacy of the Berlin Wall and has recently reaffirmed the repressive force that the SED exerted over citizens of the GDR during its years of power. In the autumn elections of 2001, the PDS enjoyed electoral success with a platform that opposed NATO retaliation against the terrorist attacks on New York and Washington earlier that year. Almost half of the voters in the eastern districts of Berlin voted for the PDS. Although still at the margins of German politics, the PDS participated in the wider anti-Bush/Blair movement that swept across Germany and France during the US-led war on Iraq in 2003. For an analysis of political extremism in Europe, see Nicholas Fraser, *The Voice of Modern Hatred: Tracing the Rise of Neo-Fascism in Europe* (Woodstock, N.Y.: Overlook, 2001); and Carmen Everts, *Politischer Extremismus: Theorie und Analyse am Beispiel der Parteien REP und PDS* (Berlin: Weissensee, 2000).

WORKS CITED

LITERATURE

Adorno, Theodor W. *Aesthetic Theory*. Ed. Gretel Adorno and Rolf Tiedemann. Trans. Robert Hullot-Kentor. Minneapolis: University of Minneapolis Press, 1997.

Adorno, Theodor W. *Erziehung zur Mündigkeit*. Frankfurt: Suhrkamp, 1970.

Adorno, Theodor W. *Negative Dialectics*. Trans. E. B. Ashton. New York: Continuum, 1983.

Adorno, Theodor W. *Prismen*. Frankfurt: Suhrkamp, 1976.

Agamben, Giorgio. *Stanzas: Word and Phantasm in Western Culture*. Trans. Ronald Martinez. Minneapolis: University of Minnesota Press, 1993.

Akty terroru i przemocy: Grudzień 1984. Warsaw: Niezależna Oficyna Wydawnicza, 1985.

Anz, Thomas, ed. *"Es geht nicht um Christa Wolf": Der Literaturstreit im vereinten Deutschland*. Munich: Edition Spangenberg, 1991.

Apter, Emily S. *Feminizing the Fetish: Psychoanalysis and Narrative Obsession in Turn-of-the-Century France*. Ithaca: Cornell University Press, 1991.

Arendt, Hannah. *Eichmann in Jerusalem: A Report on the Banality of Evil.* New York: Penguin, 1964.

Arendt, Hannah. *The Human Condition.* Chicago: University of Chicago Press, 1998.

Ash, Timothy Garton. *The Polish Revolution: Solidarity, 1980–82.* London: Granta, 1991.

Aust, Stefan. *The Baader-Meinhof Group: The Inside Story of a Phenomenon.* Trans. Anthea Bell. London: Bodley Head, 1987.

Badiou, Alain. *St. Paul: La Fondation de l'universalisme.* Paris: Presses Universitaires de France, 1997.

Balbure, Brigitte. "La Mélancolie." *Le Discours psychanalytique* 1 (February 1989): 135–62.

Barnes, Rachel. "No More House Work: With *House,* Rachel Whiteread Joined Politics, Art, and Anger." *Guardian,* 8 April 1995, 28.

Barthes, Roland. *Camera Lucida: Reflections on Photography.* New York: Hill and Wang, 1981.

Bataille, Georges. *Inner Experience.* Trans. Leslie Anne Boldt. New York: SUNY Press, 1988.

Bell, Daniel. *The Coming of Post-Industrial Society.* New York: Basic Books, 1976.

Benezra, Neal. "Rachel Whiteread: A Sense of Silence." In *Distemper: Dissonant Themes in the Art of the 1990s,* ed. Neal Benezra and Olga Viso. Washington: Smithsonian Institution, 1996.

Benjamin, Walter. "Linke Melancholie." In *Gesammelte Schriften.* Vol. 3. Frankfurt: Suhrkamp, 1972.

Benjamin, Walter. *The Origin of German Tragic Drama.* Trans. John Osborne. London: Verso, 1985.

Benjamin, Walter. "Theses on the Philosophy of History." In *Illuminations,* trans. Harry Zohn. New York: Harcourt Brace, 1968.

Benner, Erica. *Really Existing Nationalisms: A Post-Communist View from Marx and Engels.* Oxford: Clarendon, 1995.

Berger, Denis. "Que reste-t-il de la perestroïka?" *Futur antérieur* 6 (1991): 15–20.

Berger, John. "Keeping a Rendezvous." *Nation,* 7 May 1990, 625.

Berger, John. *Keeping a Rendezvous.* London: Penguin, 1992.

Berger, John. *Lilac and Flag.* New York: Pantheon, 1990.

Berger, John. *Once in Europa*. New York: Pantheon, 1987.

Berger, John. *Pig Earth*. New York: Pantheon, 1979.

Berger, John. *Ways of Seeing*. London: Penguin, 1972.

Berger, John, and Nella Bielski. *A Question of Geography*. London: Faber, 1987.

Bergson, Henri. *Matter and Memory*. Trans. W. S. Palmer and N. M. Paul. Cambridge: MIT Press, 1990.

Blackaby, F. *Deindustrialization*. London: Heinemann, 1978.

Blitzer, Jürgen. "The Eastern European Computer Industry: National Champions with a Screwdriver." In *The Globalization of Industry and Innovation in Eastern Europe: From Post-Socialist Restructuring to International Competitiveness,* ed. Christian von Hirschhausen and Jürgen Blitzer. Cheltenham: Edward Elgar, 2000.

Bloch, Ernst. *The Principle of Hope*. Trans. Neveille Plaice, Stephen Plaice, and Paul Knight. 3 vols. Cambridge: MIT Press, 1986.

Bonnell, Victoria E. *Identities in Transition: Eastern Europe and Russia after the Collapse of Communism*. International and Area Studies 93. Berkeley: Center for Slavic and East European Studies, 1996.

Bordwell, David. *Narration in the Fiction Film*. Madison: University of Wisconsin Press, 1985.

Boyer, M. Christine. *The City of Collective Memory: Its Historical Imagery and Architectural Entertainments*. Cambridge: MIT Press, 1994.

Boym, Svetlana. *The Future of Nostalgia*. New York: Basic Books, 2001.

Braun, Volker. "Das Eigentum." In *Von einem Land und vom anderen. Gedichte zur deutschen Wende,* ed. Karl Otto Conrady. Frankfurt: Suhrkamp, 1993.

Brinks, Jan Herman. *Paradigms of Political Change: Luther, Frederick II, and Bismarck: The GDR on Its Way to German Unity*. Milwaukee: Marquette University Press, 2001.

Brouwer, Marianne, ed. *Dan Graham: Works 1965–2000*. Düsseldorf: Richter Verlag, 2001.

Bruckner, Pascal. *La Mélancolie démocratique*. Paris: Seuil, 1990.

Buck-Morss, Susan. *Dreamworld and Catastrophe: The Passing of Mass Utopia in East and West*. Cambridge: MIT Press, 2000.

Buck-Morss, Susan. *The Origin of Negative Dialectics: Theodor W. Adorno, Walter Benjamin and the Frankfurt Institute*. New York: Free Press, 1977.

Bull, Martin J., and Paul Heywood, eds. *West European Communist Parties after the Revolutions of 1989.* New York: St. Martin's, 1994.

Burton, Robert. *The Anatomy of Melancholy: What it is, with all the kinds, causes, symptomes, prognostickes and several cures of it.* 1621. Ed. Lawrence Babb. East Lansing: Michigan State University Press, 1965.

Butler, Judith. *Antigone's Claim: Kinship between Life and Death.* New York: Columbia University Press, 2000.

Butler, Judith. *Gender Trouble: Feminism and the Subversion of Identity.* New York: Routledge, 1990.

Cage, John. *Silence.* Middletown, Conn.: Wesleyan University Press, 1961.

Calle, Sophie. *Die Entfernung.* Berlin: G+B Arts International, 1996.

Church, Roy A. *Strikes and Solidarity: Coalfield Conflict in Britain.* Cambridge: Cambridge University Press, 1998.

Clark, Katerina. *The Soviet Novel: History as Ritual.* Chicago: University of Chicago Press, 1981.

Comay, Rebecca. "Memory Block: Rachel Whiteread's Proposal for a Holocaust Memorial in Vienna." *Art and Design* 12, nos. 11–12 (July–August 1997): 64–75.

Condee, Nancy, ed. *Soviet Hieroglyphics: Visual Culture in Late Twentieth-Century Russia.* Bloomington: Indiana University Press, 1995.

Cooke, Lynne. "Rachel Whiteread." *Burlington Magazine* 137, no. 1105 (April 1995): 273–74.

Courtois, Stéphane, ed. *The Black Book of Communism: Crimes, Terror, Repression.* Trans. Jonathan Murphy and Mark Kramer. Cambridge: Harvard University Press, 1999.

Cousins, Mark. "Inside Outcast." *Tate* 10 (Winter 1996): 36–41.

Crimp, Douglas. "Mourning and Militancy." *October* 51 (Winter 1989): 3–18.

Crimp, Douglas. *On the Museum's Ruins.* Cambridge: MIT Press, 1993.

Curry, Jane Leftwich, ed. and trans. *The Black Book of Polish Censorship.* New York: Vintage Books, 1984.

Dennison, Lisa, and Craig Houser, eds. *Rachel Whiteread: Transient Spaces.* New York: Guggenheim Museum Publications, 2001.

Derrida, Jacques. *Archive Fever: A Freudian Impression.* Trans. Eric Prenowitz. Chicago: University of Chicago Press, 1996.

Derrida, Jacques. *Mémoires: For Paul de Man.* Trans. Cecile Lindsay, Jonathan Culler, and Eduardo Cadava. New York: Columbia University Press, 1986.

Derrida, Jacques. *Specters of Marx: The State of the Debt, the Work of Mourning, and the New International.* Trans. Peggy Kamuf. New York: Routledge, 1994.

Didi-Huberman, Georges. "Formes mortifiées: L'Empreinte comme deuil." In *L'Empreinte.* Paris: Centre Georges Pompidou, 1997.

Diewald, Martin, and Karl Ulrich Mayer, eds. *Zwischenbilanz der Wiedervereinigung: Strukturwandel und Mobilität im Transformationsprozess.* Opladen: Leske + Budrich, 1996.

Dinter, Ingrid. *Unvollendete Trauerarbeit in der DDR-Literatur: Ein Studium der Vergangenheitsbewältigung.* New York: Peter Lang, 1994.

Documenta IX. Ed. Jan Hoet. Stuttgart: Edition Cantz, 1992.

Dölling, Irene, ed. *Ein alltägliches Spiel: Geschlechterkonstruktion in der sozialen Praxis.* Frankfurt: Suhrkamp, 1997.

Domdey, Horst. "Volker Braun und die Sehnsucht nach der Grossen Kommunion. Zum Demokratiekonzept der Reformsozialisten (in der DDR)." *Deutschland Archiv* 11 (1991): 1771–74.

Dubiel, Helmut. "Linke Trauerarbeit." *Merkur* 496 (June 1990): 482–91.

Ducatel, Ken, Juliet Webster, and Werner Herrmann, eds. *The Information Society in Europe: Work and Life in an Age of Globalization.* Lanham, Md.: Rowman and Littlefield, 2000.

Duras, Marguerite, and Leslie Kaplan. "Duras, Kaplan: L'Excès-l'usine." *L'Autre journal* 5 (15 May 1985): 53–58.

Dyer, Geoff. *Ways of Telling: The Work of John Berger.* London: Pluto, 1986.

East London Advertiser, 4 November 1993.

"Eichel spart nicht mit Lob für sich und die Politik der Bundesregierung: Starkes Wirtschaftswachstum, sinkende Arbeitslosigkeit, Inflation unter Kontrolle." *Frankfurter Allgemeine Zeitung,* 28 October 2000, 1.

Einhorn, Barbara. *Cinderella Goes to Market: Citizenship, Gender, and the Women's Movement in East Central Europe.* London: Verso, 1993.

Elsaesser, Thomas. "The Red Army Faction, *Germany in Autumn,* and *Death Game.*" In *Giving Ground: The Politics of Propinquity,* ed. Joan Copjec and Michael Sorkin. London: Verso, 1999.

Emmerich, Wolfgang. "Status Melancholicus. Zur Transformation der Utopie in der DDR-Literatur." In *Literatur in der DDR: Rückblicke,* ed. Heinz-Ludwig Arnold and Frauke Meyer-Gosau. Munich: Edition Text + Kritik, 1991.

Engelhardt, Jörg, Petra Gruner, and Andreas Ludwig. *Alltagskultur der DDR: Zur Ausstellung 'Tempolinsen und P2'.* Berlin: Bebra, 1996.

Everts, Carmen. *Politischer Extremismus: Theorie und Analyse am Beispiel der Parteien REP und PDS.* Berlin: Weissensee, 2000.

Fałkowska, Janina. *The Political Films of Andrzej Wajda: Dialogism in "Man of Marble", "Man of Iron," and "Danton."* Providence: Berghahn Books, 1996.

Fédida, Pierre. "La Relique et le travail du deuil." *Nouvelle Revue de Psychanalyse* 2 (Fall 1970): 249–54.

Feijo, Benito. *Le Je-ne-sais-quoi.* Trans. Catherine Paoletti. Paris: Éditions de l'Éclat, 1989.

Ferge, Zsuzsa. "Welfare and 'Ill-Fare' Systems in Central-Eastern Europe." In *Globalization and European Welfare States: Challenges and Change,* ed. Robert Sykes, Bruno Palier, and Pauline M. Prior. New York: Palgrave, 2000.

Ford, J. *The Consequences of Mortgage Arrears and Possessions in a Depressed Housing Market.* Manchester: Joseph Rowntree Foundation Housing Research Findings, 1994.

Fraser, Nicholas. *The Voice of Modern Hatred: Tracing the Rise of Neo-Fascism in Europe.* Woodstock, N.Y.: Overlook, 2001.

Freud, Sigmund. *The Letters of Sigmund Freud.* Ed. Ernst L. Freud. Trans. Tania and James Stern. New York: Basic Books, 1960.

Freud, Sigmund. *An Outline of Psychoanalysis.* Trans. James Strachey. New York: Norton, 1963.

Freud, Sigmund. *The Standard Edition of the Complete Psychological Works of Sigmund Freud.* 24 vols. Ed. and trans. James Strachey. London: Hogarth, 1995.

Freud, Sigmund. *Totem und Tabou: Studienausgabe.* Vol. 9. Frankfurt: Fischer, 2000.

Furet, François. *The Passing of an Illusion: The Idea of Communism in the Twentieth Century.* Trans. Deborah Furet. Chicago: University of Chicago Press, 1999.

Gershuny, Jonathan. *After Industrial Society.* Totowa, N.J.: Humanities Press, 1978.

Gilbraith, John. *The New Industrial State.* Boston: Houghton Mifflin, 1967.

Gorz, André. *Reclaiming Work: Beyond the Wage-Based Society.* Trans. Chris Turner. London: Polity, 1999.

Graham, Dan. "Gordon Matta-Clark." *Kunstforum International* 4 (October–November 1985): 114–19.

Grimm, Jacob, and Wilhelm Grimm. *Household Tales.* Vol. 2. Trans. Margaret Hunt. London: George Bell, 1884.

Groys, Boris. *The Total Art of Stalinism: Avantgarde, Aesthetic Dictatorship, and Beyond.* Trans. Charles Rougle. Princeton: Princeton University Press, 1992.

Guattari, Félix, and Antonio Negri. *Communists Like Us: New Spaces of Liberty, New Lines of Alliance.* New York: Semiotext(e), 1990.

Guibert, Hervé, and Yve-Alain Bois. *Sophie Calle.* Paris: Musée d'Art Moderne de la Ville de Paris, 1991.

Gunther, Hans. *Die Verstaatlichung der Literatur.* Stuttgart: J. B. Metzler, 1984.

Habermas, Jürgen. *Die nachholende Revolution.* Frankfurt: Suhrkamp, 1990.

Habermas, Jürgen. "The New Opacity: The Crisis of the Welfare State and the Exhaustion of Utopian Energies." In *The New Conservatism: Cultural Criticism and the Historians' Debate,* trans. Shierry Weber Nicholson. Cambridge: MIT Press, 1989.

Habermas, Jürgen. *Die Normalität einer Berliner Republik: Kleine politische Schriften VIII.* Frankfurt: Suhrkamp, 1995.

Halbwachs, Maurice. *The Collective Memory.* 1922. Trans. Francis J. Ditter Jr. and Vida Yazdi Ditter. New York: Harper and Row, 1980.

Hardt, Michael, and Antonio Negri. *Empire.* Cambridge: Harvard University Press, 2000.

Harrison, Tony. *Prometheus.* London: Faber and Faber, 1998.

Hassoun, Jacques. *La Cruauté mélancolique.* Paris: Aubier, 1995.

Haug, Wolfgang Fritz. *Kritik der Warenästhetik.* Frankfurt: Suhrkamp, 1971.

Heath, A. F., Roger Jowell, and John Curtice. "Labour's Long Road Back." In *The Rise of New Labour: Party Policies and Voter Choices,* ed. A. F. Heath, Roger Jowell, and John Curtice. New York: Oxford University Press, 2001.

Hegel, G. W. F. *Phenomenology of Spirit.* Trans. A. V. Miller. Oxford: Oxford University Press, 1977.

Heidegger, Martin. *Being and Time*. Trans. Joan Stambaugh. Albany: SUNY Press, 1996.

Hell, Julia. *Post-Fascist Fantasies: Psychoanalysis, History, and the Literature of East Germany*. Durham: Duke University Press, 1997.

Herf, Jeffrey. *Divided Memory: The Nazi Past in the Two Germanys*. Cambridge: Harvard University Press, 1997.

Hoet, Jan. *On the Way to Documenta IX*. Stuttgart: Edition Cantz, 1991.

Hölderlin, Friedrich. *Gedichte*. Frankfurt: Deutscher Klassiker Verlag, 1992.

Homer. *The Odyssey*. Trans. Robert Fagles. New York: Viking, 1996.

Horkheimer, Max, and Theodor W. Adorno. *Dialectic of Enlightenment*. Trans. John Cumming. New York: Continuum, 1974.

Huyssen, Andreas. "Sculpture, Materiality, and Memory in an Age of Amnesia." In *Displacements: Mirosław Bałka, Doris Salcedo, Rachel Whiteread*. Toronto: Art Gallery of Ontario, 1998.

Huyssen, Andreas. *Twilight Memories: Marking Time in a Culture of Amnesia*. New York: Routledge, 1995.

Insdorf, Annette. *Double Lives, Second Chances: The Cinema of Krzysztof Kieślowski*. New York: Miramax, 1999.

"Die Innovationstragfähigkeit der Planwirtschaft in der DDR—Ursachen und Folgen." *Deutschland Archiv* 26 (7 July 1993): 807–18.

Jacoby, Russell. "Towards a Critique of Automatic Marxism: The Politics of Philosophy from Lukács to the Frankfurt School." *Telos* 10 (Winter 1971): 137–46.

Jameson, Fredric. *The Cultural Turn: Selected Writings on the Postmodern, 1983–1998*. London: Verso, 1998.

Jameson, Fredric. *Late Marxism: Adorno, or, the Persistence of the Dialectic*. London: Verso, 1990.

Jameson, Fredric. "On Negt and Kluge." *October* 46 (Fall 1988): 151–77.

Jędrzejewicz, Wacław. *Piłsudski: A Life for Poland*. New York: Hippocrene, 1982.

Kant, Immanuel. *The Conflict of the Faculties*. Trans. Mary J. Gregor. Lincoln: University of Nebraska Press, 1992.

Kant, Immanuel. *Observations on the Feeling of the Beautiful and Sublime*. Trans. John T. Goldthwait. Berkeley: University of California Press, 1960.

Kaplan, Leslie. *L'Excès-l'usine.* Paris: P.O.L., 1982.

Kaufmann, Hans. "Gespräch mit Christa Wolf." *Weimarer Beiträge* 6 (1974): 90–112.

Kimmelman, Michael. "How Public Art Turns Political." *New York Times,* 28 October 1996, C 15, C 18.

Kleinman, Mark. *Housing, Welfare, and the State in Europe: A Comparative Analysis of Britain, France, and Germany.* Cheltenham: Edward Elgar, 1996.

Klibansky, Raymond, Erwin Panofsky, and Fritz Saxl. *Saturn and Melancholy: Studies in the History of Natural Philosophy, Religion, and Art.* London: Nelson, 1964.

Kluge, Alexander. *Lebensläufe.* Frankfurt: Fischer, 1964

Kluge, Alexander. *Lernprozesse mit tödlichem Ausgang.* Frankfurt: Suhrkamp, 1973.

Krauss, Rosalind. "Rachel Whiteread: Making Space Matter." *Tate* 10 (Winter 1996): 32–36.

Kristeva, Julia. *Black Sun: Depression and Melancholia.* New York: Columbia University Press, 1989.

Kristeva, Julia. *Hannah Arendt: Life Is a Narrative.* Toronto: University of Toronto Press, 2001.

Kroplin, Regina, ed. *Ostdeutsche Frauen im gesellschaftlichen Transformationsprozess: Eine Untersuchung zur Situation der Frauen im Beruf und in der Familie in der DDR und die Fortsetzung geschlechtsspezifischer Segregation im Transformationsprozess.* Düsseldorf: Hans-Bockler-Stiftung, 1998.

Krüger, Reto. "Einige Bemerkungen zu den Abgußarbeiten." In *Bruce Nauman: Werke aus den Sammlungen Froehlich und FER,* ed. Götz Adriani. Ostfildern-Ruit: Hatje Cantz, 1999.

Lacan, Jacques. "Desire and the Interpretation of Desire in *Hamlet.*" Trans. James Hulbert. *Yale French Studies* 55–56 (1977): 11–52.

Lacan, Jacques. *Le Désir et son interprétation: Séminaire 1958–59.* Paris: L'Association freudienne internationale, 1984.

Lacan, Jacques. *The Four Fundamental Concepts of Psycho-Analysis.* Trans. Alan Sheridan. New York: Norton, 1979.

LaCapra, Dominick. *History and Memory after Auschwitz.* Ithaca: Cornell University Press, 1998.

Laclau, Ernesto. *New Reflections on the Revolution of Our Time.* Trans. Jon Barnes. London: Verso, 1990.

Lagache, Daniel. *La Psychanalyse.* Paris: Presses Universitaires de France, 1967.

Lahusen, Thomas, and Evgeny Dobrenko. *Socialist Realism without Shores.* Durham: Duke University Press, 1997.

Laplanche, Jean, and Jean-Bertrand Pontalis. *The Language of Psycho-Analysis.* Trans. Donald Nicholson Smith. New York: Norton, 1973.

Leach, Robert. *British Political Ideologies.* London: Prentice Hall, 1996.

Lecher, Wolfgang, and Hans-Wolfgang Platzer. "Global Trends and the European Context." In *The European Union: European Industrial Relations,* ed. Wolfgang Lecher. London: Routledge, 1998.

Lee, Pamela M. *Object to Be Destroyed: The Work of Gordon Matta-Clark.* Cambridge: MIT Press, 2000.

Le Foll, Jospehine. "Cranach fétichiste." *Beaux Arts Magazine* 126 (September 1994): 79–86.

Lefort, Claude. *La Complication: Retour sur le communisme.* Paris: Fayard, 1999.

Lefort, Claude. *The Political Forms of Modern Society: Bureaucracy, Democracy, Totalitarianism.* Trans. John B. Thompson. Cambridge: MIT Press, 1986.

Lepenies, Wolf. "Reflection and the Inhibition of Action." In *Melancholy and Society,* trans. Jeremy Gaines and Doris Jones. Cambridge: Harvard University Press, 1992.

Lewis, Jane, ed. *Gender, Social, and Welfare State Restructuring in Europe.* Aldershot: Ashgate, 1998.

Lingwood, James, ed. *House: Rachel Whiteread.* London: Phaidon, 1995.

Long, Kristi S. *We All Fought for Freedom: Women in Poland's Solidarity Movement.* Boulder: Westview, 1996.

Magenau, Jörg. *Christa Wolf: Eine Biographie.* Berlin: Kindler, 2002.

Maier, Charles S. *Dissolution: The Crisis of Communism and the End of East Germany.* Princeton: Princeton University Press, 1997.

Maier, Charles S. "Heißes und kaltes Gedächtnis. Zur politischen Halbwertzeit des faschistischen und kommunistischen Gedachtnisses." Das Gedächtnis des Jahrhunderts,

Institut für die Wissenschaften vom Menschen, Vienna. 9–11 March 2001. <http://www
.univie.ac.at/iwm/t-22txt5.htm>.

Mannoni, Octave. "Je sais bien, mais quand même." In *Clefs pour l'imaginaire, ou, l'autre scène*. Paris: Seuil, 1969.

Marx, Karl. *Capital: A Critique of Political Economy*. 3 vols. New York: Vintage, 1977.

Marx, Karl. "The German Ideology." In *The Portable Karl Marx*, ed. and trans. Eugene Kamenka. Harmondsworth: Penguin, 1983.

Massey, Doreen. "Space-Time and the Politics of Location." *Architectural Design* 68 (March–April 1998): 34–38.

Meschede, Friedrich, ed. *Rachel Whiteread: Gouachen*. Stuttgart: Cantz, 1993.

Messmer, Michael. "Apostle to the Techno/Peasants: Word and Image in the Work of John Berger." In *Image and Ideology in Modern/Postmodern Discourse*, ed. David Downing and Susan Bazargan. Albany: SUNY Press, 1991.

Michałek, Bolesław, and Frank Turaj. *The Modern Cinema of Poland*. Bloomington: Indiana University Press, 1988.

Michnik, Adam. "Acumen of the Irreconciled: A Few Conjectures on Dictatorship." In *Human Rights and Revolutions*, ed. Jeffrey N. Wasserstrom, Lynn Avery Hunt, and Marilyn Blatt Young. Lanham, Md.: Rowman & Littlefield, 2000.

Müller, Heiner. "Medeamaterial." In *Stücke*. Berlin: Henschel, 1988.

Müller, Heiner. "Mehr Utopie, mehr Phantasie und mehr Freiräume für Phantasie. Ein Gespräch mit Ulrich Dietzel." *Sinn und Form* 4 (1985): 1193–1217.

Müller, Heiner, and Jan Hoet. "Insights into the Process of Production — A Conversation." In *Documenta IX,* ed. Jan Hoet. Stuttgart: Cantz, 1992.

Mulvey, Laura. *Fetishism and Curiosity*. London: British Film Institute, 1996.

Münkler, Herfried, ed. *Furcht und Faszination: Facetten der Fremdheit*. Berlin: Akademie der Wissenschaften, 1997.

Nauman, Bruce, and Joan Simon. "Breaking the Silence: An Interview with Bruce Nauman." *Art in America* 76, no. 9 (September 1988): 141–203.

Negri, Antonio, and Jim Fleming. *Marx beyond Marx: Lessons on the Grundrisse*. South Hadley, Mass.: Bergin & Garvey, 1984.

Negt, Oskar. *Arbeit und menschliche Würde*. Göttingen: Steidel, 2001.

WORKS CITED

Negt, Oskar, and Alexander Kluge. *Geschichte und Eigensinn*. 3 vols. Frankfurt: Suhrkamp, 1981.

Negt, Oskar, and Alexander Kluge. *Öffentlichkeit und Erfahrung*. Frankfurt: Suhrkamp, 1972.

Negt, Oskar, and Alexander Kluge. *Public Sphere and Experience: Toward an Analysis of the Bourgeois and Proletarian Public Sphere*. Trans. Peter Labanyi, Jamie Owen Daniel, and Assenka Oksiloff. Minneapolis: University of Minnesota Press, 1993.

Neue Gesellschaft für Bildende Kunst. *Wunderwirtschaft: DDR-Konsumkultur in den 60er Jahren*. Cologne: Böhlau, 1996.

Nietzsche, Friedrich. *On the Genealogy of Morality*. Trans. Carol Diethe. Cambridge: Cambridge University Press, 1994.

Nietzsche, Friedrich. *The Will to Power*. Trans. Walter Kaufmann and R. J. Hollingdale. New York: Vintage, 1968.

Nixon, Mignon. "Bad Enough Mother." *October* 71 (Winter 1995): 71–92.

Nora, Pierre. *Realms of Memory: Rethinking the French Past*. Ed. Lawrence Kritzman, trans. Arthur Goldhammer. New York: Columbia University Press, 1996.

Offe, Claus. *Contradictions of the Welfare State*. Ed. John Keane. London: Hutchinson, 1984.

Offe, Claus. *Varieties of Transition: The East European and East German Experience*. Cambridge: MIT Press, 1997.

O'Kane, J. "History, Performance and Counter-Cinema: A Study of *Die Patriotin*." *Screen* 26 (1983): 2–17.

Olick, Jeffrey K., and Joyce Robbins. "Social Memory Studies: From Collective Memory to the Historical Sociology of Mnemonic Practices." *Annual Review of Sociology* 24 (1998): 105–40.

Pavsek, Christopher. "*History and Obstinacy:* Negt and Kluge's Redemption of Labor." *New German Critique* 68 (Spring/Summer 1996): 137–63.

Pfeil, Fred. "Between Salvage and Silvershades: John Berger and What's Left." *Triquarterly* 88 (Fall 1993): 230–45.

Pietsch, Hans. "Rachel Whiteread: Der Blick ins Innere der Dinge." *Art* 2 (February 1999): 46–55.

Podgorecki, Adam, and Vittorio Olgiati, eds. *Totalitarian and Post-Totalitarian Law*. Aldershot: Dartmouth Press, 1996.

Popitz, Heinrich. *Technik und Industriearbeit: Soziologische Untersuchungen in der Hüttenindustrie.* Tübingen: Mohr, 1976.

Préaud, Maxime. *Mélancolies.* Paris: Herscher, 1982.

Protokoły Porozumień Gdańsk, Szczecin, Jastrzębie. Statut NSZZ "Solidarność." Warsaw: KAW, 1980.

Pucci, Pietro. *Odysseus Polutropos: Intertextual Readings in the "Odyssey" and the "Iliad."* Ithaca: Cornell University Press, 1987.

Rainer, Peter. *Independent Social Movements in Poland.* London: LSE/Orbis, 1981.

Revill, David. *The Roaring Silence.* New York: Arcade, 1992.

Ricoeur, Paul. "Entre la mémoire et l'histoire." Das Gedächtnis des Jahrhunderts, Institut für die Wissenschaften vom Menschen, Vienna. 9–11 March 2001. <http://www.univie.ac.at/iwm/t-22txt5.htm>.

Robers, Norbert. *Joachim Gauck: Die Biografie einer Institution.* Berlin: Henschel, 2000.

Rocksloh-Papendieck, Barbara. *Verlust der kollektiven Bindung: Frauenalltag in der Wende.* Pfaffenweiler: Centaurus Verlag, 1995.

Salecl, Renata. "The Sirens and Feminine Jouissance." *differences* 9, no. 1 (Spring 1997): 14–35.

Sander, Helke. "'You Can't Always Get What You Want': The Films of Alexander Kluge." *New German Critique* 49 (Winter 1990): 59–68.

Sauvy, Alfred. "Trois mondes, une planète." *L'Observateur,* no. 118 (14 August 1952): 14.

Savitch, H. V. *Post-Industrial Cities: Politics and Planning in New York, Paris, and London.* Princeton: Princeton University Press, 1988.

Schlüpmann, Heidi. "Femininity as Productive Force: Alexander Kluge and Critical Theory." *New German Critique* 49 (Winter 1990): 69–78.

Schor, Naomi. "Female Fetishism: The Case of George Sand." In *The Female Body in Western Culture: Contemporary Perspectives,* ed. Susan Rubin Suleiman. Cambridge: Harvard University Press, 1986.

Silverman, Kaja. *Male Subjectivity at the Margins.* New York: Routledge, 1992.

Simon, Annette. *Versuch, mir und anderen die ostdeutsche Moral zu erklären.* Giessen: Psychosozial-Verlag, 1995.

Simon, Joan. Interview with Gerry Hovagimyan. In *Gordon Matta-Clark: A Retrospective,* ed. Mary Jane Jacob. Chicago: Museum of Contemporary Art, 1985.

Sky, Alison, and Robert Smithson. "Entropy Made Visible." In *Robert Smithson: Collected Writings,* ed. Jack D. Flam. Berkeley: University of California Press, 1996.

Sophocles. *Antigone.* In *The Theban Plays.* Trans. E. F. Watling. London: Penguin, 1974.

Staeck, Klaus, and Gerhard Steidl, eds. *Joseph Beuys: Das Wirtschaftswertprinzip.* Heidelberg: Edition Staeck, 1990.

Starobinski, Jean. "The Idea of Nostalgia." *Diogenes* 54 (Summer 1966): 81–103.

Stead, Jean. *Never the Same Again: Women and the Miners' Strike, 1984–85.* London: Women's Press, 1987.

Stråth, Bo, ed. *After Full Employment: European Discourses on Work and Flexibility.* Brussels: PIE Lang, 2000.

Sycowna, Bożena. "Człowiek z marmuru." *Powiększenie.* Cracow: Studenckie Centrum Kultury Uniwersytetu Jagiełłońskiego Rotunda, 1981.

Szaruga, Leszek. *Wobec totalitaryzmu: kostium koscielny w prozie polskiej wobec cenzury.* Szczecin: Ottonianum, 1994.

Szporer, Michael. "Woman of Marble: An Interview with Krystyna Janda." *Cinéaste* 18, no. 3 (1991): 14.

Thierse, Wolfgang. *Zukunft Ost: Perspektiven für Ostdeutschland in der Mitte Europas.* Berlin: Rowohlt, 2001.

Thomas, Neil. "The Making of *House:* Technical Notes." In *House: Rachel Whiteread,* ed. James Lingwood. London: Phaidon, 1995.

Tismaneanu, Vladimir. *Fantasies of Salvation: Post-Communist Political Mythologies.* Princeton: Princeton University Press, 1998.

Todorov, Tzvetan. *The Poetics of Prose.* Trans. Richard Howard. Oxford: Basil Blackwell, 1977.

Trappe, Heike. *Emanzipation oder Zwang? Frauen in der DDR zwischen Beruf, Familie und Sozialpolitik.* Berlin: Akademie Verlag, 1995.

Trumpener, Katie. *The Divided Screen: The Cinemas of Postwar Germany.* Princeton: Princeton University Press, forthcoming.

Turner, Bryan S. "A Note on Nostalgia." *Theory, Culture and Society* 4 (1987): 147–56.

Ugresic, Dubravka. "The Confiscation of Memory." *New Left Review* 218 (1996): 26–39.

Verdery, Katherine. *The Political Lives of Dead Bodies: Reburial and Postsocialist Change.* New York: Columbia University Press, 1999.

Vernant, Jean-Pierre. *Mortals and Immortals: Collected Essays.* Ed. Froma Zeitlin. Princeton: Princeton University Press, 1991.

Vidler, Anthony. *The Architectural Uncanny: Essays in the Modern Unhomely.* Cambridge: MIT Press, 1992.

Vidler, Anthony. *Warped Space: Art, Architecture, and Anxiety in Modern Culture.* Cambridge: MIT Press, 2000.

Virno, Paolo, and Michael Hardt. *Radical Thought in Italy.* Minneapolis: University of Minnesota Press, 1996.

Vollrath, Ernst. "Hannah Arendt bei den Linken." *Neue politische Literatur* 3 (1993): 361–72.

Walicki, Andrzej. "Intellectual Elites and the Vicissitudes of 'Imagined Nation' in Poland: Coping with the Problem of Nation in Poland." In *Intellectuals and the Articulation of the Nation,* ed. Ronald Grigor Suny and Michael D. Kennedy. Ann Arbor: University of Michigan Press, 1999.

Wallerstein, Immanuel. "De Bandoung à Seattle: 'C'était quoi, le tiers-monde?'" *Le Monde diplomatique* (August 2000): 18–19.

Walther, Joachim. "Christa Wolf." In *Meinetwegen Schmetterlinge: Gespräche mit Schriftstellern.* Berlin: Buchverlag Der Morgen, 1973.

Wiesenthal, Simon, ed. *Projekt: Judenplatz Wien.* Vienna: Paul Zsolnay, 2000.

Wolf, Christa. *Auf dem Weg nach Tabou: Texte 1990–94.* Cologne: Kiepenhauer und Witsch, 1994.

Wolf, Christa. *Cassandra: A Novel and Four Essays.* Trans. Jan van Heurck. New York: Farrar, Straus and Giroux, 1984.

Wolf, Christa. *Divided Heaven.* Trans. Joan Becker. Berlin: Seven Seas, 1965.

Wolf, Christa. *Der geteilte Himmel.* Leipzig: Reclam, 1976.

Wolf, Christa. *Hierzulande, Andernorts: Erzählungen und andere Texte, 1994–98.* Munich: Luchterhand, 1999.

Wolf, Christa. *Kassandra: Vier Vorlesungen und eine Erzählung.* Berlin: Aufbau, 1983.

Wolf, Christa. *Kein Ort. Nirgends.* Darmstadt: Luchterhand, 1979.

Wolf, Christa. *Kindheitsmuster.* Berlin: Aufbau, 1976.

Wolf, Christa. *Leibhaftig.* Munich: Luchterhand, 2002.

Wolf, Christa. *Lesen und Schreiben: Neue Sammlung: Essays, Aufsätze, Reden.* Darmstadt: Luchterhand, 1980.

Wolf, Christa. *Medea: A Modern Retelling.* Trans. John Cullen. New York: Doubleday, 1998.

Wolf, Christa. *Medea: Stimmen.* Munich: Luchterhand, 1996.

Wolf, Christa. *Nachdenken über Christa T.* Halle: Mitteldeutscher Verlag, 1968.

Wolf, Christa. *No Place on Earth.* Trans. Jan van Heurck. New York: Farrar, Straus and Giroux, 1982.

Wolf, Christa. *Parting from Phantoms: Selected Writings, 1990–94.* Trans. Jan van Heurck. Chicago: University of Chicago Press, 1997.

Wolf, Christa. *Patterns of Childhood.* Trans. Ursula Molinaro. New York: Farrar, Straus and Giroux, 1980.

Wolf, Christa. *The Quest for Christa T.* Trans. Christopher Middleton. London: Virago, 1982.

Wolf, Christa. "Reading and Writing." In *The Author's Dimension: Selected Essays,* trans. Jan van Heurck. New York: Farrar, Straus and Giroux, 1993: 20–48.

Wolf, Christa. "Von Kassandra zu Medea." In *Hierzulande, Andernorts: Erzählungen und andere Texte, 1994–98.* Munich: Luchterhand, 1999.

Wolf, Christa. *Was bleibt: Erzählung.* Frankfurt: Luchterhand, 1990.

Wolf, Christa. *What Remains and Other Stories.* Trans. Heike Schwarzbauer and Rick Takvorian. New York: Farrar, Straus and Giroux, 1993.

Yampolsky, Mikhail. "In the Shadow of Monuments: Notes on Iconoclasm and Time." Trans. John Kachur. In *Soviet Hieroglyphics: Visual Culture in Late Twentieth-Century Russia,* ed. Nancy Condee. Bloomington: Indiana University Press, 1995.

Yankélévitch, Vladimir. *Le Je-ne-sais-quoi et le presque-rien.* Paris: Seuil, 1980.

Yankélévitch, Vladimir. *L'Irréversible et la nostalgie.* Paris: Flammarion, 1974.

Young, Brigitte, ed. *Triumph of the Fatherland: German Unification and the Marginalization of Women.* Ann Arbor: University of Michigan Press, 1999.

Young, James E. *At Memory's Edge: After-Images of the Holocaust in Contemporary Art and Architecture*. New Haven: Yale University Press, 2000.

"Young Mister Lincoln de John Ford." *Cahiers du Cinéma* 223 (August/September 1970): 29–47.

Z historii walki o wolność słowa w Polsce: Cenzura w PRL w latach 1981–1987. Cracow: Towarzystwo Autorów i Wydawców Prac Naukowych Universitas, 1990.

Zerilli, Linda M. G. "The Arendtian Body." In *Feminist Interpretations of Hannah Arendt,* ed. Bonnie Honig. University Park: Pennsylvania State University Press, 1995.

Zielińska, Eleonora. "Between Ideology, Politics, and Common Sense: The Discourse of Reproductive Rights in Poland." In *Reproducing Gender: Politics, Publics, and Everyday Life after Socialism,* ed. Susan Gal and Gail Kligman. Princeton: Princeton University Press, 2000.

Žižek, Slavoj. *For They Know Not What They Do: Enjoyment as a Political Factor.* London: Verso, 1991.

Zysman, John, and Andrew Schwartz. *Enlarging Europe: The Industrial Foundations of a New Political Reality.* International and Area Studies 99. Berkeley: Center for Slavic and East European Studies, 1998.

3

CINEMA AND PERFORMANCE

Angels in America: The Millennium Approaches and *Perestroika.* Dir. Tony Kushner. Walter Kerr Theater, New York, 1993–94.

Brassed Off. Dir. Mark Herman. Prominent Features, 1996.

Człowiek z marmuru [Man of Marble]. Dir. Andrzej Wajda. Film Polski, 1977.

Człowiek ze żelaza [Man of Iron]. Dir. Andrzej Wajda. Film Polski, 1981.

D'Est [From the East]. Dir. Chantal Akerman. Lieurac Productions, 1993.

Deutschland im Herbst [Germany in Autumn]. Dirs. Rainer Werner Fassbinder, Heinrich Böll, Edgar Reitz, Alexander Kluge, Volker Schlöndorff, et. al. Filmverlag der Autoren, 1981.

Fabryka [Factory]. Dir. Krzysztof Kieślowski. WFD, 1970.

Gelegenheitsarbeit einer Sklavin [Part-Time Work of a Female Slave]. Dir. Alexander Kluge. Kairos Film, 1975.

Der geteilte Himmel [Divided Heaven]. Dir. Konrad Wolf. DEFA, 1964.

Melancholie I, oder Die zwei Schwestern [Melancholie I, or the Two Sisters]. Dir. Jörg Aufenanger. Berliner Ensemble Theater, Berlin, 1996.

Murarz [The Bricklayer]. Dir. Krzysztof Kieślowski. WFD, 1973.

Now That Communism Is Dead, My Life Feels Empty. Dir. Richard Foreman. Ontological Hysterical Theater, New York, 2001.

Panna nikt [Miss Nobody]. Dir. Andrzej Wajda. Studio Filmowe Perspektywa, 1997.

Pan Tadeusz, czyli Ostatni Zajazd na Litwie [Pan Tadeusz]. Dir. Andrzej Wajda. Filmart, 1999.

Die Patriotin [The Patriot]. Dir. Alexander Kluge. Kairos Films, 1979.

Prometheus. Dir. Tony Harrison. Channel Four Films, 1998.

A Requiem for Communism. Chor. Amy Pivar. Dance Theater Workshop, New York, 1993.

Robotnicy [Workers]. Dirs. Andrzej Zajączkowski and Andrzej Chodakowski. WFD, 1980.

Robotnicy '71 [Workers '71]. Dirs. Krzysztof Kieślowski and Tomasz Zygadło. WFD, 1972.

Trois Couleurs: Blanc [Three Colors: White]. Dir. Krzysztof Kieślowski. Miramax, 1994.

Trois Couleurs: Bleu [Three Colors: Blue]. Dir. Krzysztof Kieślowski. Miramax, 1993.

Trois Couleurs: Rouge [Three Colors: Red]. Dir. Krzysztof Kieślowski. Miramax, 1994.

ILLUSTRATION SOURCES

Figure 0.1: Sean Kelly Gallery, New York.

Figure 0.2: Marian Goodman Gallery, New York.

Figure 0.3: Sammlung Industrielle Gestaltung, Berlin.

Figures 1.1, 1.2, 1.4: Alan Chin, New York.

Figures 1.3, 5.6, 5.12, 7.1: Charity Scribner, Berlin.

Figure 1.5: Arndt and Partner, Berlin.

Figures 2.1, 2.2, 2.3: Studio Perspektywa, Warsaw.

Figure 3.1: Akademie der Künste, Berlin. © Artists Rights Society (ARS), New York/VG Bild-Kunst, Bonn.

Figures 3.2, 3.3: Nick Wall, London.

Figures 3.4, 3.5, 3.6, 3.7: Channel 4, London.

Figure 4.1: Anthony d'Offay Gallery, London.

Figure 4.2: Geographers' A-Z Map Co. Ltd., London.

Figures 4.3, 4.4, 4.5: Artangel, London.

Figures 5.1, 5.2, 5.3: Nina Lorenz-Herting, Berlin.

Figures 5.4, 5.5: Galerie Gina Kehayoff, Munich.

Figures 5.7, 5.10: Artists Rights Society (ARS), New York/VG Bild-Kunst, Bonn.

Figure 5.8: Victoria and Albert Museum, London.

Figures 5.9, 5.11: Jonas Maron, Berlin.

Figures 6.1, 6.2: Progress Film-Verleih Gmbh, Berlin.

Figure 6.3: Musée d'Unterlinden, Colmar.

INDEX

East Germany. *See* Germany, Eastern, after unification (New Federal States); Germany, East (German Democratic Republic)

East West (*Ost West,* Boltanski), 114–116, 115*fig.,* 117*fig.*

Economic Values (*Wirtschaftswerte,* Beuys), 13, 114, 116, 118–121, 120*fig.,* 123–127, 126*fig.,* 132, 195, 197

Economy, 5, 127. *See also* Digital economy; Informational economy

disintegration of in Eastern Bloc, 16, 111, 148

exchange, 118

transitional in new Europe, 27, 60, 87, 159, 163

Eichel, Hans, 157

Eichmann, Adolf, 183

Eigensinn (obstinacy, self-will), 106, 107

Eisenhüttenstadt (formerly Stalinstadt), 29*fig.,* 30*fig.,* 31, 34, 35*fig.,* 161

history of, 27

socialist housing replaced by museum, 10, 28

Emancipatory potential, 10, 147, 165

Empire, 4, 168

Engels, Friedrich, 116, 160

England, 5, 15, 89, 168, 169

decline of welfare state in, 4, 11, 75

and industrial labor, 66, 77, 84, 87

and mining, 11, 73, 75, 83, 182, 184

nationalism in, 169

and nostalgia for the East, 63–64

and Whiteread's *House,* 12–13, 90, 96, 101, 102

Enteignung (dispossession), 106

Environment, destruction of, 64, 68, 118

Europe, 10, 27, 66, 77, 111, 112, 116, 136, 137, 146, 149, 183, 197

and collective memory, 6, 12, 17, 19, 25, 92, 132, 167

decline of heavy industry and fate of industrial workers in, 4, 5, 6, 9, 11, 16, 68, 73, 84, 87, 151, 157–158

and legacies of fascism and socialism, 15, 172

mourning for socialism in, 3, 9, 14, 89–90, 95

museum fever in, 33

nostalgia for socialism in, 63–64, 75, 118

political extremism in, 165, 205

postsocialist cultural changes in, 159, 163

and three-worlds schema, 167

unification of, 42, 161

and women, 20, 46, 158, 160, 163

Europe, Eastern, 3–4, 14, 19, 23–24, 46, 64, 118, 182. *See also* Germany, Eastern, after unification (New Federal States); Germany, East (German Democratic Republic)

connections to Western Europe, 5, 15, 146, 168–169, 173

decline of heavy industry in, 9, 11, 73, 157

failure of digital technology in, 16, 174

failure of socialist workers' states in, 67, 68, 114

and longing for collective memory, 167

and opening of Berlin Wall, 39

postcommunist reconstruction and transitions in, 27, 59, 60, 158, 159, 160, 163

and relation between nationalism and socialism, 169

and transitional justice, 13

and waiting-room mentality, 127

Western idealization of, 4, 123, 127

and women, 10, 83, 160

Europe, Western, 14, 19, 28, 125, 127, 158, 159. *See also* Germany; Germany, West; Leftists, Western

connections to Eastern Europe, 5, 15, 146–147, 168–169, 173, 202

and modernity, 202–203

mourning and nostalgia for socialism in, 3–4, 11, 63–64, 66, 118, 123, 170

and relation between nationalism and socialism, 169

in relation to Solidarity, 47

and scholarship on socialist collapse, 171

Everyday life. *See* Socialist material culture

Exhibitions, 26, 33, 34, 42. *See also* Museums

of disappeared monuments, 39, 41

exhibition value replaces exchange value, 10

of objects from everyday GDR life, 10, 13, 24, 114, 116

used to legitimize socialist regime, 25

Exile, 106, 144, 145, 147

Expropriation, 66, 106, 186, 187

Extremist politics, 165, 205

Factories, 96, 170. *See also* Factory seconds; Labor; Workers

depicted in Berger and Kaplan, 66, 67–71, 81, 183, 185–186

depicted in Wolf, 136, 137, 164

and physical labor, 19, 85, 87, 151

INDEX

Museum of German History (Berlin), 25
Museum of Working-Class Life, 25–26
Museums, 3, 94, 95. *See also* Kindergarten Museum; Open Depot (Offenes Depot)
 collections replace the collective, 10, 43
 and collective memory, 25, 26
 and competition between socialist and Nazi pasts, 33, 176
 in contrast to archives, 36, 37, 38, 42
 emphasis on private life, 34
 exhibit relics of socialist everyday life, 10, 23–24, 28, 114, 125
 and guestbooks, 28, 42, 176
 and memory fever, 92, 95
 post-unification debates about, 39
 in relation to history, 31, 42, 43
Music, 14, 66, 91
 in Berger's depiction of gulag, 186
 in *Brassed Off*, 75, 77–78, 80–81, 82*fig.*, 83, 86*fig.*, 186
 in factory life, 11, 66, 71
 in Kieślowski, 161
 in the *Odyssey*, 78–80
Myth, 66, 148
 in Negt and Kluge, 105
 of Prometheus, 64
 of Sirens and Odysseus, 78–80, 81

Narrative technique, 84. *See also* Literature; Writing
 in Kaplan and Berger, 69–70
 in Wolf, 140–141, 145, 199
Nationalism, 50, 77, 169
National Remembrance Institute (Instytut Pamięci Narodowej), 171
Nauman, Bruce, 94, 102, 189
Nazism, 25
 and concentration camps, 177, 183–184
 in relation to succeeding regimes, 31, 33, 168
 study of, 15, 172
Negri, Antonio, 6, 170, 187
 and theory of immaterial labor, 5, 163, 182, 204
 and three-worlds schema, 167–168
Negt, Oskar, 12, 13, 16, 66, 87, 90, 163
 and *Antigone*, 106–107, 192–193, 201
 and Auschwitz, 73–75, 81, 183
 and factory time, 20, 26, 71, 151

and *Medea,* 141
and obstinacy, 104–107
and public sphere, 9, 43, 171
and theories of capital, 85, 186–187
Works:
 History and Obstinacy, 6, 12, 85, 104–106, 150, 163
 Public Sphere and Experience, 6, 71, 85, 104, 150
New Federal States. *See* Germany, Eastern, after unification (New Federal States)
New Labor, 169
New York, 11, 175, 205
Nietzsche, Friedrich, 20, 159
Nora, Pierre, 38, 169, 175, 177
Nostalgia, 10, 13, 26, 81, 85, 109, 132, 158, 165, 171
 in Berger, 67–68
 in Beuys, 123
 in contrast to melancholia, 121, 204
 in contrast to memory, 66, 71
 in contrast to mourning, 114, 116, 196
 definition of, 64
 for the East *(Ostalgie)*, 11, 63, 182
 in Herman, 75, 77, 83, 84, 184, 186
 for nineteenth-century industry, 9
 and Odysseus, 80
Nowa Huta (New Foundry), 4, 73, 161

Objects, everyday. *See* Socialist material culture
Obstinacy, 14, 104–107, 164
Odyssey (Homer), 78–80
Oedipal complex, 11, 51, 57, 140, 142
Öffentlichkeit (public sphere), 6, 171
Open Depot (Offenes Depot), 27–31, 29*fig.*, 30*fig.*, 31, 35*fig.*, 36, 39, 116, 121
 in contrast to archive, 25, 26, 37, 38, 42–43
 emphasis on private life, 34
 location and founding of, 10, 27, 28
 objects from everyday GDR life in, 24, 114
Oranienburg, 31, 32*fig.*, 33–34, 38, 176–177
Ostalgie ("nostalgia for the East"), 11, 63, 182
Ostzeiten ("Eastern times"), 116

Pain, 19, 20, 91, 150, 174
Pankhurst, Sylvia, 96
Paris, 4, 33, 104, 123, 132, 161. *See also* France
Party of Democratic Socialists (Germany), 205
Patriarchy, 48, 54, 60, 81, 147